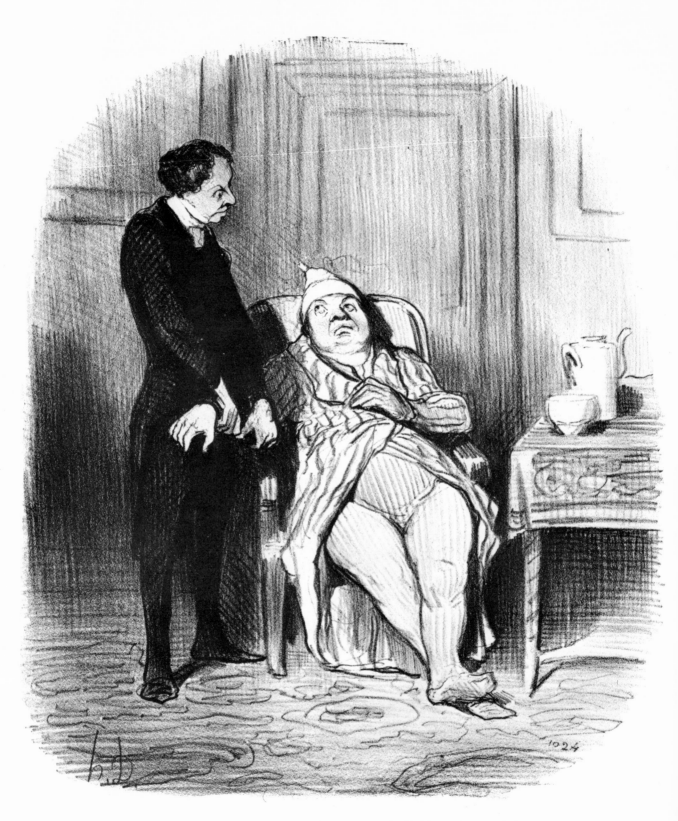

39 "Oh, doctor, I'm sure I'm consumptive" (Honoré Daumier)

Medicine and the Artist

137 Great Prints ❧ Selected with Commentary

by Carl Zigrosser

THIRD ENLARGED EDITION

Dover Publications, Inc., New York

Published in Canada by General Publishing Company, Ltd.,
30 Lesmill Road, Don Mills, Toronto, Ontario.
Published in the United Kingdom by Constable and Company, Ltd.,
10 Orange Street, London W.C.2.

This Dover edition, first published in 1970, is an enlarged and slightly
altered republication of the second revised edition (1959) of the *Ars
Medica* catalogue originally published by the Philadelphia Museum of
Art. This edition is published by special arrangement with the Museum.
In the present volume, for which a new Foreword has been written by
the compiler, *all* the catalogued items are illustrated on individual plates
and the text of the catalogue appears in the form of Notes to the Plates.

Medicine and the Artist belongs to the Dover Pictorial Archive Series.
Up to five illustrations from this book may be reproduced on any one
project or in any single publication free and without special permission,
provided the credit line is added: "Reproduced from *Medicine and the
Artist (Ars Medica)* by permission of the Philadelphia Museum of Art."
Wherever possible, also indicate the author and publisher. Please address
the publisher for permission to make more extensive use of illustrations
in this book than that authorized above.

The republication of this book in whole is prohibited.

Standard Book Number: 486-62133-2
Library of Congress Catalog Card Number: 69-17472

Manufactured in the United States of America

Dover Publications, Inc.
180 Varick Street
New York, N.Y. 10014

ὁ βίος βραχύς, ἡ δὲ τέχνη μακρή.

[Life is short, but art is long: HIPPOCRATES, *Aphorisms*.]

Introduction to the Dover Edition

This picture book is a reprint, somewhat revised, of an exhibition catalogue which accompanied a traveling show of medical prints organized by the Philadelphia Museum of Art in 1959. It was assembled from works in the permanent collection of the Museum. Through the generosity of the Smith Kline and French Laboratories, a special fund had been given the Museum for the purchase of prints of medical interest, and they formed the bulk of the original show. This nucleus was supplemented by works from the Museum's other holdings. This reprint now displays the original exhibition in its entirety.

Since 1959, the Museum has made numerous additions to this *Ars Medica* collection, again through grants from the above-mentioned pharmaceutical house and from other sources. Smith Kline and French Laboratories have furnished a conspicuous example of enlightened and generous support of the arts in their continuing grants of purchase funds for *Ars Medica*. As the result of their cooperation and that of other private individuals and institutions, the Philadelphia Museum of Art is becoming a center for pictorial research in subjects relating to the history of medicine and allied professions.

In spite of the sizable amount of newly acquired material available for inclusion in a pictorial survey, it was deemed wise in this reprint to preserve the unity of the first publication and limit the contents to the 137 illustrations described therein. With the exception of a Greek coin and a wash drawing by Woodward all the material included consists of printed pictures or "prints." Because printmaking in the West first began early in the fifteenth century, the scope of the present survey extends from the fifteenth to the twentieth centuries, from the late Gothic and Renaissance to modern times. Within this segment of history much of our culture and technology has come into being, and the period indeed is rich in landmarks of medical import. Printmaking has always been associated with the printed word throughout its history, and many of the prints included in this survey first appeared in books, now become rare.

Since prints are so much in evidence it might be fitting to describe how they are made. Three major methods have been devised for the production of printed pictures. The first and oldest is by means of the "relief" principle, namely to cut away from the plane surface of a wood block everything that does not appear in the design. Thus the lines and masses stand in relief from the rest of the block and, when inked and printed on paper, appear as a woodcut or wood engraving. The second, the "intaglio" method, is the opposite of the relief technique: the lines and the dots (which suggest mass) are incised

in a copper plate; when ink is forced into them and when the plate together with a piece of paper is run through a press, the ink is transferred to the paper and thereby forms a line engraving, etching, or drypoint (all linear in character), or a mezzotint, stipple, or aquatint (to suggest tone or mass). The third, or "chemical," method makes use of the antipathy of grease and water to make printed facsimiles. The drawing is executed with a greasy crayon on a special kind of stone. This is fixed in the stone with an etch. The blank (that is, without crayon marks) parts of the stone are dampened, and the stone rolled up with greasy ink, which will stick on the drawing but not on the damp parts. The design, when run through a press, is transferred to paper to become a lithograph. Such are the three principal techniques employed by artists and craftsmen of the past to make printed pictures or "prints." They are still used by artists today in their creative work. Photomechanical methods are now employed for all other kinds of work, such as illustrations in books and magazines, and reproductions of paintings.

The *Ars Medica* collection (presented here as *Medicine and the Artist*) aims to portray, in a nutshell, the essential aspects of medical iconography, as they have been reflected in graphic art through six centuries. Each print was chosen not only for its quality as a work of art but also for its story-telling value, to illustrate the various categories of medical history and practice. And many great artists have told this story, including Schongauer, Dürer, Rembrandt, Holbein, Bellini, Watteau, Boucher, Hogarth, Goya, Rowlandson, Gillray, Daumier, Gavarni, Blake, Bellows, Lautrec, Munch, Kollwitz, and Klee. Though *Medicine and the Artist*, by reason of its subject matter, will naturally have a special interest for the medical profession, it is designed to appeal to the general public as well, for it is devoted to a theme of vital concern to everyone. The collection represents, one might say, a happy conjunction of the Fine Arts with the Healing Arts.

CARL ZIGROSSER

Contents and List of Plates

Plates PAGE 1
Notes to the Plates 137
Index of Artists 177

THE PLATES

I / From Medicine Man to Doctor of Medicine

1 Medicine Man Curing a Patient (Seth Eastman)
2 Uroscopy, or Physician and Patient (Erhard Reuwich)
3 The Physician (Italian School, 1500)
4 The Consultation (Italian School, XVI century)
5 Visit to a Plague Patient (Gentile Bellini)
6 The Doctors (Hans Burgkmair)
7 The Physician (Jost Amman)
8 Portrait of Dr. Ephraim Bonus (Rembrandt)

II / Allegories of the Healing Arts

9 Head of Asklepios (Greek coin, II century B.C.)
10 St. Cosmas and St. Damian (Johannes Wechtlin)
11 Allegory of the Medical Profession (School of Hendrik Goltzius)
 A Physician as God
 B Physician as an Angel
 C Physician as a Man
 D Physician as a Devil
12 Christ Healing the Sick (Rembrandt)
13 M.D. (Harry Sternberg)

III / Great Names

14 Title page with 24 portraits of ancient and medieval physicians (Hans Weiditz)
15 Paracelsus (Balthazar Jenichen)
16 Ambroise Paré (German School, XVI century)
17 Andreas Vesalius (Jan Stephan von Calcar)
18 William Harvey (Richard Gaywood)
19 Santorio Santorio (Giacomo Piccini)
20 Pasteur in His Laboratory (Timothy Cole)
21 Sigmund Freud (Hermann Struck)

IV / Physicians and the Arts and Sciences

22 François Rabelais (Baltazar Moncornet)
23 Sir Thomas Browne (Robert White)
24 Carolus Linnaeus (Robert Dunkarton)
25 Sir Francis Seymour Haden (self-portrait)
26 Albert Schweitzer (Arthur William Heintzelman)

V / Pharmacy

27 Pharmacy, with Doctor Selecting Drugs (German School, XVI century)
28 Preparation of Theriac (German School, XVI century)
29 The Apothecary (Jost Amman)
30 Preparation of Medicinal Oils (English School, XVI century)
31 A Seventeenth-Century Apothecary Shop (German School)
32 Ride to Rumford (Thomas Rowlandson)
33 Apothecary and Pharmacist (Honoré Daumier)

VI / The Practice of Medicine

34 Physician Ministering to a Patient (Hans Weiditz)
35 Physician Prescribing Venesection (Hans Weiditz)

CONTENTS AND LIST OF PLATES

36 Phlebotomy (Abraham Bosse)

37 Physician Attending a Young Woman (Jan Steen)

38 Consultation (Louis Boilly)

39 "Oh, doctor, I'm sure I'm consumptive" (Honoré Daumier)—*Frontispiece*

40 The Country Doctor (Honoré Daumier)

VII / The Practice of Surgery

41 Amputation (Johannes Wechtlin)

42 Cautery (Johannes Wechtlin)

43 Extension Apparatus for Fractured Arm (Johannes Wechtlin)

44 The Death of Henri II (Jacques Perrissin)

45 Village Surgeon (Cornelis Dusart)

46 "Let's see, open your mouth" (Honoré Daumier)

VIII / Hospitals in Peace and War

47 Hospital Interior (French School, ca. 1500)

48 Infirmary of the Charity Hospital, Paris (Abraham Bosse)

49 Pennsylvania Hospital in Pine Street, Philadelphia (William Birch)

50 Middlesex Hospital, London (Rowlandson and Pugin)

51 Extraction of an Arrowhead (Johannes Wechtlin)

52 A Military Hospital (Francisco Goya)

53 Surgeon at Work during an Engagement (Winslow Homer)

IX / Hygiene and Preventive Medicine

54 Men's Bath (Albrecht Dürer)

55 Men's Bath (Italian School, xvi century)

56 Business Men's Class (George Bellows)

57 The Rat Catcher (Cornelis Visscher)

58 The Circumcision (Crispin de Passe)

59 Vaccination (Leopoldo Méndez)

60 Thames Water (William Heath)

X / Medical Teaching

61 Petrus de Montagnana in the Lecture Chair (Gentile Bellini)

62 The College of Physicians (Rowlandson and Pugin)

63 The Gross Clinic (Thomas Eakins)

64 Ward Rounds (Robert Riggs)

65 A Lesson in Anatomy (Gavarni)

XI / Anatomy Demonstrations

66 Lesson in Dissection (Italian School, xv century)

67 Skeleton (German School, xvi century)

68 Skeleton Leaning on a Spade (Workshop of Titian)

69 The Ninth Plate of Muscles (Workshop of Titian)

70 Vesalius Teaching Anatomy (Jan Stephan von Calcar)

71 Anatomy Lesson of Pieter Paaw (Jacob de Gheyn)

XII / Charts and Diagrams

72 Betony (German School, xv century)

73 Corn Poppy (Hans Weiditz)

74 The Zodiac Man (Italian School, xv century)

75 Bloodletting Chart (Johannes Wechtlin)

76 A Chart of Veins (Workshop of Titian)

77 Surgical Instruments (German School, xvi century)

78 The Muscles of the Head (Jacques Gautier Dagoty)

XIII / The Artist Observes the Sick

79 An Omnibus during an Epidemic of Grippe (Honoré Daumier)

80 Colic on His Wedding Night (Gavarni)

81 Carnot Ill (Henri de Toulouse-Lautrec)

82 The Sick Child (Edvard Munch)

83 Visit to the Children's Hospital (Käthe Kollwitz)

XIV / The Artist Looks at Disease

84 St. Anthony's Fire or Ergotism (Johannes Wechtlin)

85 Ague and Fever (Thomas Rowlandson)

86 The Gout (James Gillray)

87 The Headache (George Cruikshank)

88 Dropsy Courting Consumption (Thomas Rowlandson)

XV / Satire and Caricature

89 The Imaginary Invalid (François Boucher)

90 How Merrily We Live That Doctors Be (Robert Dighton)

91 The Doctor and His Friends (George M. Woodward)

92 A Visit to the Doctor (Thomas Rowlandson)

93 Address of Thanks to Influenza (T. West)

94 Cow Pock (James Gillray)

95 Vaccine in Conflict with the Medical Faculty (French School, XIX century)

XVI / Charlatans

96 A Surgical Operation (Lucas van Leyden)

97 Operation for Stones in the Head (H. Weydmans)

98 The Quack (Willem Buytewech)

99 The Quack (Annibale Carracci)

100 Dr. Misaubin (Antoine Watteau)

101 The Company of Undertakers (William Hogarth)

102 Of What Illness Will He Die? (Francisco Goya)

XVII / The Sleep of Reason

103 The Sleep of Reason Produces Monsters (Francisco Goya)

104 Dream (Albrecht Dürer)

105 Job Troubled by Dreams (William Blake)

106 Nightmare (Rockwell Kent)

107 The Physician Curing Fantasy (French School, XVII century)

108 St. Anthony Tormented by Demons (Martin Schongauer)

109 First Attempts (Francisco Goya)

110 The Old Man Wandering among Phantoms (Francisco Goya)

111 Demons Ridicule Me (James Ensor)

112 The Vapors (Alexandre Colin)

XVIII / The Madhouse (XVI–XIX centuries)

113 Plate of Sketches (Albrecht Dürer)

114 Bedlam Hospital, London (William Hogarth)

115 St. Luke's Hospital, London (Rowlandson and Pugin)

116 The Madhouse (Wilhelm von Kaulbach)

XIX / The Madhouse (XX century)

117 Dance in a Madhouse (George Bellows)

118 Psychopathic Ward (Robert Riggs)

119 Insane People at Mealtime (Erich Heckel)

120 A Man in Love (Paul Klee)

XX / The Beginning and End of Life

121 The Course of Life (late XVIII century)

122 The Birth of the Virgin (Albrecht Dürer)

123 Childbirth (Jost Amman)

124 L'Accouchement (Abraham Bosse)

125 Gypsy Encampment (Jacques Callot)

126 Morbetto (Raphael)

127 Death and the Physician (Hans Holbein the Younger)

128 The Death Scene (William Hogarth)

XXI / Emblems of Mortality

129 Job Afflicted with Boils (William Blake)

130 Death the Destroyer (Alfred Rethel)

131 Woman and Death (Käthe Kollwitz)

132 The Secret of Life (Harry Sternberg)

133 Hercules Combating the Hydra (Andrea Mantegna)

134 To Succor the Sick (Crispin de Passe)

Medicine and the Artist

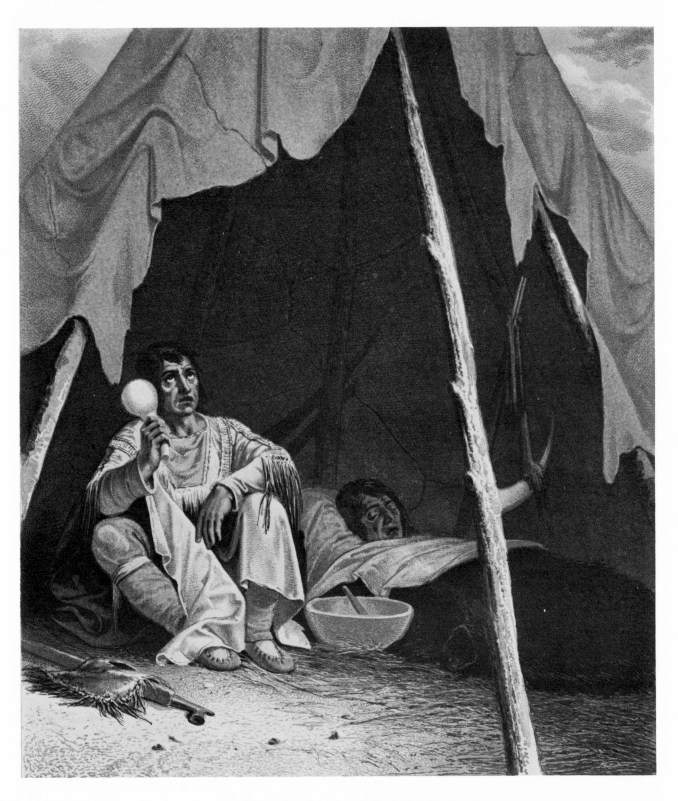

1 Medicine Man Curing a Patient (Seth Eastman)

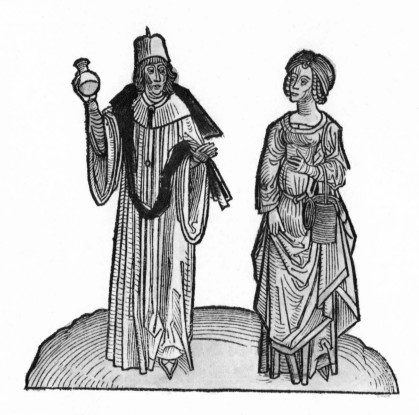

2 Uroscopy, or Physician and Patient (Erhard Reuwich)

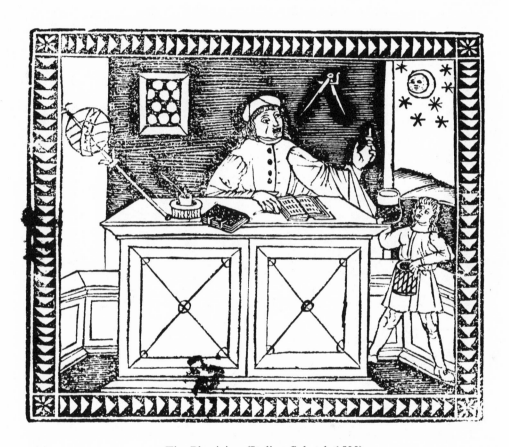

3 The Physician (Italian School, 1500)

4 The Consultation (Italian School, XVI century)

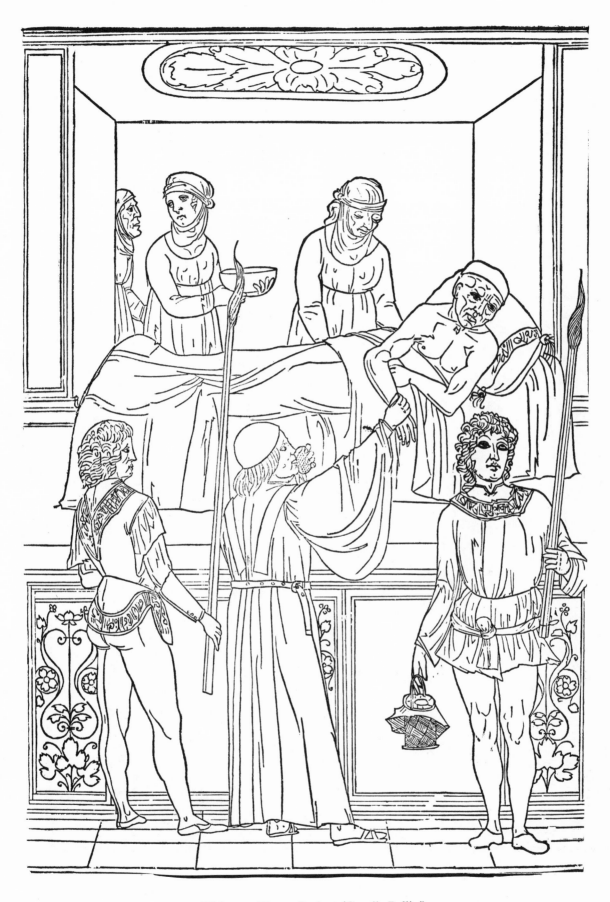

5 Visit to a Plague Patient (Gentile Bellini)

6 The Doctors (Hans Burgkmair)

Der Doctor.

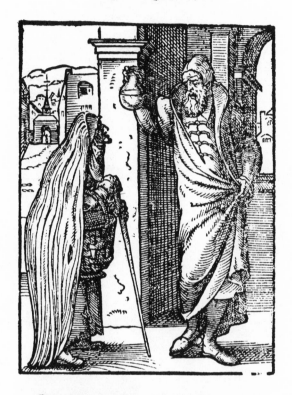

Ich bin ein Doctor der Artzney/
An dem Harn kan ich sehen frey/
Was Kranckheit ein Menschn thut beladn/
Dem kan ich helffen mit Gotts Gnaden/
Durch ein Syrup oder Recept/
Das seiner Kranckheit widerstrebt.
Daß der Mensch wider werd gesund/
Arabo die Artzney erfund.

D iij Der

7 The Physician (Jost Amman)

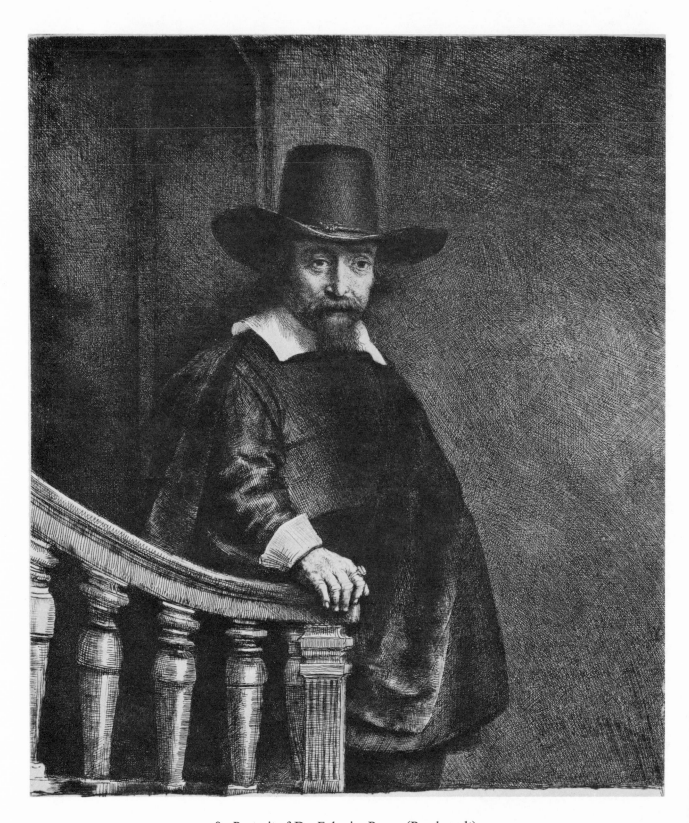

8 Portrait of Dr. Ephraim Bonus (Rembrandt)

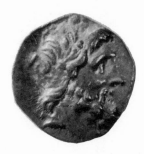

9 Head of Asklepios (Greek coin, II century B.C.)

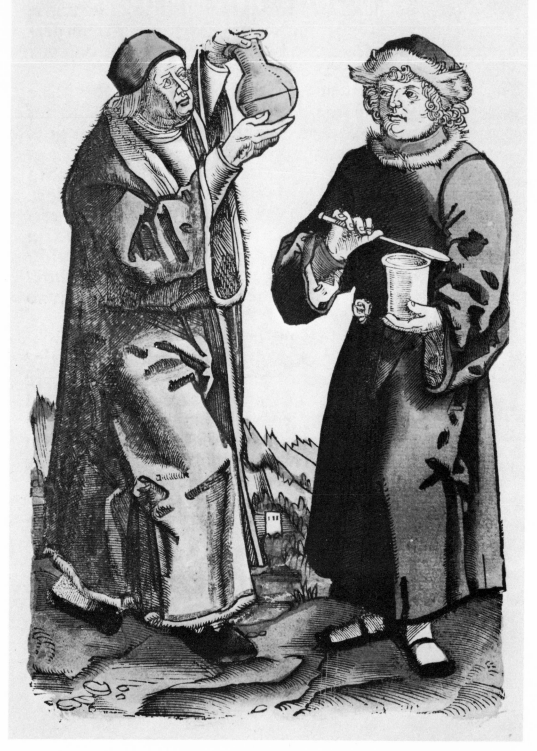

Nit quid pro quo/nit weiſſz für ſchwartz
Darzeychen ſoll ein weiſer Artz/
Sonder erfaren ſein der ding/
Will anders er das ym geling.

10 St. Cosmas and St. Damian (Johannes Wechtlin)

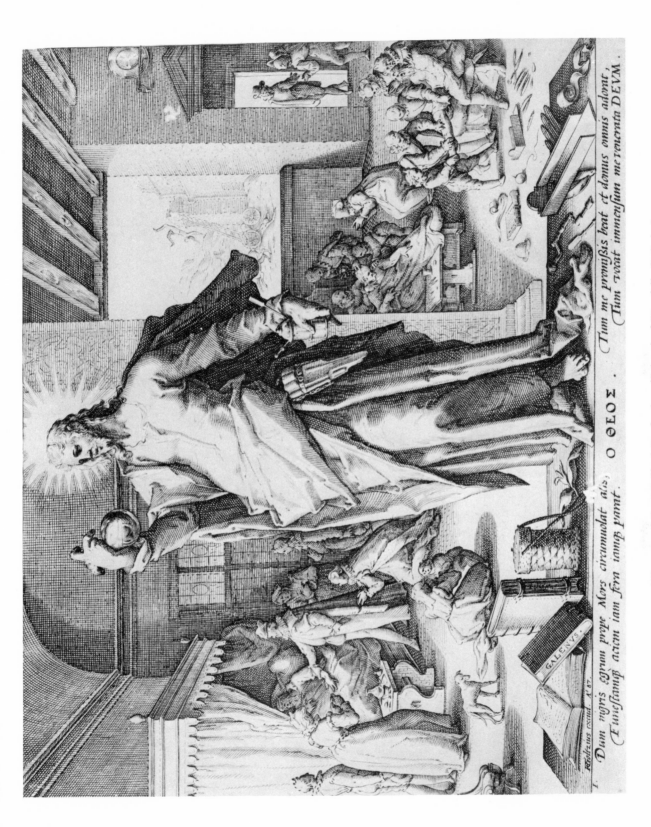

11 Allegory of the Medical Profession (School of Hendrik Goltzius)
A Physician as God

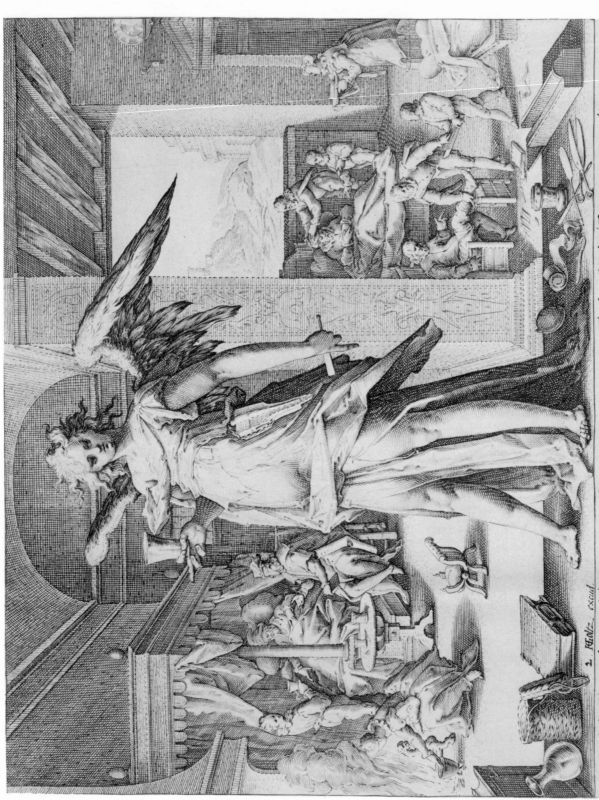

Paulum ubi convaluit; paulum de numine nostro H TOY ΘΕΟΥ ΧΕΙΡ. Thūçlo nobis dimiſſus es ANGELVS alto;
Ceſſit, et in noſtris auribus iſta ſonant: Præmia quæ veſtri et quanta laboris erunt:

2. Goltz. excud.

11 Allegory of the Medical Profession (School of Hendrik Goltzius)

B Physician as an Angel

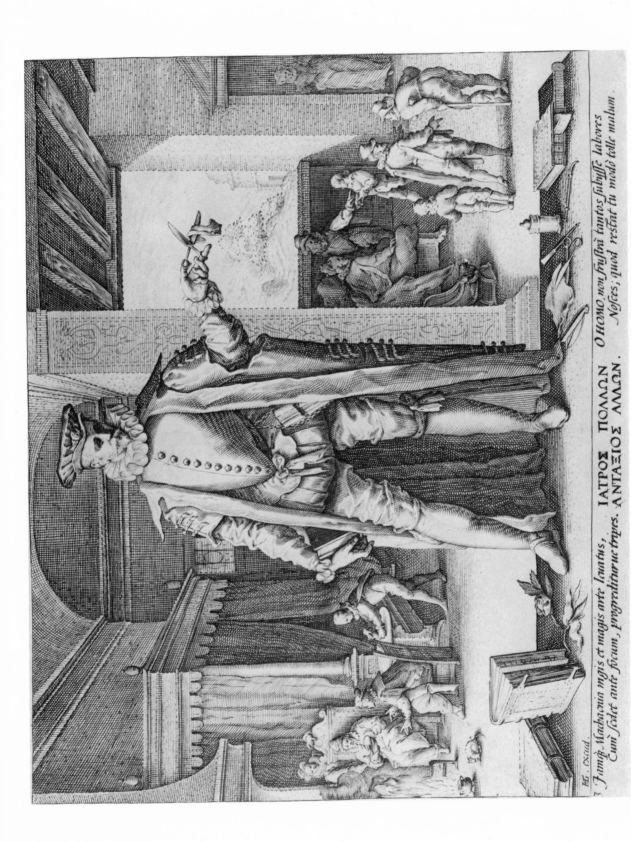

11 Allegory of the Medical Profession (School of Hendrik Goltzius)

c Physician as a Man

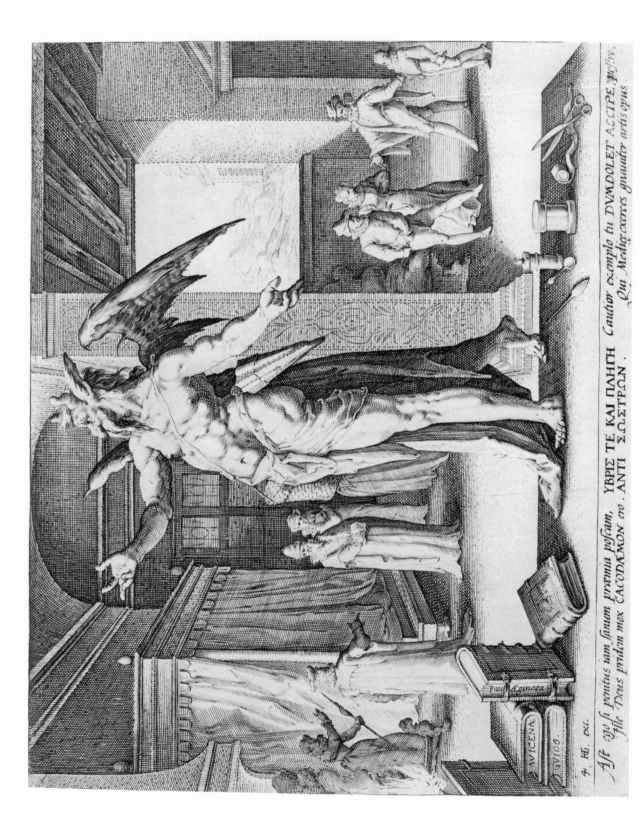

11 Allegory of the Medical Profession (School of Hendrik Goltzius)
D Physician as a Devil

12 Christ Healing the Sick (Rembrandt)

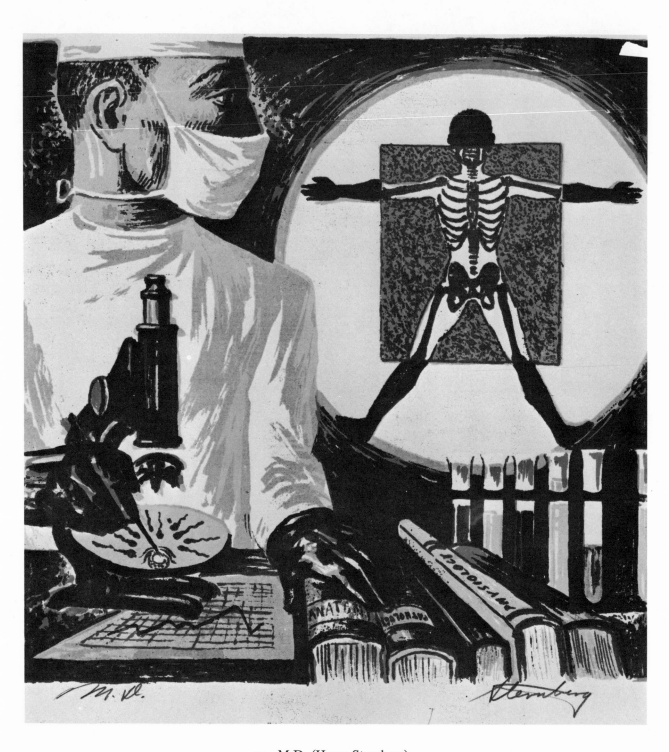

13 M.D. (Harry Sternberg)

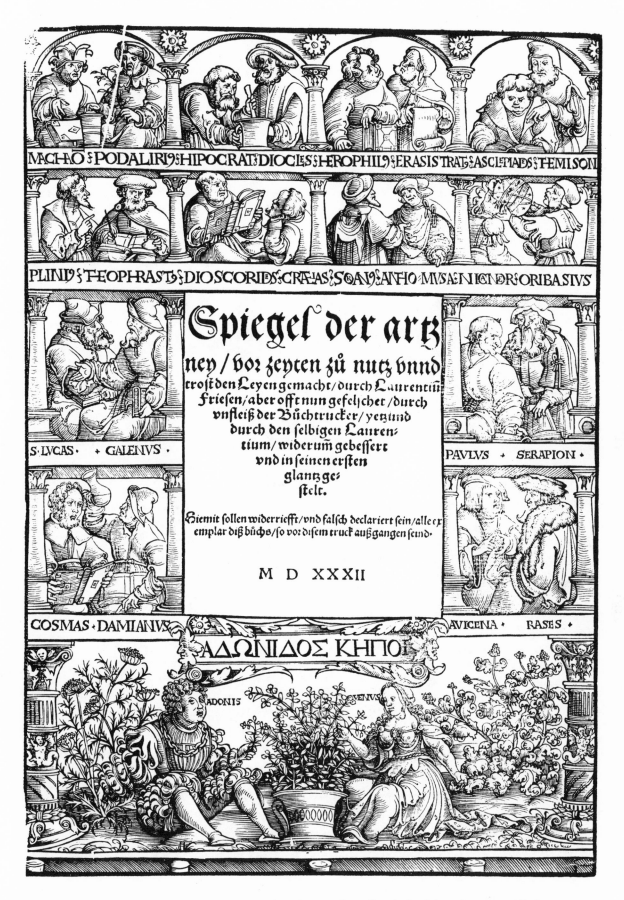

14 Title page with 24 portraits of ancient and medieval physicians (Hans Weiditz)

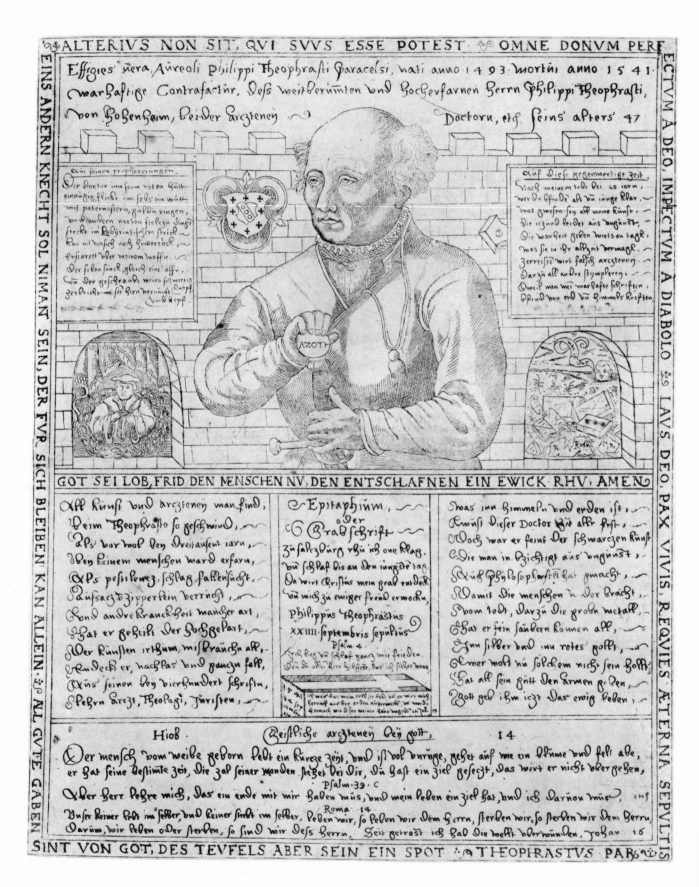

15 Paracelsus (Balthazar Jenichen)

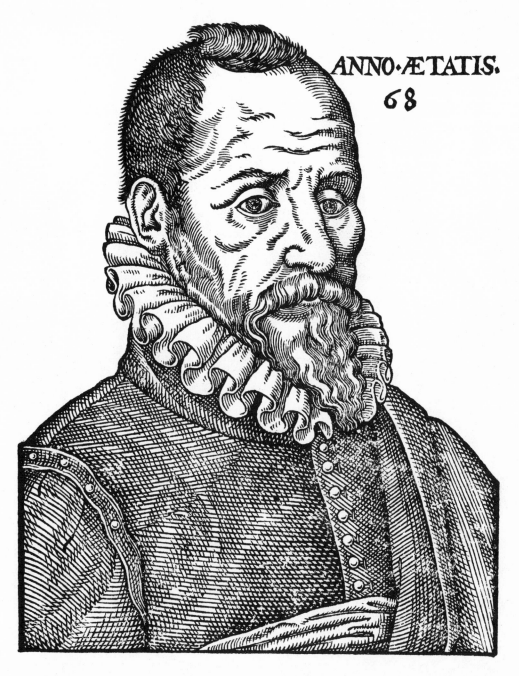

ANNO·ÆTATIS. 68

16 Ambroise Paré (German School, XVI century)

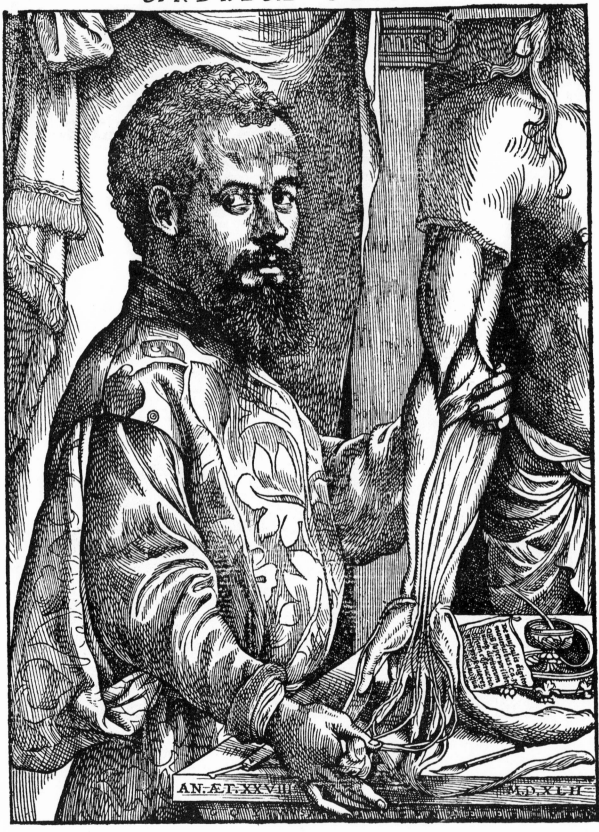

AN. ÆT. XXVIII M.D.XLII.

17 Andreas Vesalius (Jan Stephan von Calcar)

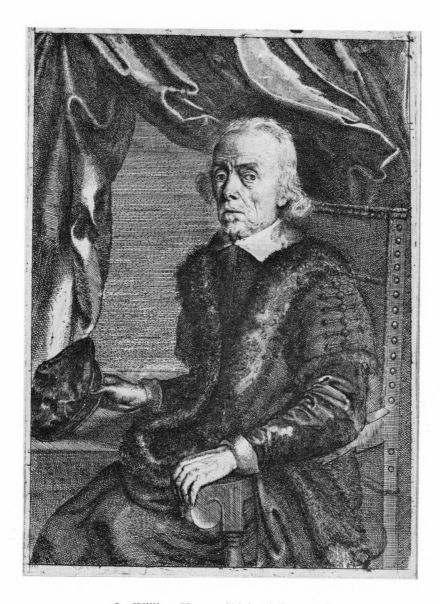

18 William Harvey (Richard Gaywood)

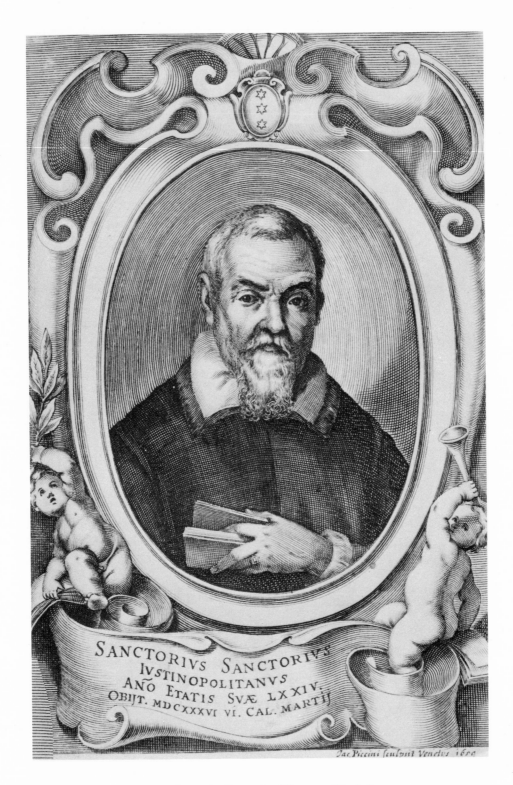

SANCTORIVS SANCTORIVS
IVSTINOPOLITANVS
AÑO ETATIS SVÆ LXXIV.
OBIJT. MDCXXXVI VI. CAL. MARTIJ

Jac. Piccini sculpsit Venetÿs 1650

19 Santorio Santorio (Giacomo Piccini)

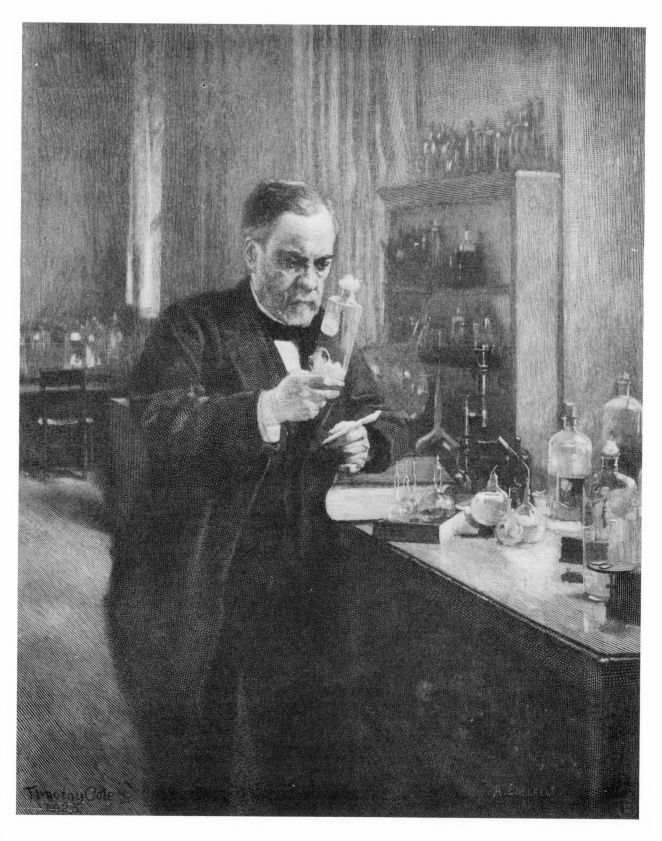

20 Pasteur in His Laboratory (Timothy Cole)

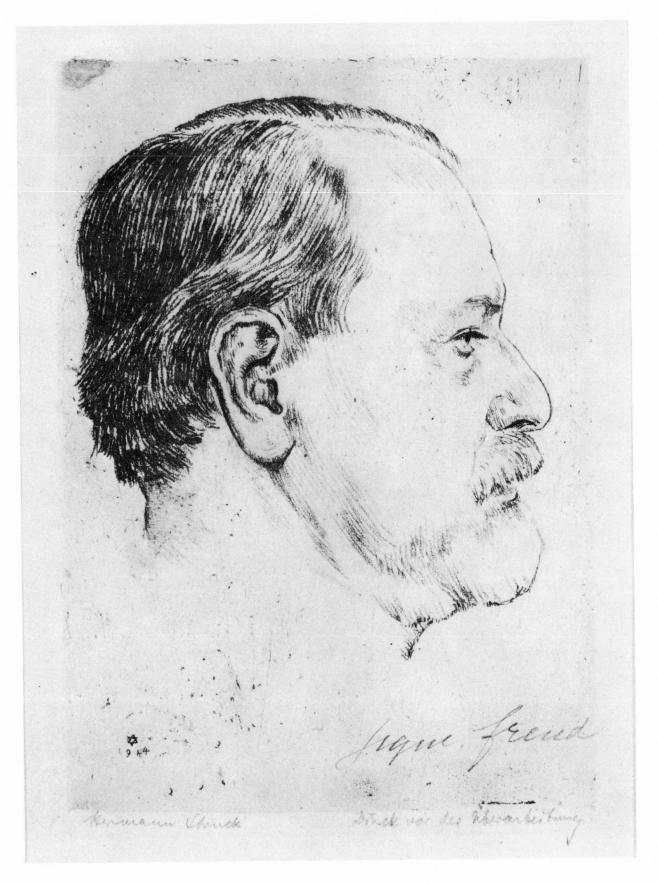

21 Sigmund Freud (Hermann Struck)

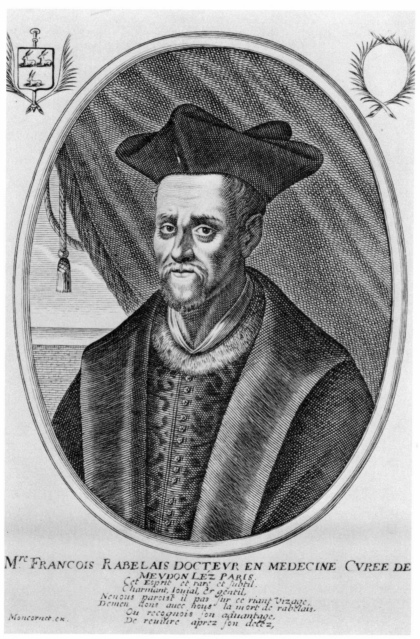

Mᵣᵉ FRANCOIS RABELAIS DOCTEVR EN MEDECINE CVREE DE
MEVDON LEZ PARIS.
Cet Esprit et rare et subtil,
Charmant, Iouial, & gentil,
Nenous paroist il pas sur ce riant Vizage,
Demen dons auec hous la mort de rabelais.
Ou recognois son auantage,
De reuiure aprez son deteez,

Moncornet ex.

22 François Rabelais (Baltazar Moncornet)

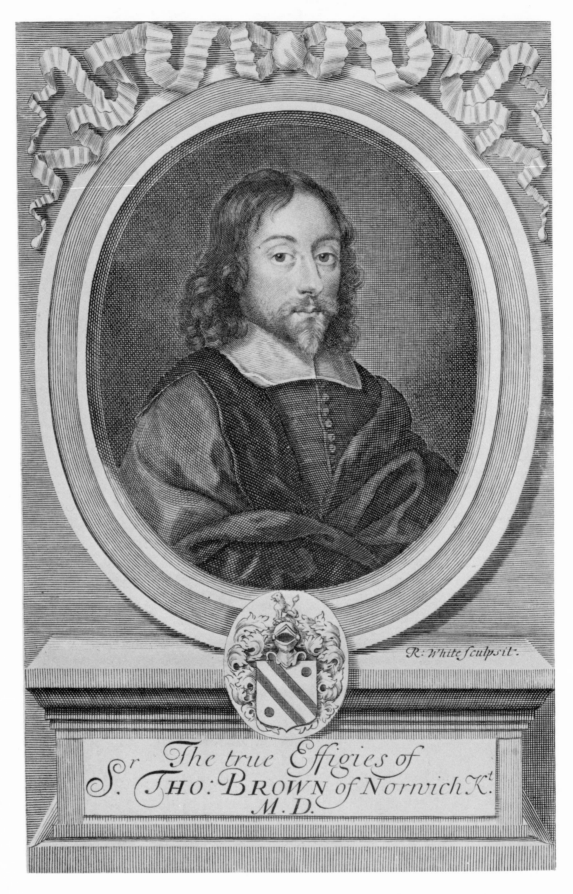

R: White sculpsit.

The true Effigies of
Sr. THO: BROWN of Norwich Kt.
M.D.

23 Sir Thomas Browne (Robert White)

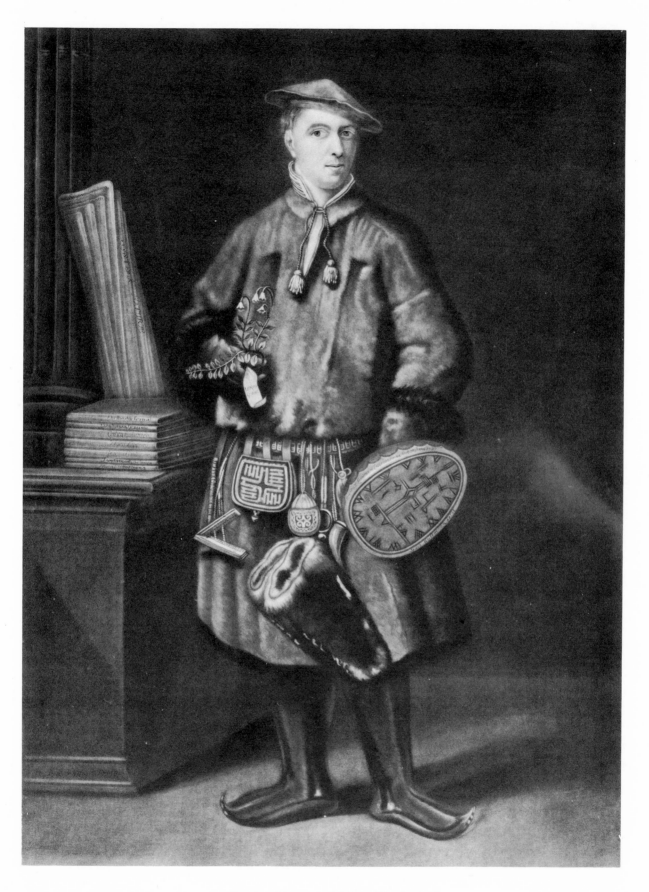

24 Carolus Linnaeus (Robert Dunkarton)

25 Sir Francis Seymour Haden (self-portrait)

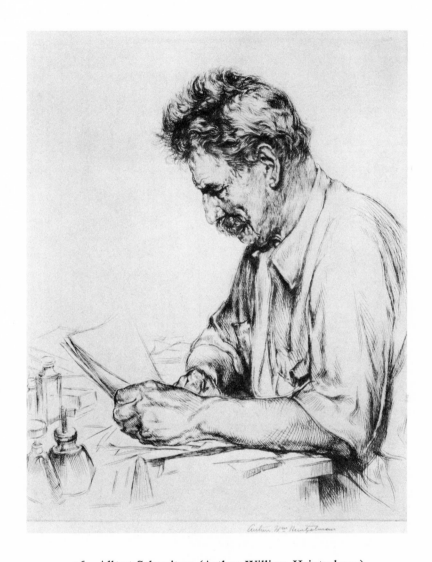

26 Albert Schweitzer (Arthur William Heintzelman)

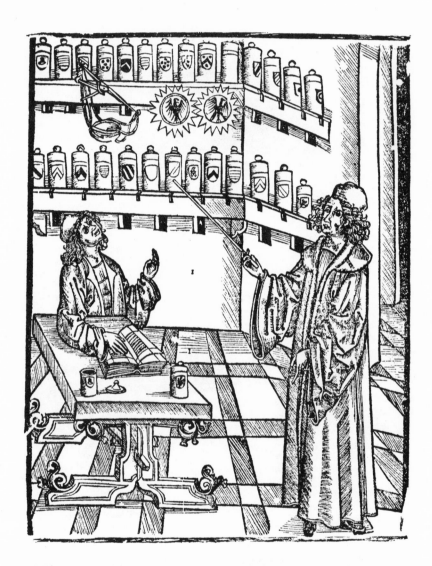

27 Pharmacy, with Doctor Selecting Drugs (German School, XVI century)

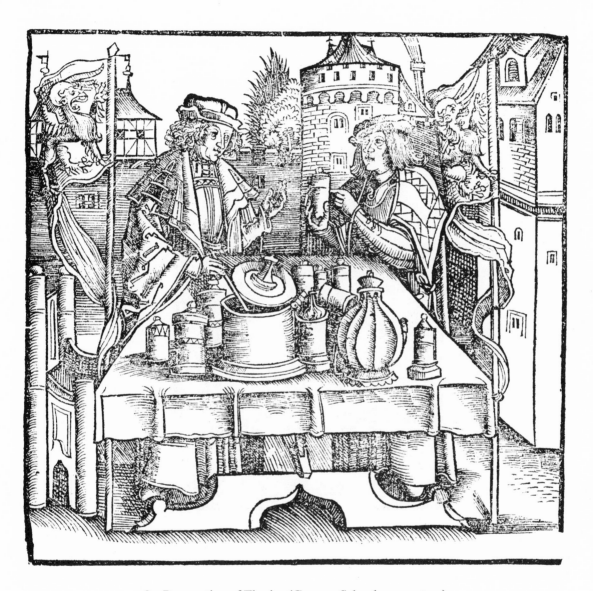

28　Preparation of Theriac (German School, XVI century)

Der Apotecker.

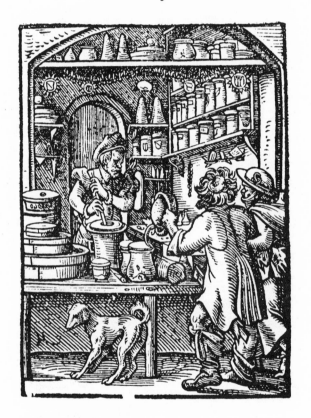

29 The Apothecary (Jost Amman)

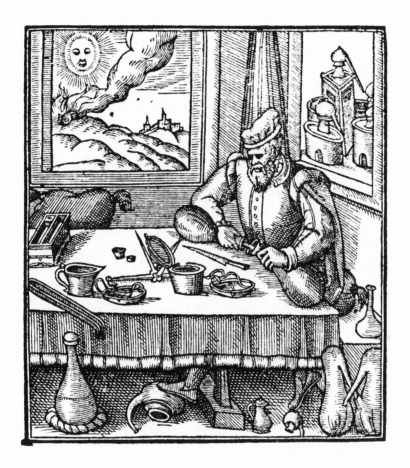

30 Preparation of Medicinal Oils (English School, XVI century)

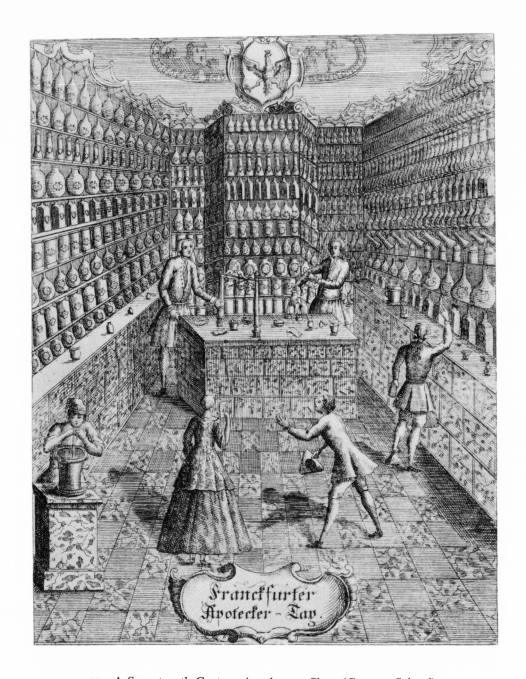

31 A Seventeenth-Century Apothecary Shop (German School)

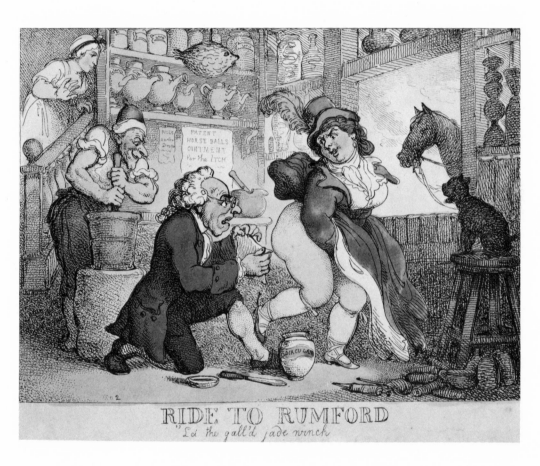

32 Ride to Rumford (Thomas Rowlandson)

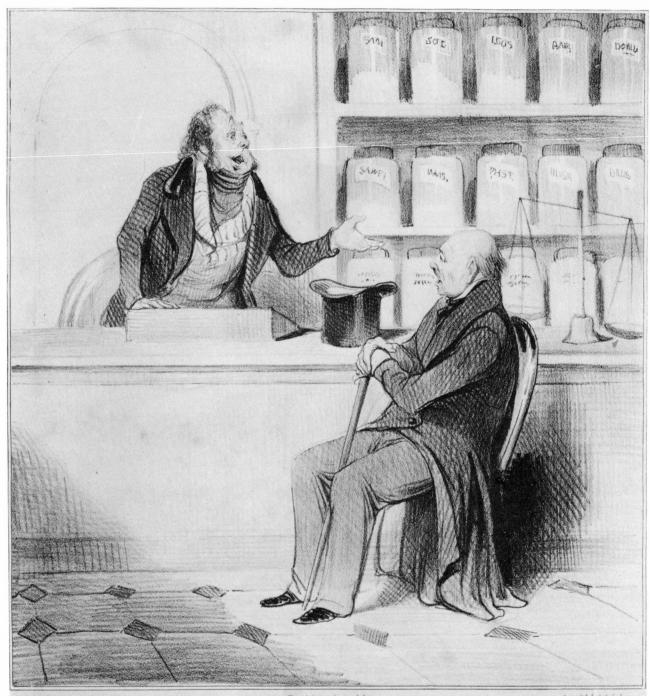

33 Apothecary and Pharmacist (Honoré Daumier)

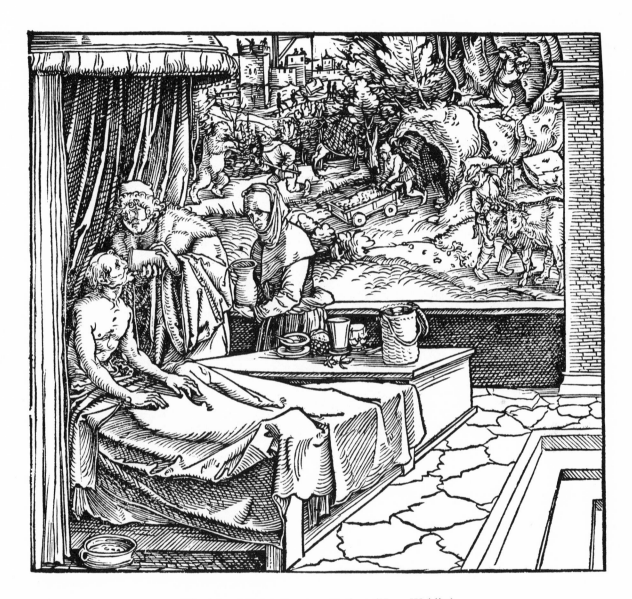

34 Physician Ministering to a Patient (Hans Weiditz)

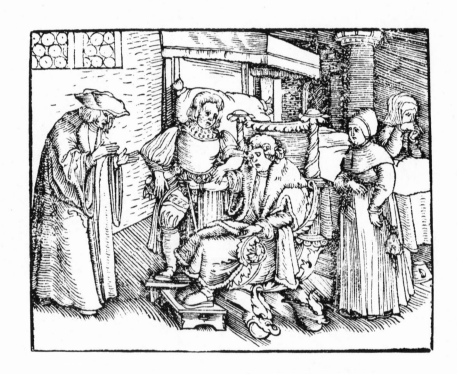

35　Physician Prescribing Venesection (Hans Weiditz)

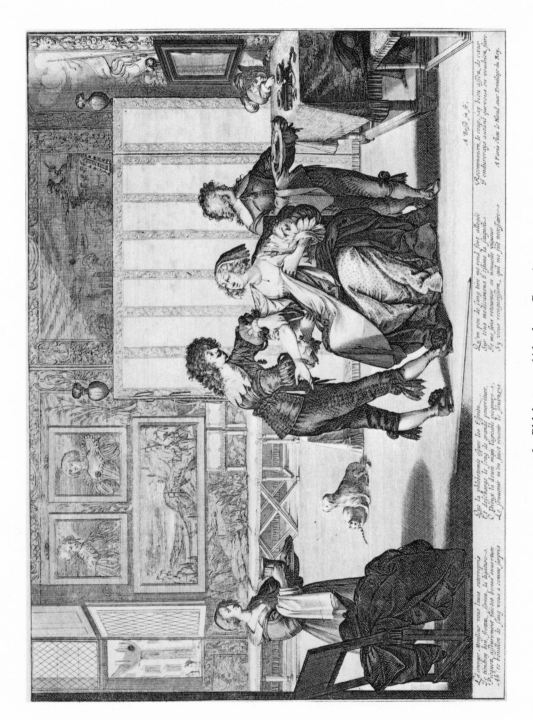

36 Phlebotomy (Abraham Bosse)

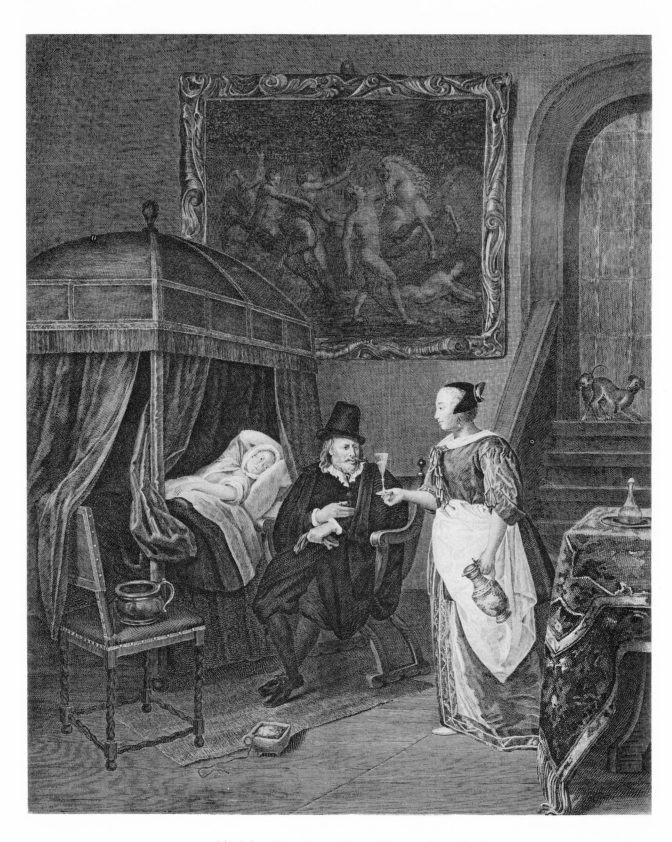

37 Physician Attending a Young Woman (Jan Steen)

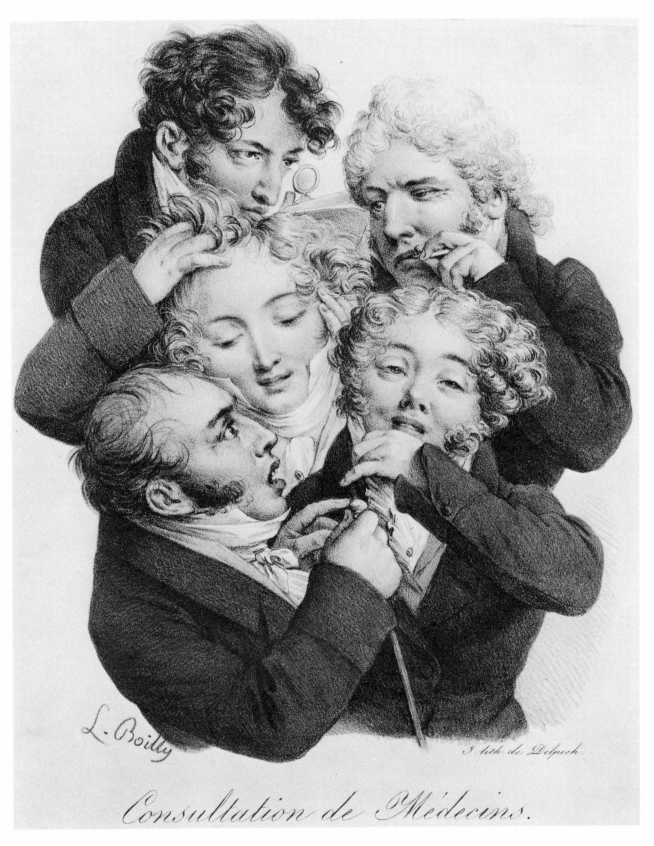

L. Boilly

J. lith. de Delpech.

Consultation de Médecins.

38 Consultation (Louis Boilly)

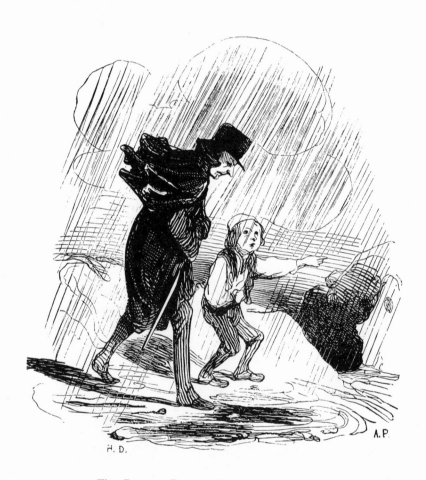

40 The Country Doctor (Honoré Daumier)
Plate 39 appears as the frontispiece of this volume.

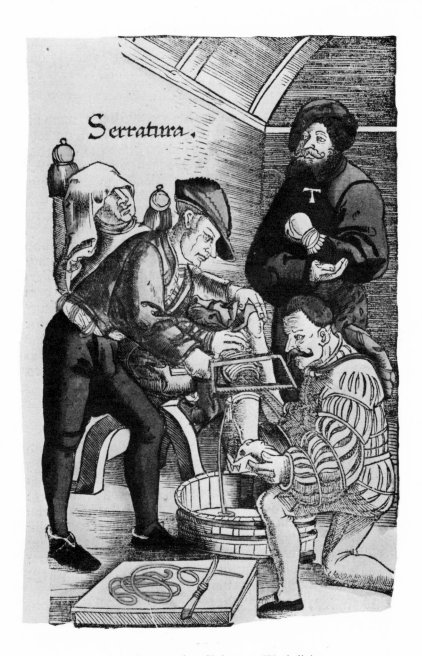

41 Amputation (Johannes Wechtlin)

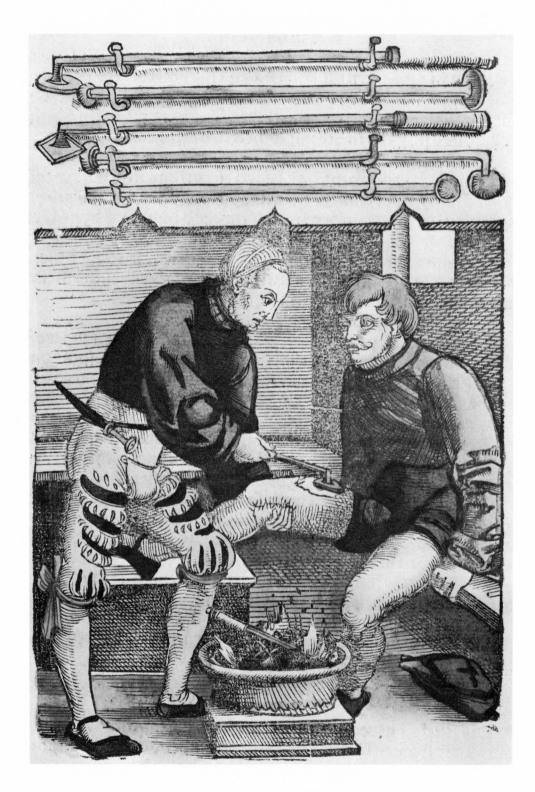

42 Cautery (Johannes Wechtlin)

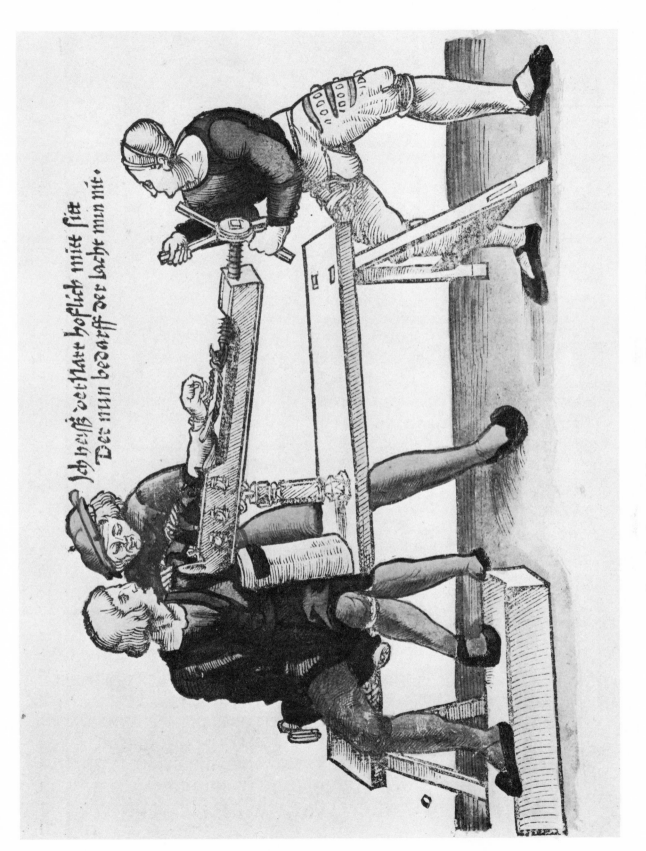

43 Extension Apparatus for Fractured Arm (Johannes Wechtlin)

TOVRNELLES

44 The Death of Henri II (Jacques Perrissin)

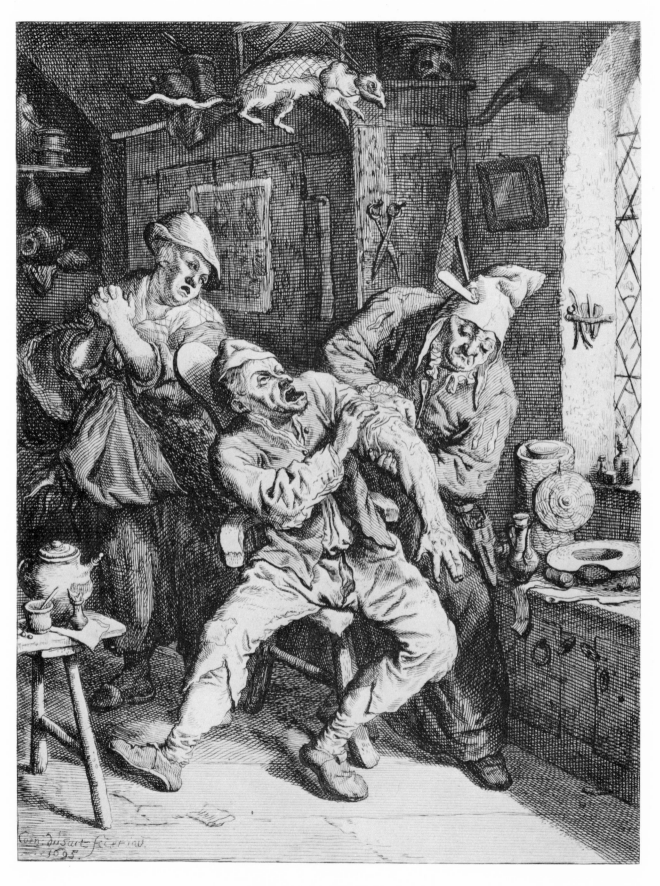

45 Village Surgeon (Cornelis Dusart)

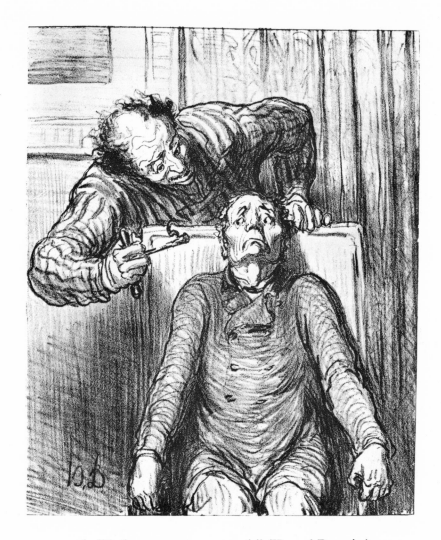

46 "Let's see, open your mouth" (Honoré Daumier)

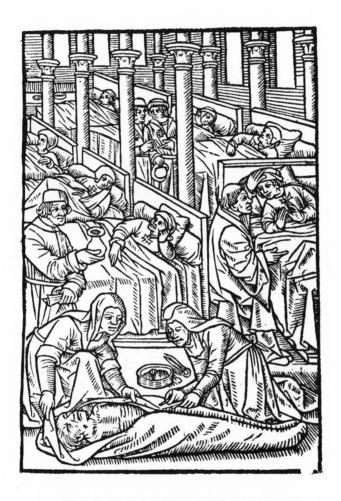

47 Hospital Interior (French School, ca. 1500)

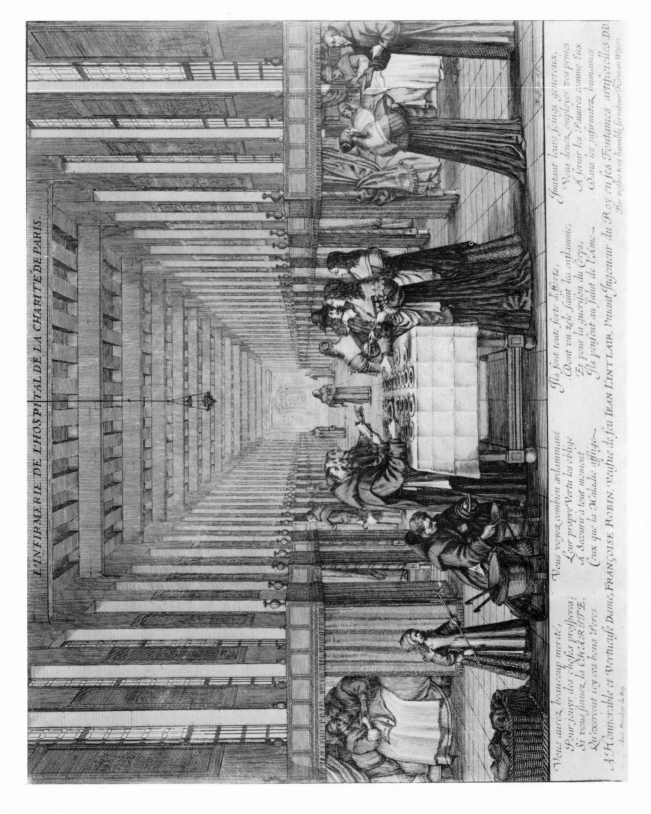

48 Infirmary of the Charity Hospital, Paris (Abraham Bosse)

49 Pennsylvania Hospital in Pine Street, Philadelphia (William Birch)

50 Middlesex Hospital, London (Rowlandson and Pugin)

Ist das der danck/vnd vnser Soldt/
So sey der teüfel dem Kryeg holdt/
Erfars ein andrer/ich biñ satt/
Mir hat man zogen schoh/roch/matt.

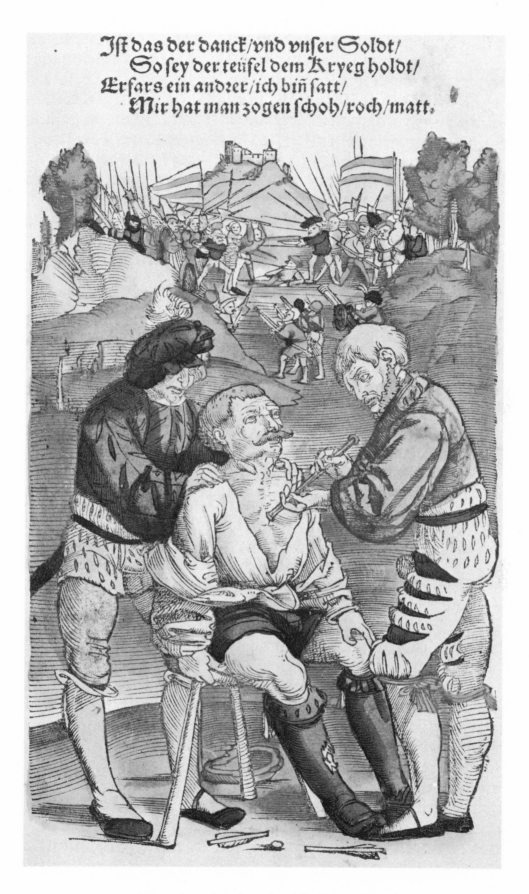

51 Extraction of an Arrowhead (Johannes Wechtlin)

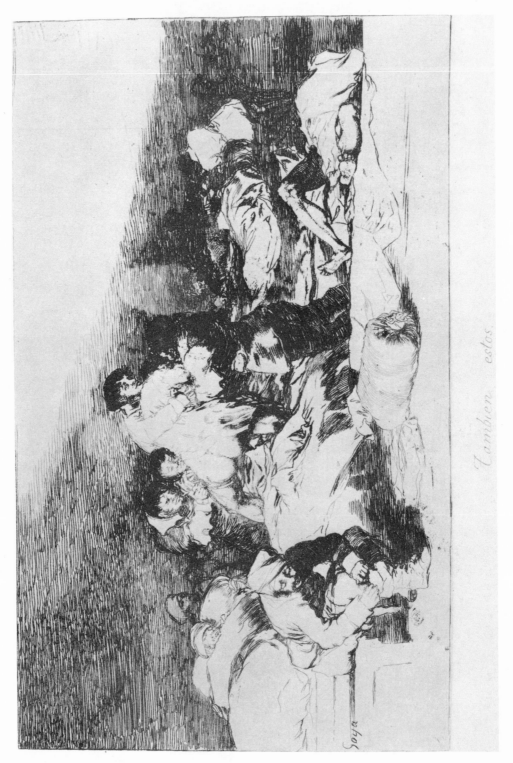

Tambien estos

52 A Military Hospital (Francisco Goya)

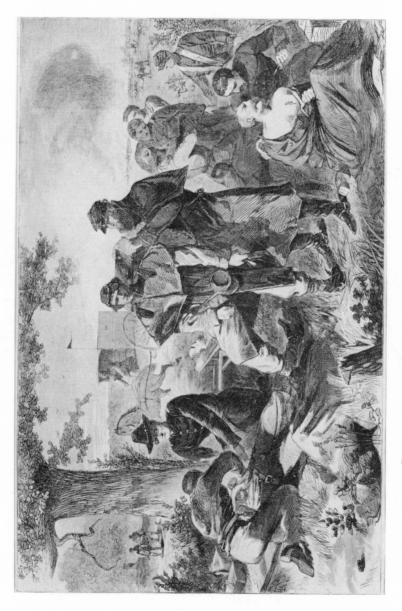

53 Surgeon at Work during an Engagement (Winslow Homer)

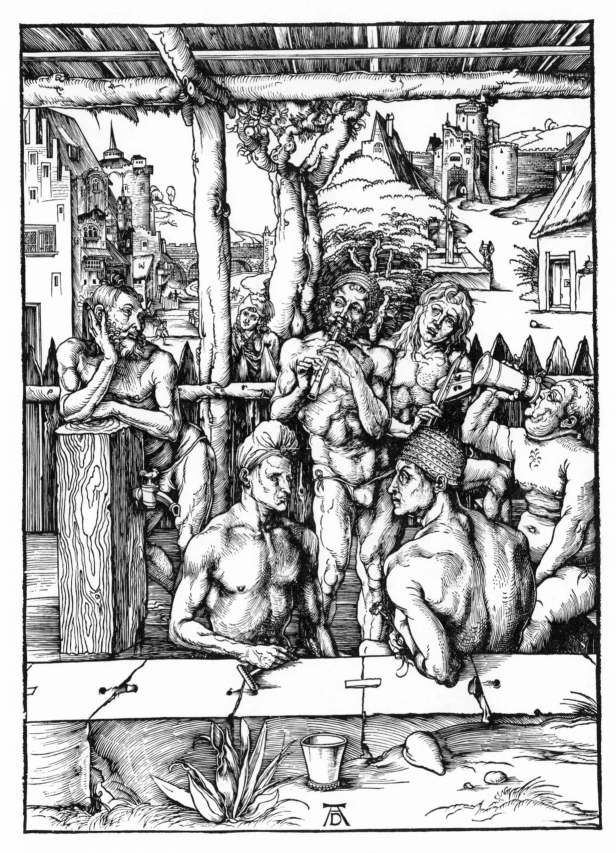

54 Men's Bath (Albrecht Dürer)

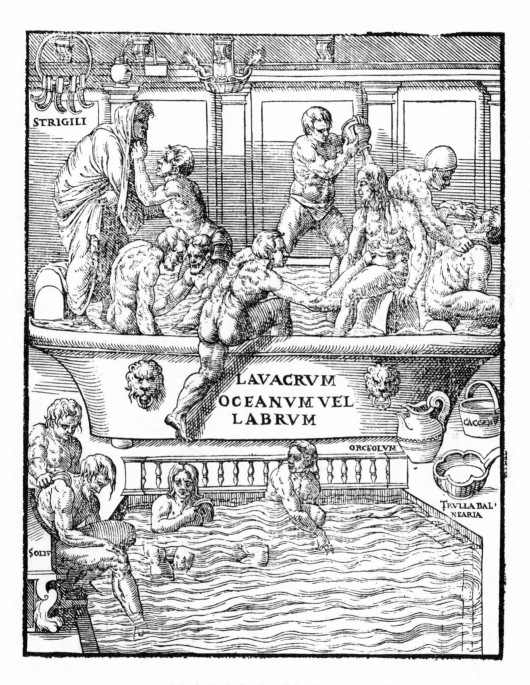

55 Men's Bath (Italian School, XVI century)

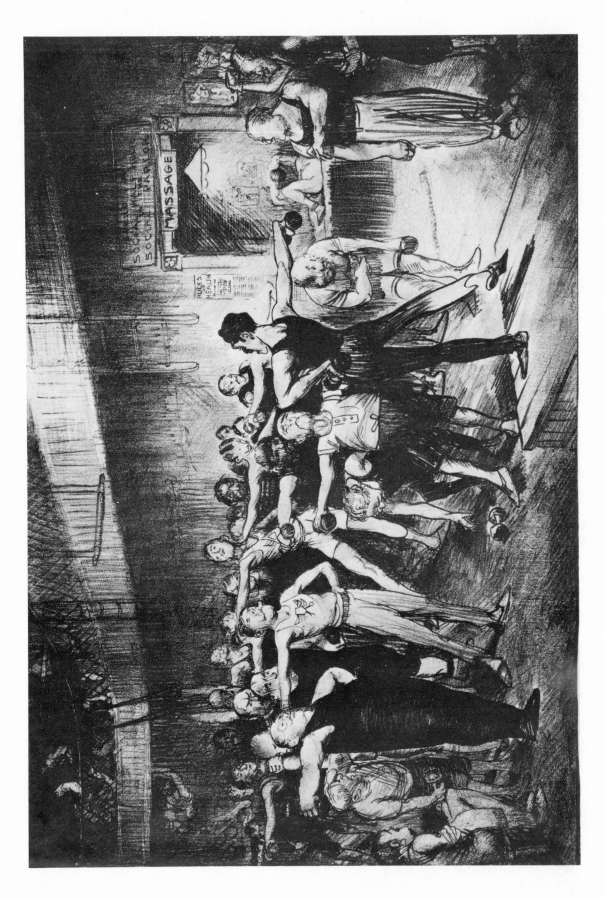

56 Business Men's Class (George Bellows)

Tefe fugas mures! magnis si fueibus acces exiguos fures, furor est. me respice rilis si modo numus adest mures felesque fugabo.

57 The Rat Catcher (Cornelis Visscher)

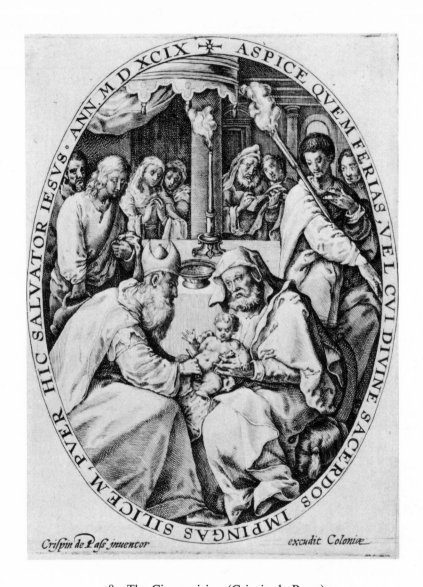

58 The Circumcision (Crispin de Passe)

59 Vaccination (Leopoldo Méndez)

60 Thames Water (William Heath)

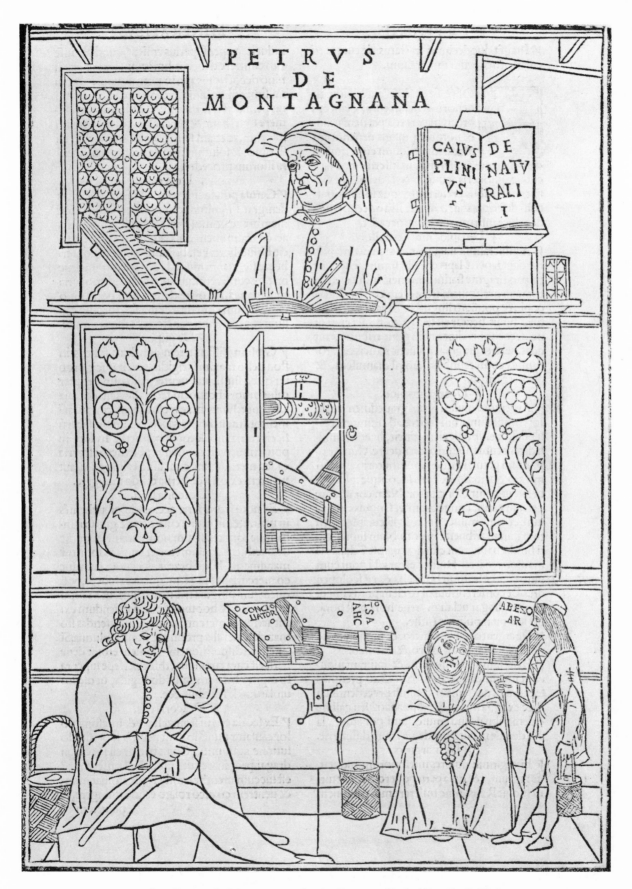

61 Petrus de Montagnana in the Lecture Chair (Gentile Bellini)

62 The College of Physicians (Rowlandson and Pugin)

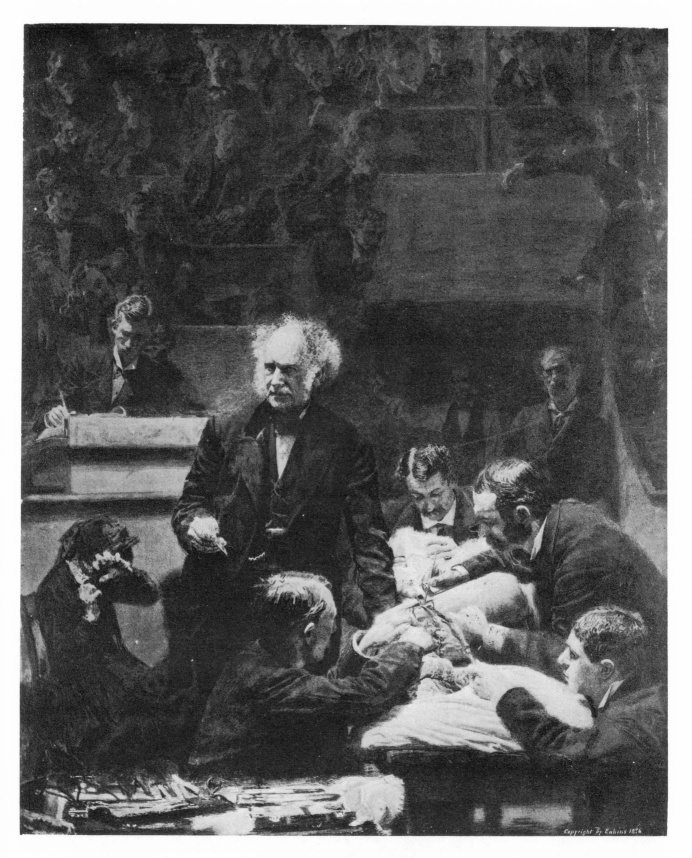

63 The Gross Clinic (Thomas Eakins)

64 Ward Rounds (Robert Riggs)

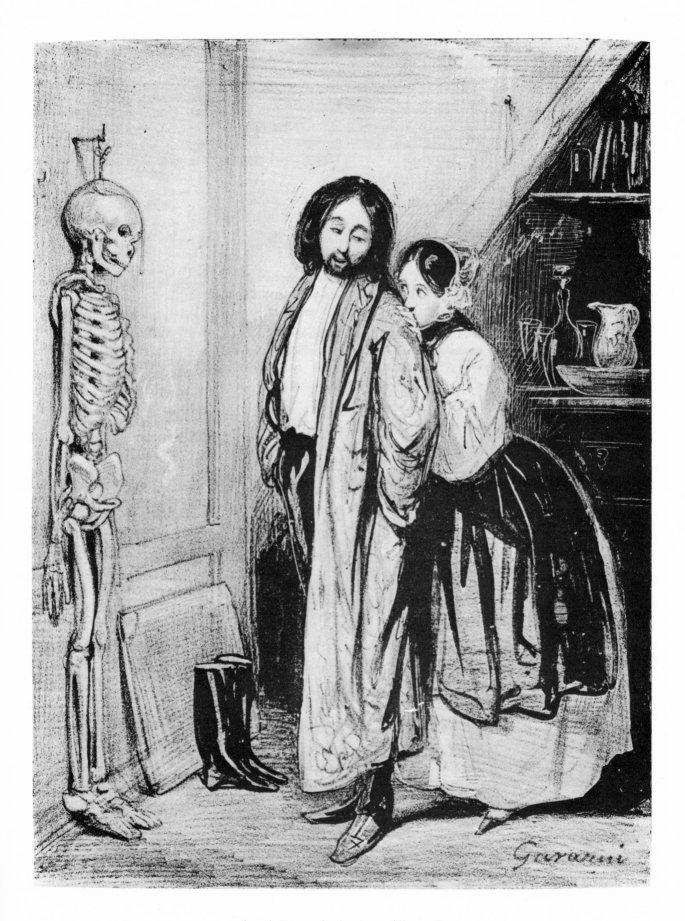

65 A Lesson in Anatomy (Gavarni)

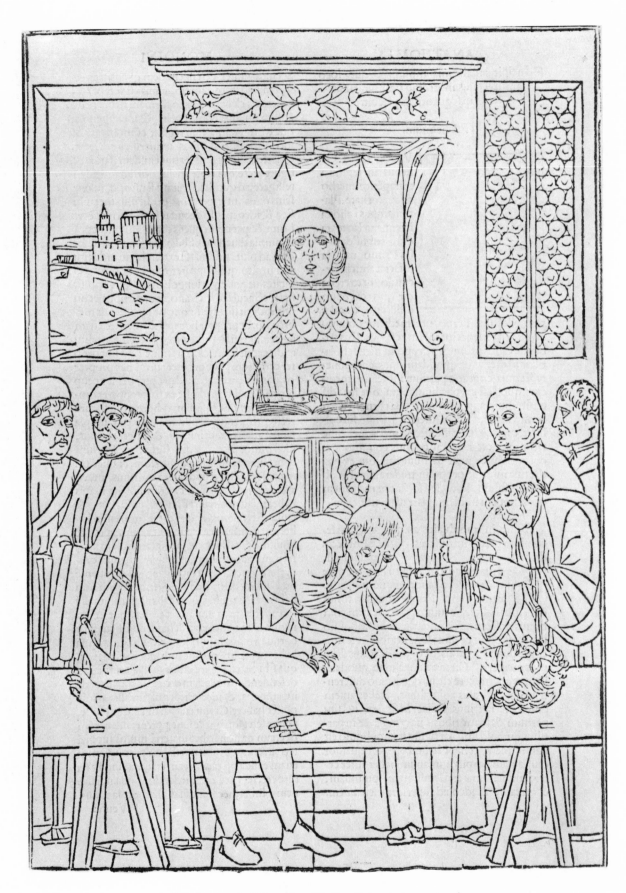

66 Lesson in Dissection (Italian School, xv century)

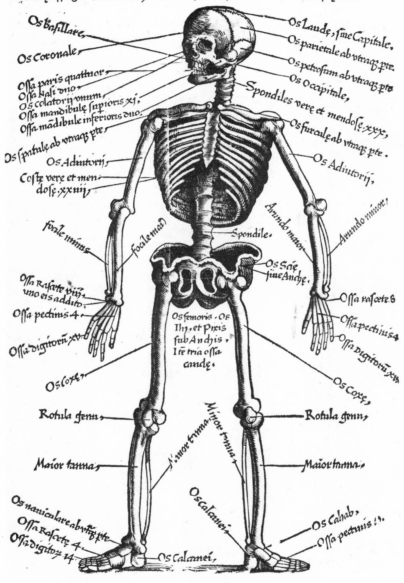

67　Skeleton (German School, XVI century)

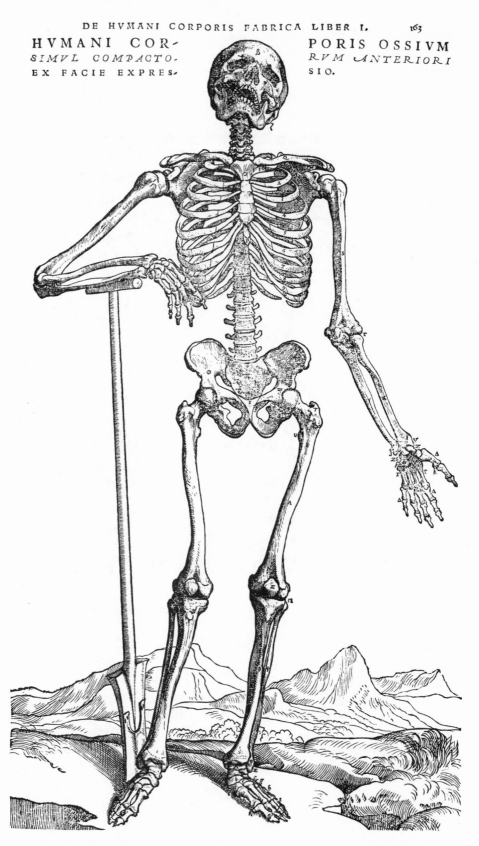

68 Skeleton Leaning on a Spade (Workshop of Titian)

NONA
MVSCV.
LORVM TA.
BVLA.

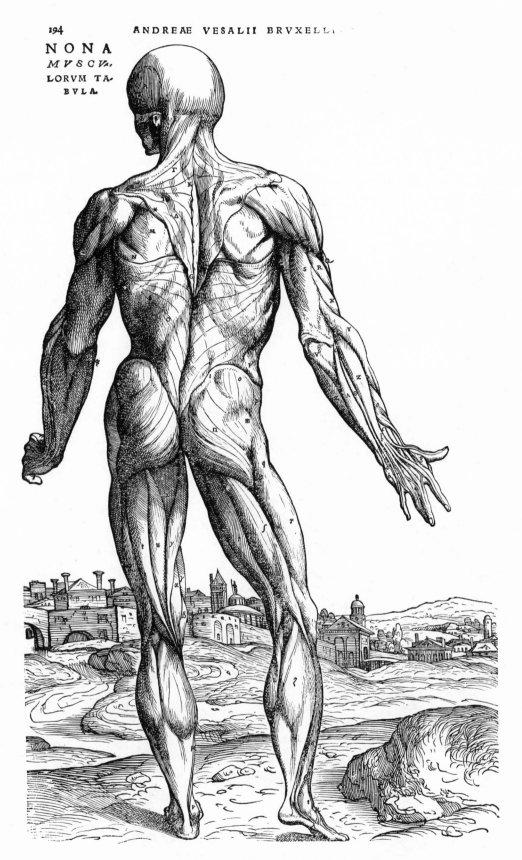

69 The Ninth Plate of Muscles (Workshop of Titian)

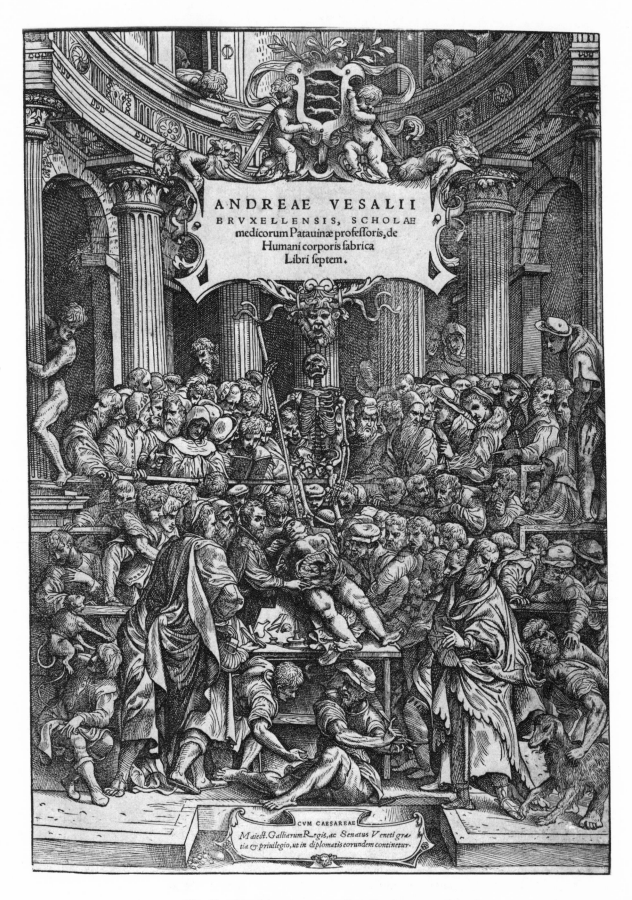

ANDREAE VESALII
BRVXELLENSIS, SCHOLAE
medicorum Patauinæ profefforis, de
Humani corporis fabrica
Libri feptem.

CVM CAESAREAE
Maieft.GalliarumRegis, ac Senatus Veneti gra-
tia & priuilegio, ut in diplomatis eorundem continetur.

70 Vesalius Teaching Anatomy (Jan Stephan von Calcar)

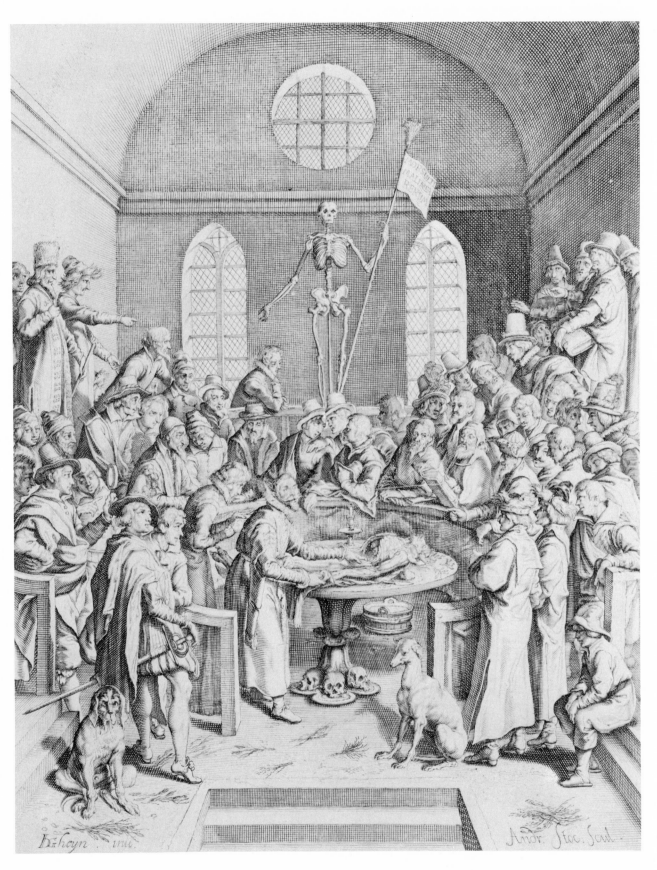

71 Anatomy Lesson of Pieter Paaw (Jacob de Gheyn)

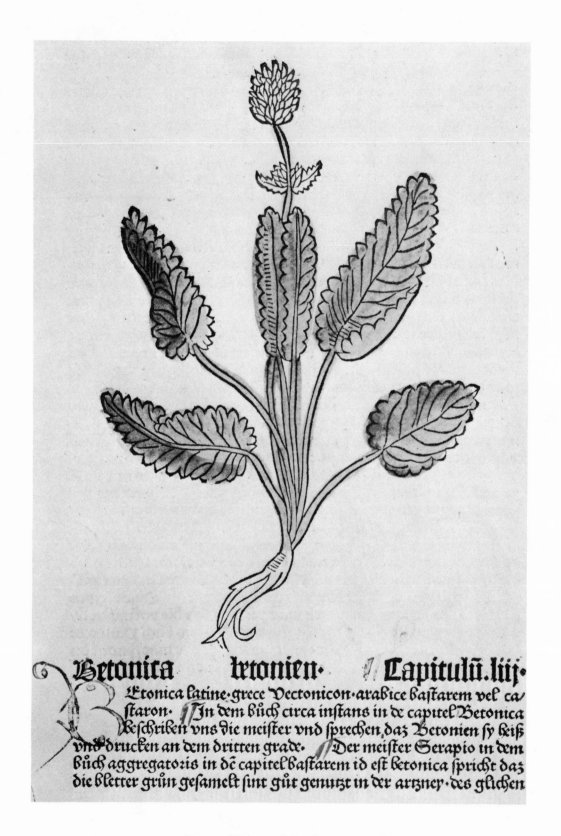

Betonica · betonien · ¶ Capitulū · liiſ ·

Etonica latine · grece Vectonicon · arabice baſtarem vel ca
ſtaron · ¶ In dem büch circa inſtans in de capitel Betonica
beſchriben vns die meiſter vnd ſprechen · daz Betonien ſy heiß
vnd drucken an dem dritten grade · ¶ Der meiſter Serapio in dem
büch aggregatoris in dē capitel baſtarem id eſt betonica ſpricht daz
die bletter grün geſamelt ſint güt genutzt in der artzney · des glichen

72 Betony (German School, xv century)

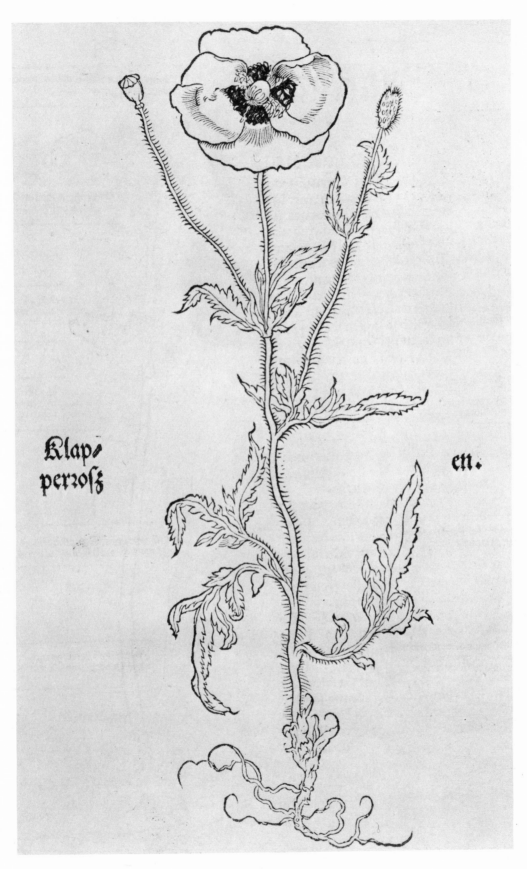

Klap-
perroß

en.

73 Corn Poppy (Hans Weiditz)

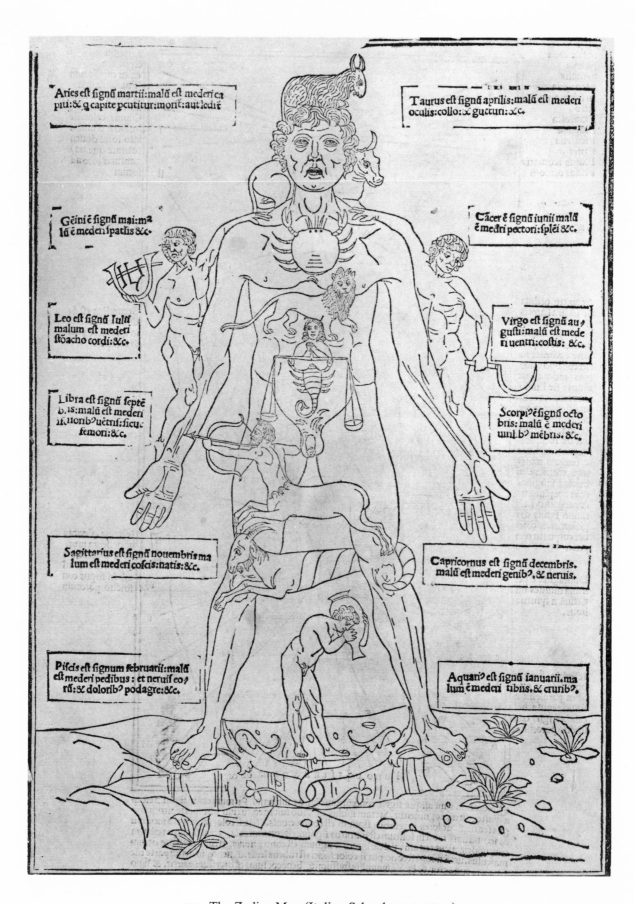

Aries est signū martii: malū est mederi capiti: & q capite pcutitur: morit aut ledit

Taurus est signū aprilis: malū est mederi oculis: collo: & guttuti: xc.

Gēmiē signū mai: malū ē medeti spatlis &c.

Cācer ē signū iunii malū ē medeti pectori: splēi &c.

Leo est signū Iulii malum est mederi stoacho cordi: &c.

Virgo est signū augusto: malū est mederi uentri: costis: &c.

Libra est signū septēbris: malū est mederi rēnonib9 uētris: sicut femori: &c.

Scorpi9ē signū octobris: malū ē mederi uirilib9 mēbris. &c.

Sagittarius est signū nouembris malum est mederi coscis: natis: &c.

Capricornus est signū decembris. malū est mederi genib9, & neruis.

Piscis est signum februarii: malū est mederi pedibus: et neruis eorū: & doloribi9 podagre: &c.

Aquari9 est signū ianuarii, malum ē mederi tibiis, & cruribi9.

74 The Zodiac Man (Italian School, xv century)

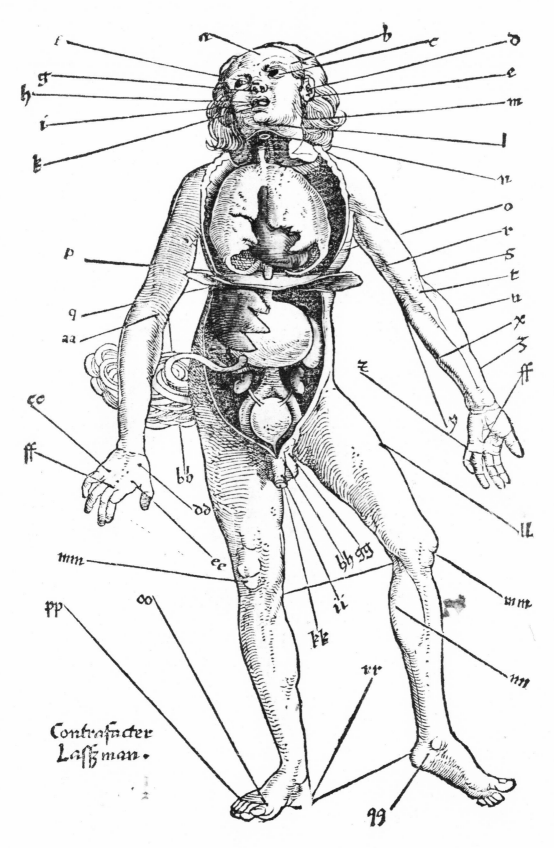

75 Bloodletting Chart (Johannes Wechtlin)

INTEGRA ET AB OMNIBVS
PARTIBVS *LIBERA AC*
nuda uenæ *cauæ delineatio.*

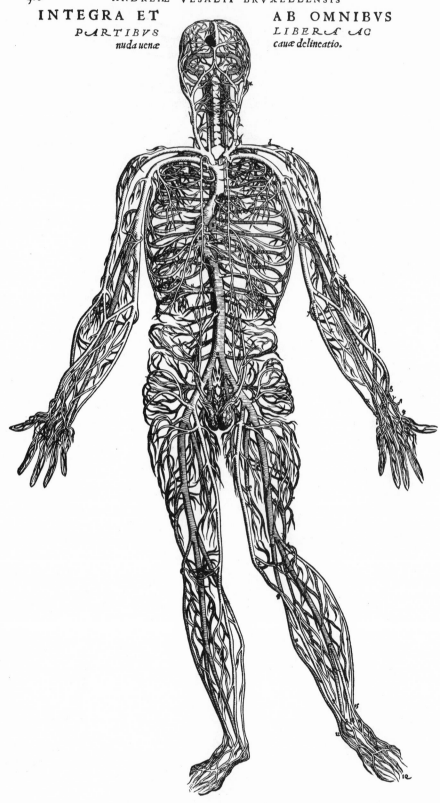

76 A Chart of Veins (Workshop of Titian)

Zů den erweychten Augbrawen/ sye wider vff zůrichten.

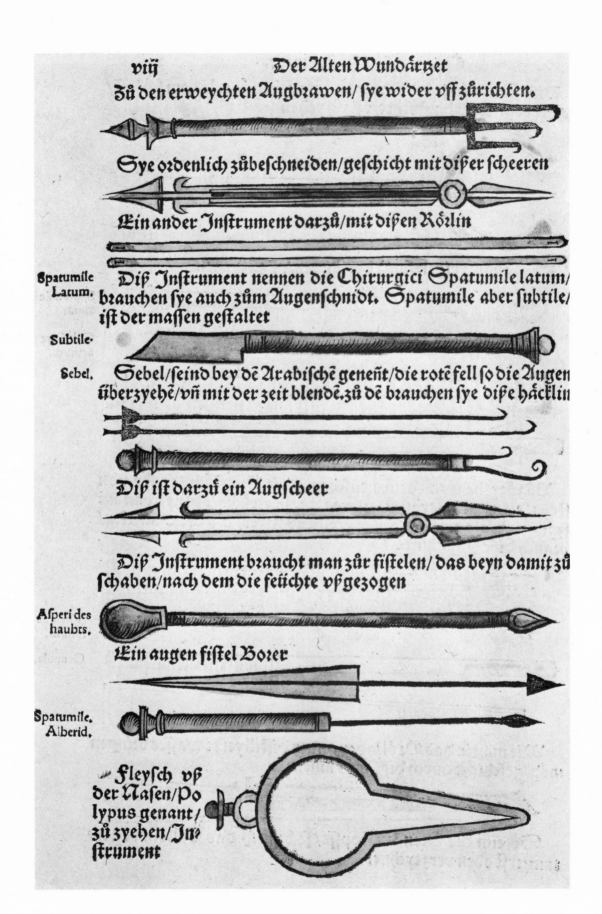

Sye ordenlich zůbeschneiden/geschicht mit diser scheeren

Ein ander Instrument darzů/mit disen Rörlin

Spatumile Latum. Diß Instrument nennen die Chirurgici Spatumile latum/ brauchen sye auch zům Augenschnidt. Spatumile aber subtile/ ist der massen gestaltet

Subtile.

Sebel. Sebel/seind bey dē Arabischē genent/die rotē fell so die Augen überzyehē/vñ mit der zeit blende.zů dē brauchen sye dise häcklin

Diß ist darzů ein Augscheer

Diß Instrument braucht man zůr fistelen/das beyn damit zů schaben/nach dem die feüchte vfgezogen

Asperi des haubts.

Ein augen fistel Borer

Spatumile. Alberid.

Fleysch vß der Nasen/Po lypus genant/ zů zyehen/In-strument

77 Surgical Instruments (German School, XVI century)

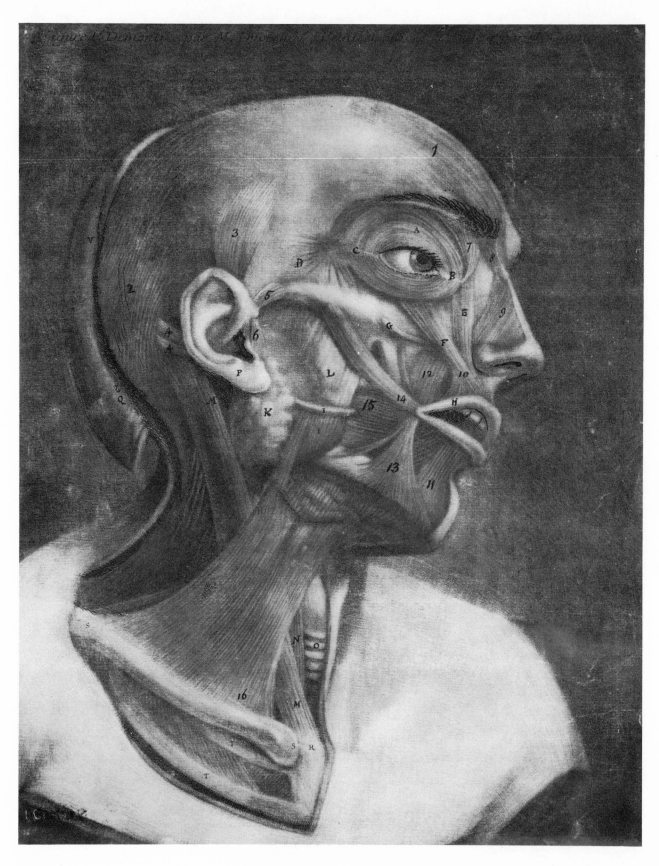

78 The Muscles of the Head (Jacques Gautier Dagoty)

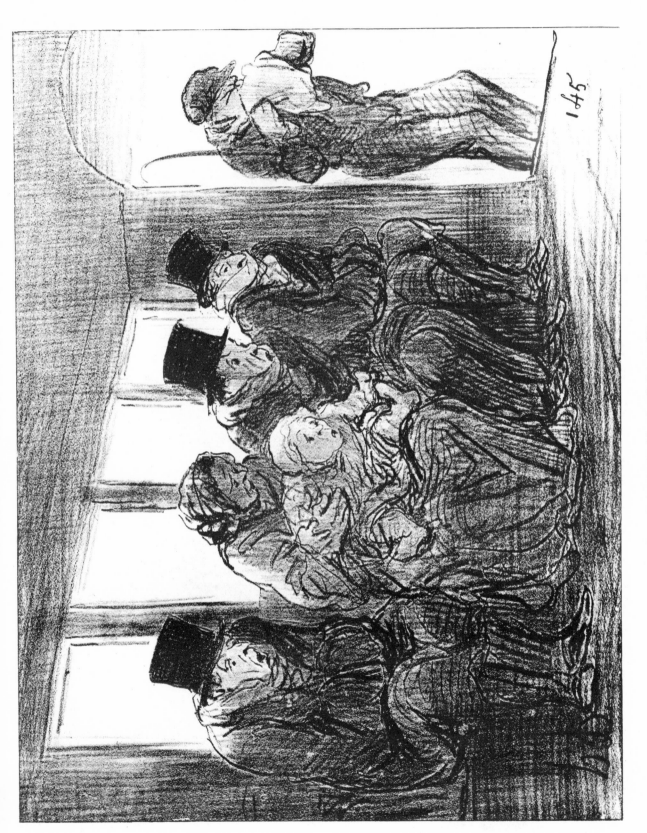

79 An Omnibus during an Epidemic of Grippe (Honoré Daumier)

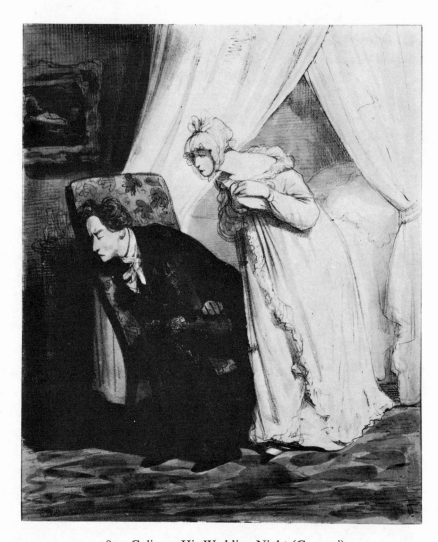

80 Colic on His Wedding Night (Gavarni)

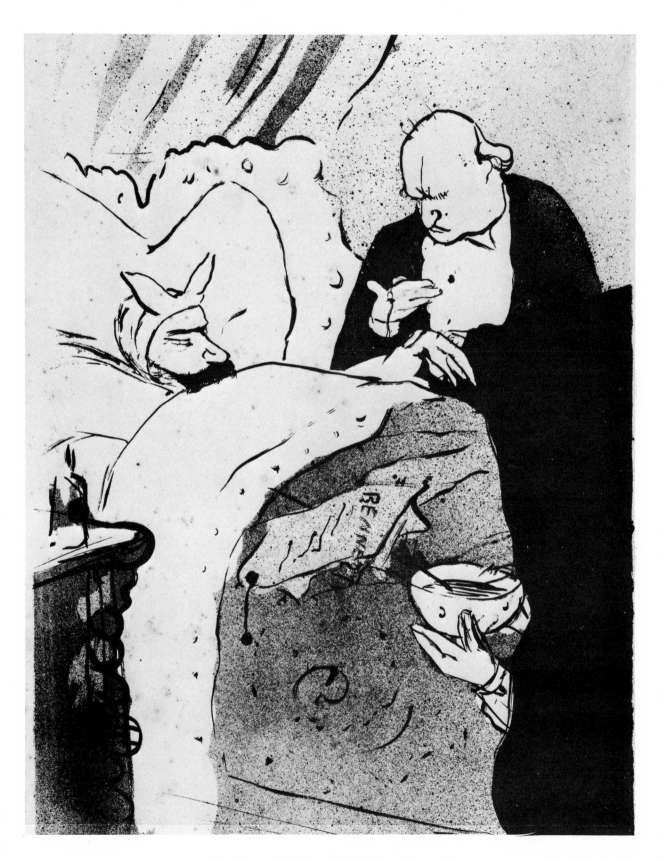

81 Carnot Ill (Henri de Toulouse-Lautrec)

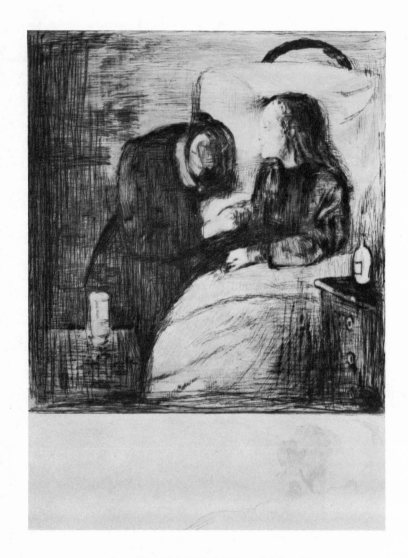

82 The Sick Child (Edvard Munch)

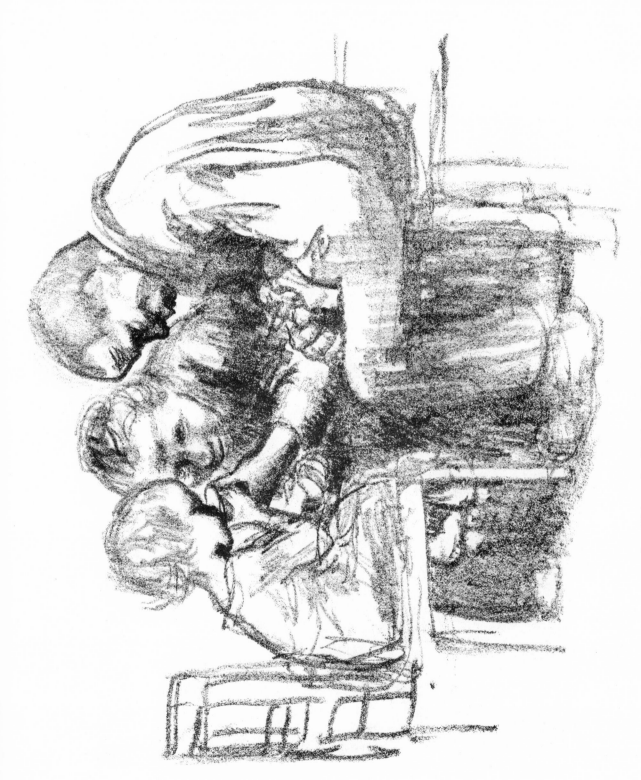

83 Visit to the Children's Hospital (Käthe Kollwitz)

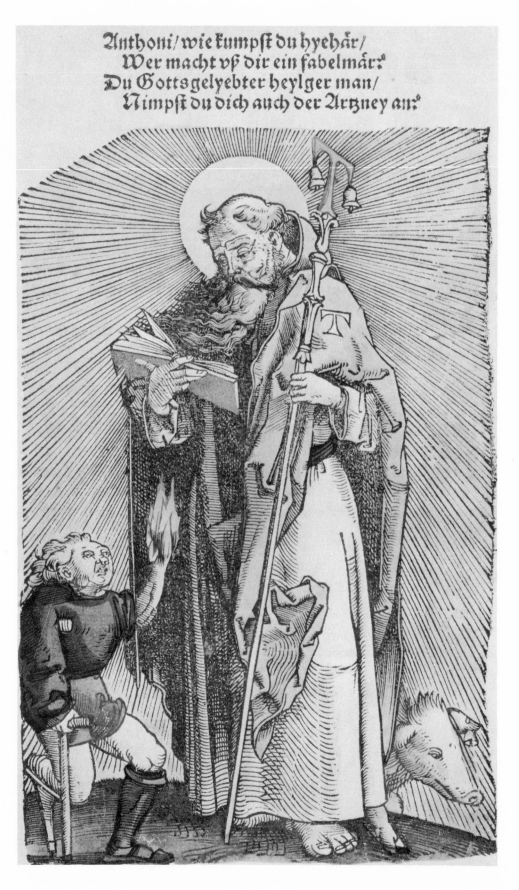

Anthoni/ wie kumpst du hyehär/
Wer macht uß dir ein fabelmär?
Du Gottsgelyebter heylger man/
Nimpst du dich auch der Artzney an?

84 St. Anthony's Fire or Ergotism (Johannes Wechtlin)

85 Ague and Fever (Thomas Rowlandson)

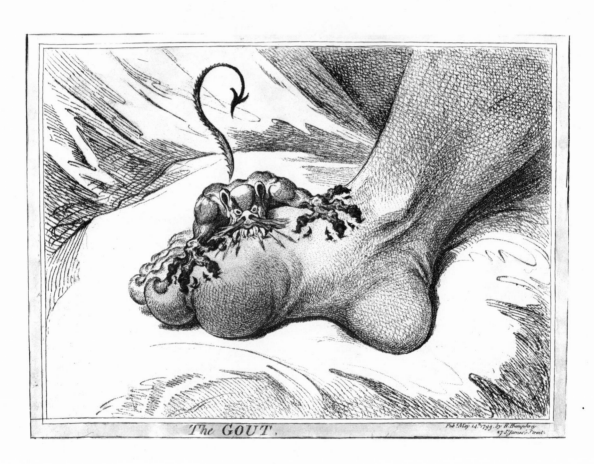

The GOUT.

86 The Gout (James Gillray)

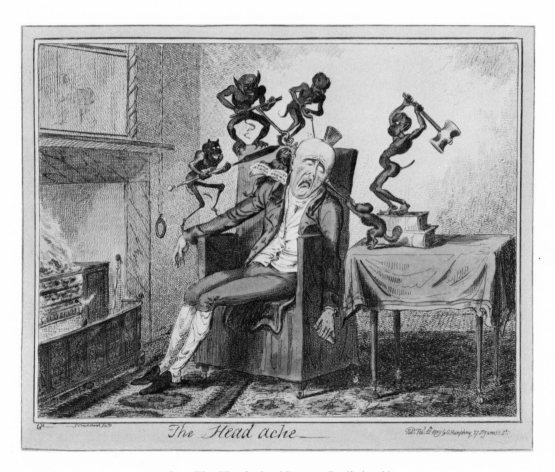

The Head ache

87 The Headache (George Cruikshank)

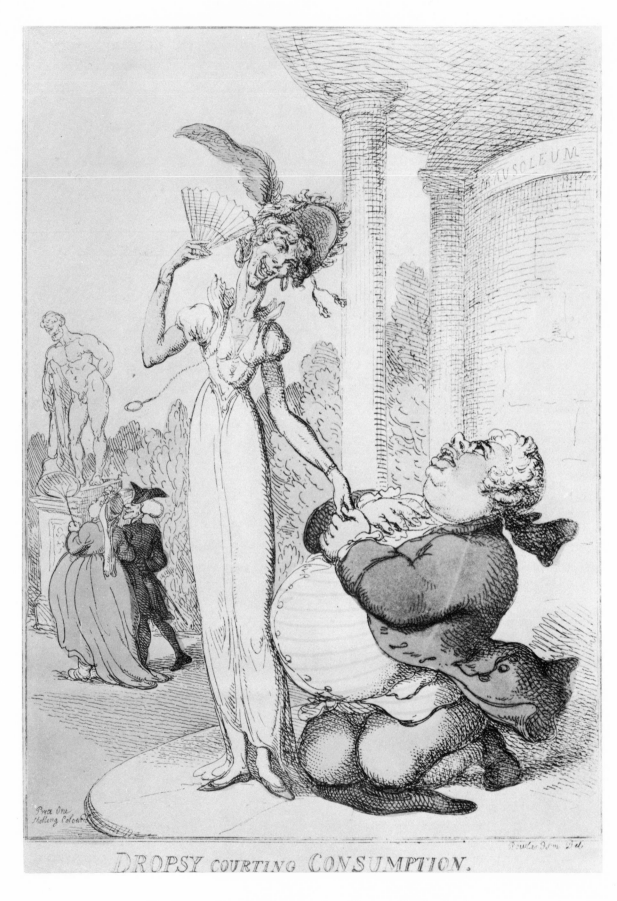

Price One
Shilling Coloured

MAUSOLEUM

DROPSY COURTING CONSUMPTION.

88 Dropsy Courting Consumption (Thomas Rowlandson)

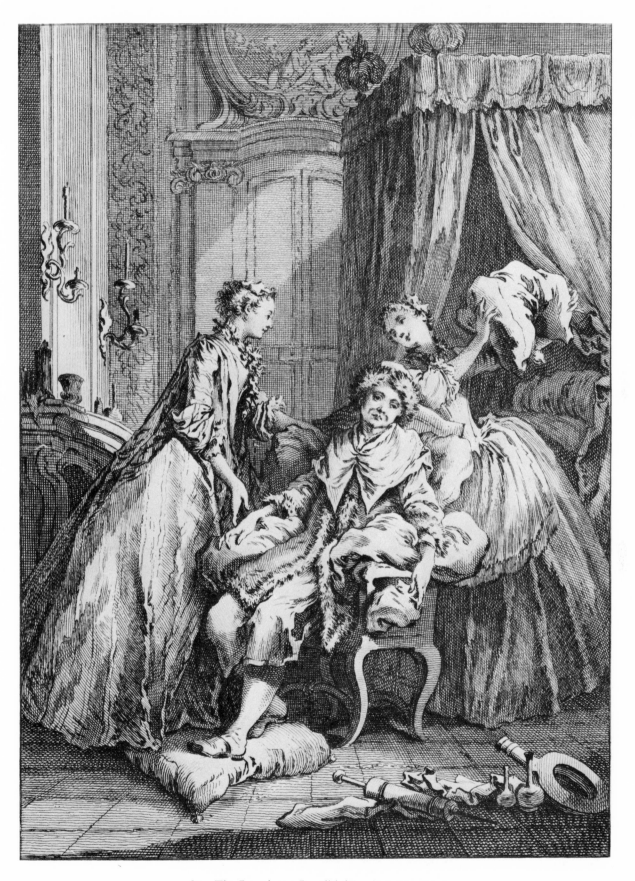

89 The Imaginary Invalid (François Boucher)

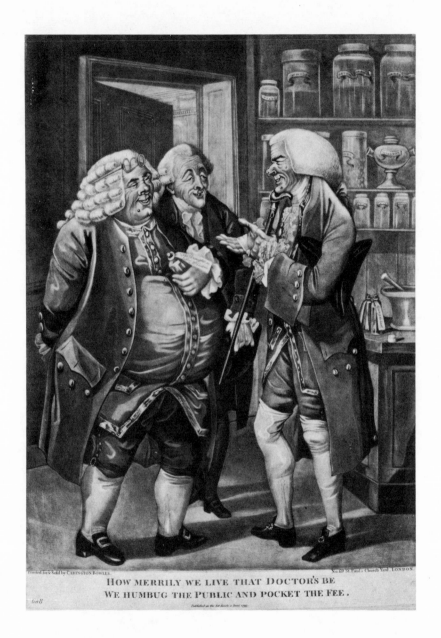

90 How Merrily We Live That Doctors Be (Robert Dighton)

"Since here we are are met—
"That a jolly set
"A fig for sack and sherry,
"Our cans will clink,
"Our liquor will drink,
And will be wondrous merry".

91 The Doctor and His Friends (George M. Woodward)

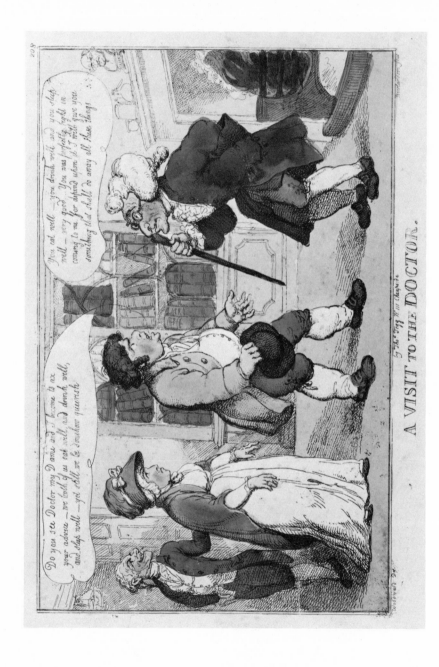

92 A Visit to the Doctor (Thomas Rowlandson)

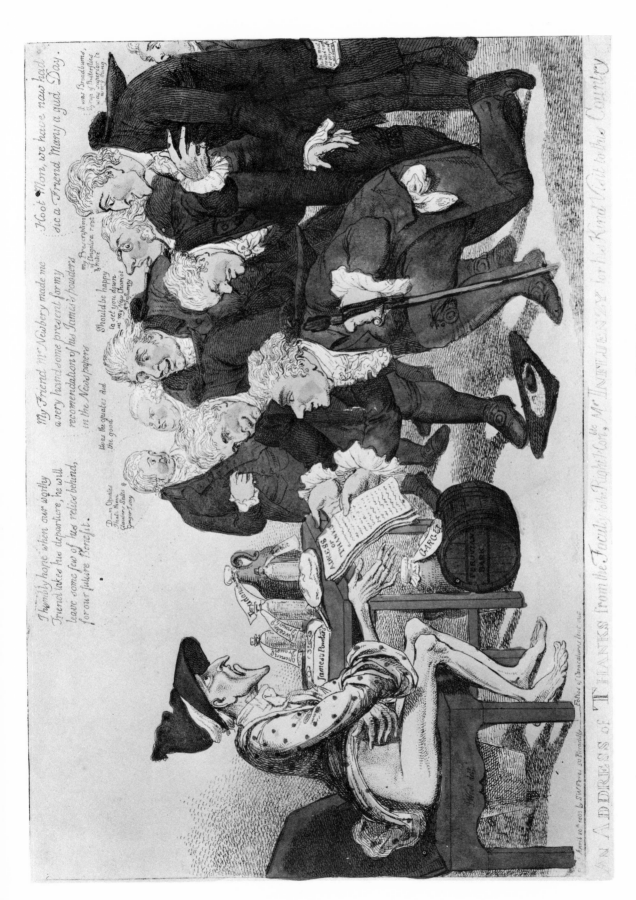

93 Address of Thanks to Influenza (T. West)

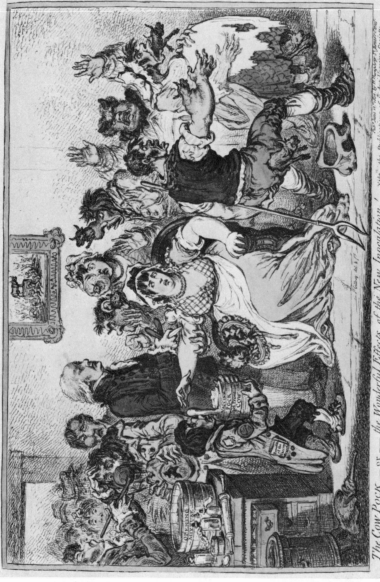

94　Cow Pock (James Gillray)

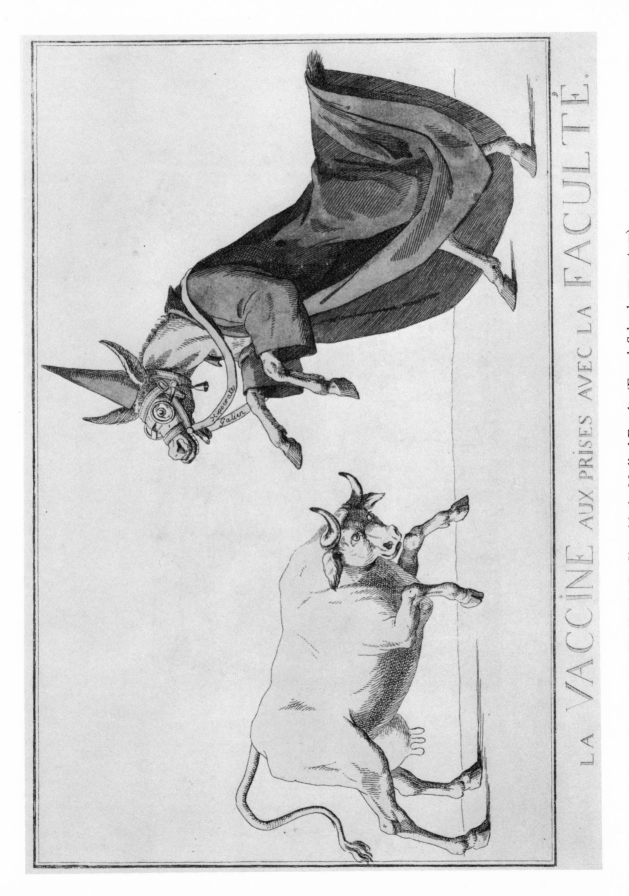

LA VACCINE AUX PRISES AVEC LA FACULTÉ.

95 Vaccine in Conflict with the Medical Faculty (French School, xix century)

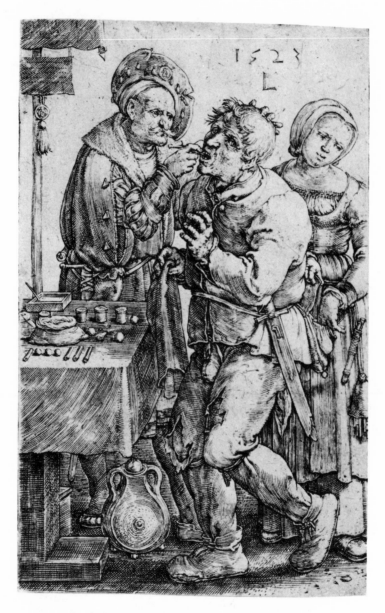

96 A Surgical Operation (Lucas van Leyden)

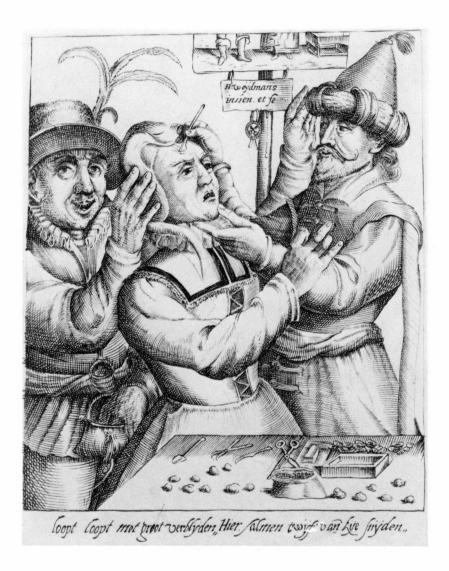

loopt loopt met groot verblyden, Hier salmen twijf van kije snijden..

97 Operation for Stones in the Head (H. Weydmans)

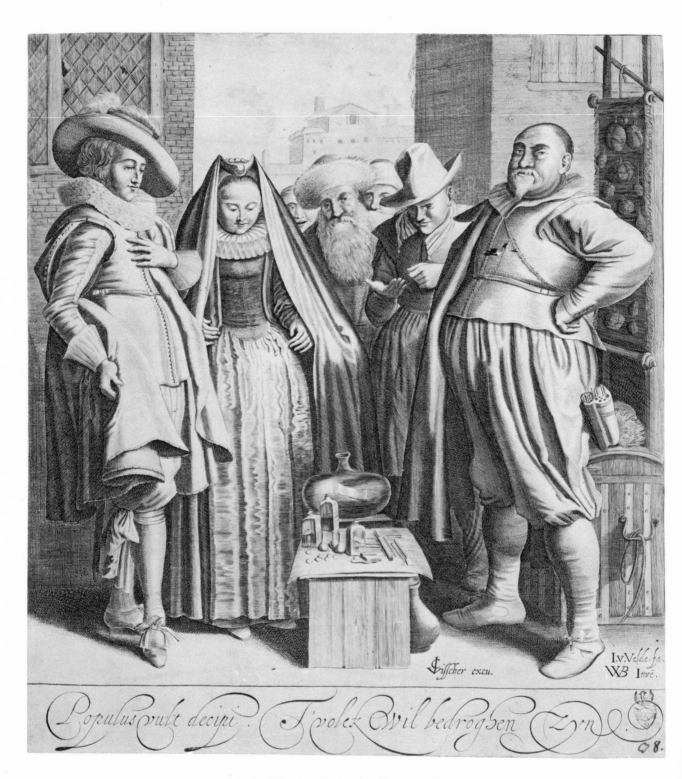

Populus vult decipi. *'T volck wil bedroghen zyn.*

98 The Quack (Willem Buytewech)

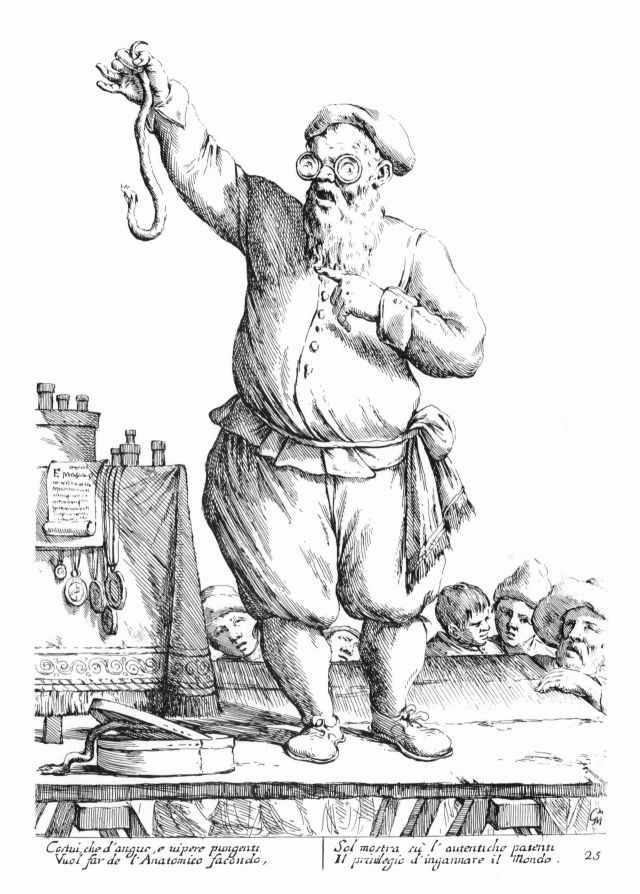

Costui, che d'angue, e vipere pungenti,
Vuol far de l'Anatomico facondo,

Sol mostra su l' autentiche patenti
Il privilegio d'ingannare il Mondo.

25

99 The Quack (Annibale Carracci)

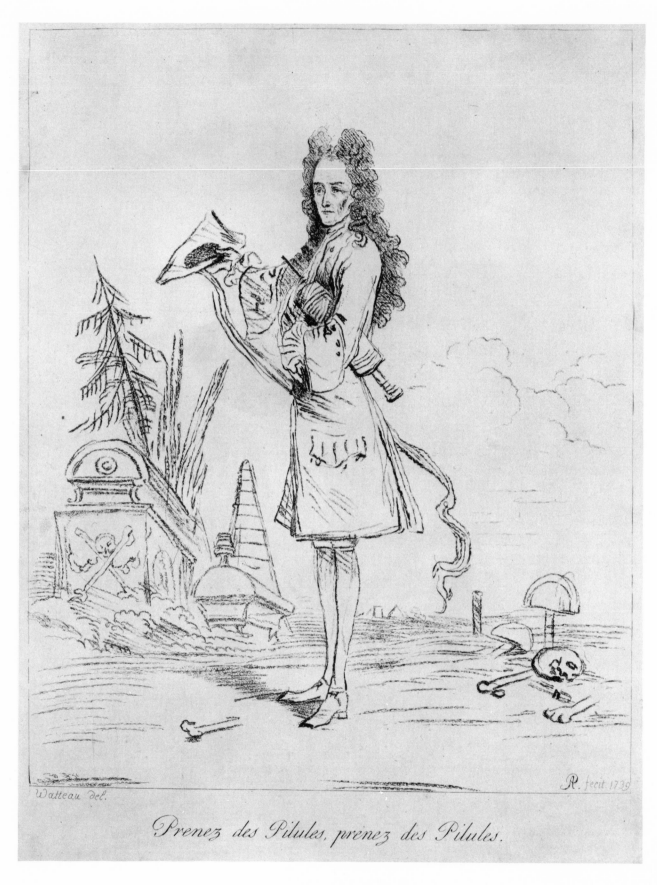

Watteau del.

R. fecit 1739

Prenez des Pilules, prenez des Pilules.

100 Dr. Misaubin (Antoine Watteau)

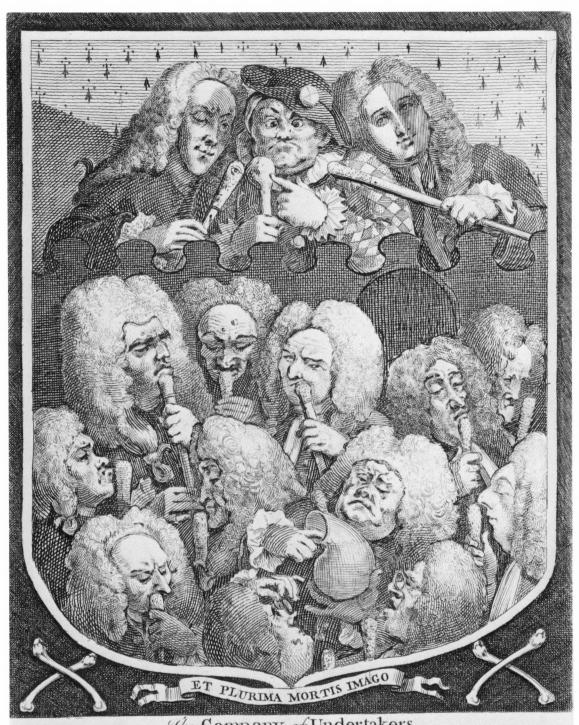

The **Company** of **Undertakers**

Beareth Sable, an Urinal proper, between 12 Quack-Heads of the Second & 12 Cane Heads Or, Consultant. On a Chief Nebulæ, Ermine, One Compleat Doctor issuant, checkie Sustaining in his Right Hand a Baton of the Second. On his Dexter & Sinister sides two Demi-Doctors, issuant of the second, & two Cane Heads issuant of the third; The first having One Eye conchant, towards the Dexter Side of the Escocheon; the Second Faced per pale proper & Gules, Guardent. —
With this Motto ———— Et Plurima Mortis Imago.

Price Six pence

101 The Company of Undertakers (William Hogarth)

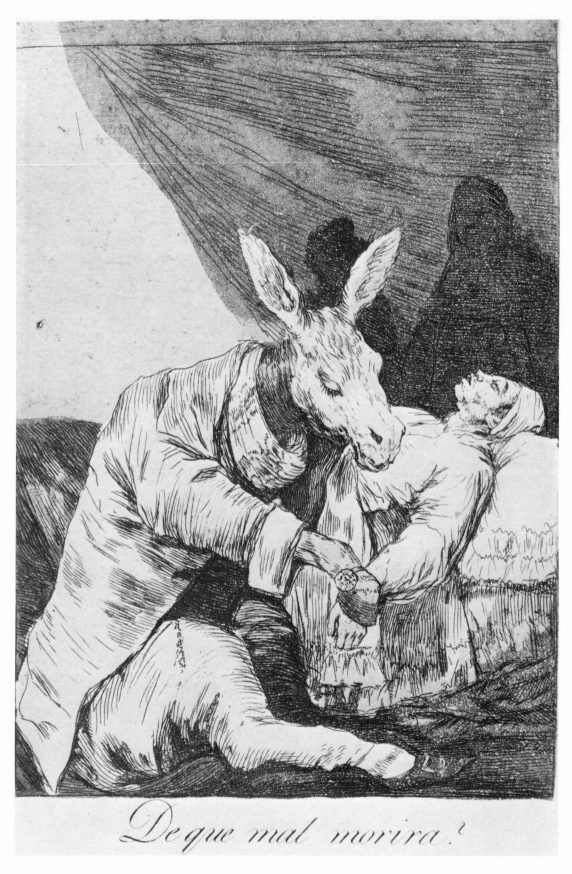

De que mal morira?

102 Of What Illness Will He Die? (Francisco Goya)

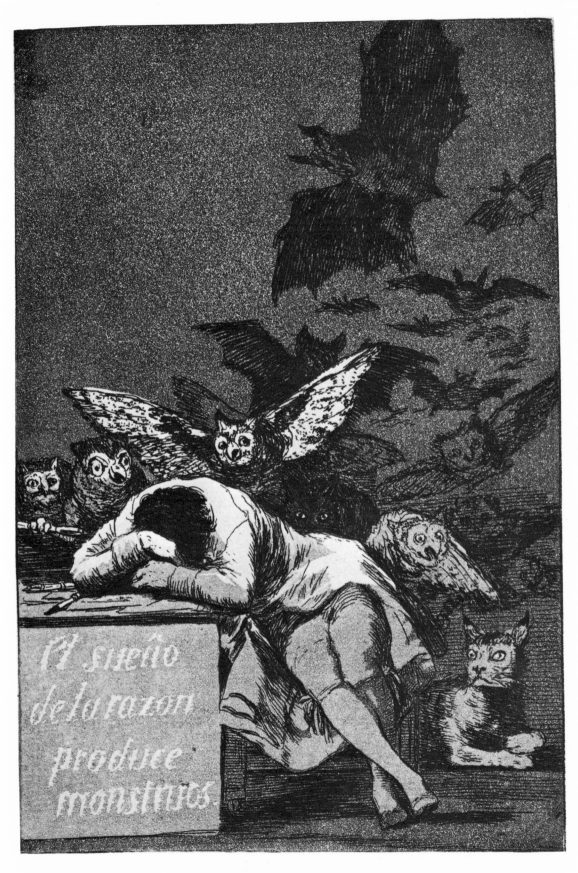

103 The Sleep of Reason Produces Monsters (Francisco Goya)

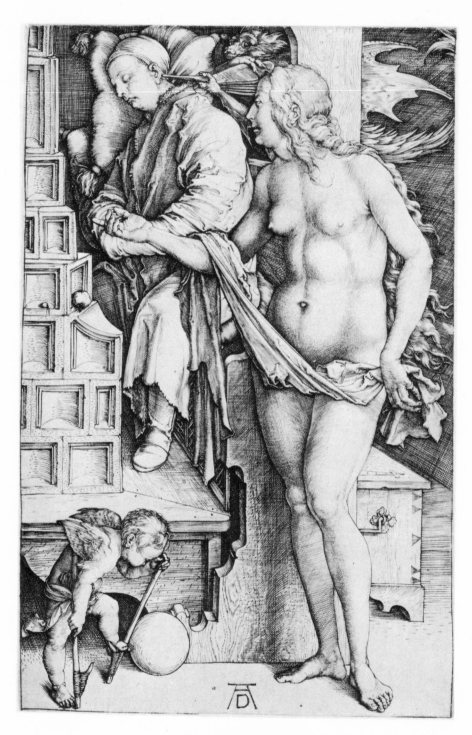

104 Dream (Albrecht Dürer)

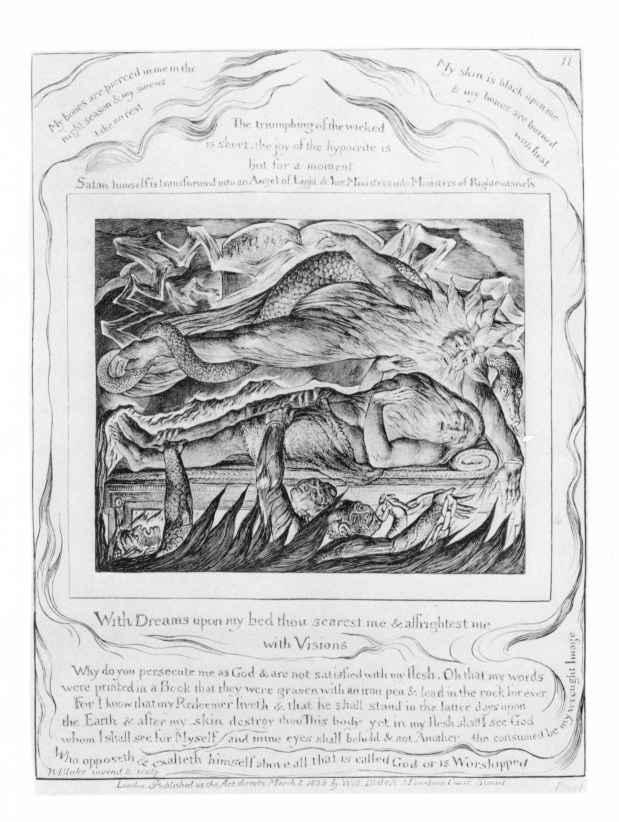

My bones are pierced in me in the night season & my sinews take no rest

My skin is black upon me & my bones are burned with heat

The triumphing of the wicked is short, the joy of the hypocrite is but for a moment

Satan himself is transformed into an Angel of Light & his Ministers into Ministers of Righteousness

With Dreams upon my bed thou scarest me & affrightest me with Visions

Why do you persecute me as God & are not satisfied with my flesh. Oh that my words were printed in a Book that they were graven with an iron pen & lead in the rock for ever For I know that my Redeemer liveth & that he shall stand in the latter days upon the Earth & after my skin destroy thou This body yet in my flesh shall I see God whom I shall see for Myself and mine eyes shall behold & not Another tho consumed be my wrought Image

Who opposeth & exalteth himself above all that is called God or is Worshipped

W Blake invent & sculp

London. Published as the Act directs March 8. 1825 by Will Blake N 3 Fountain Court Strand

105 Job Troubled by Dreams (William Blake)

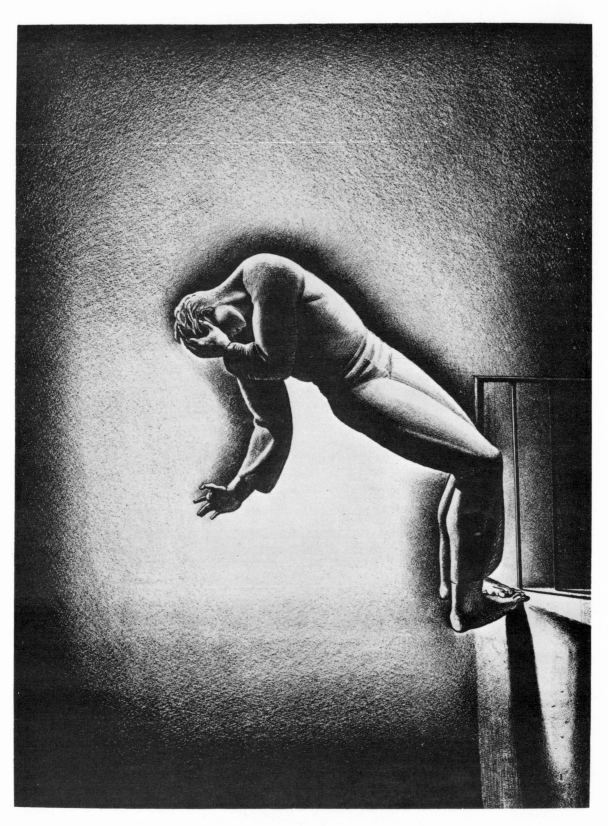

106 Nightmare (Rockwell Kent)

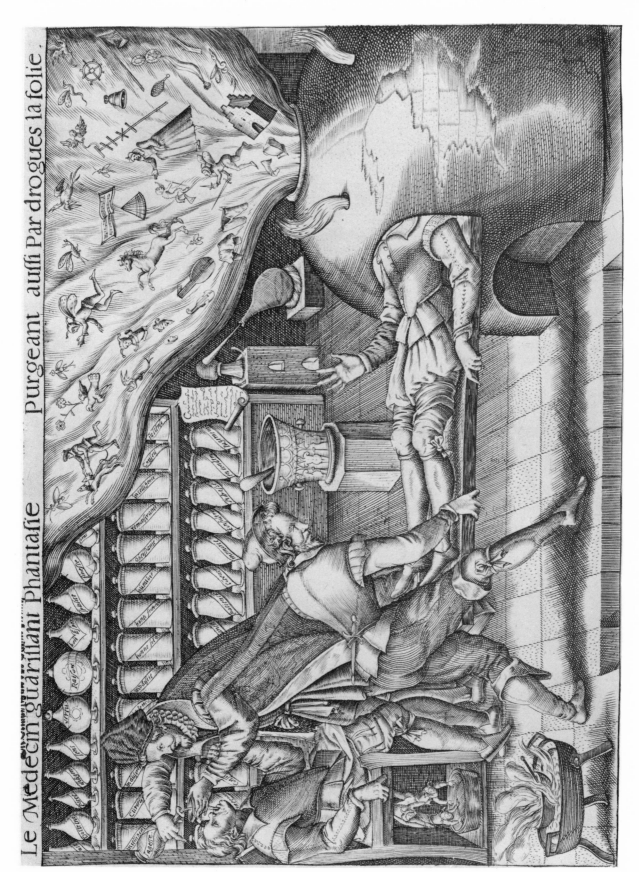

107 The Physician Curing Fantasy (French School, XVII century)

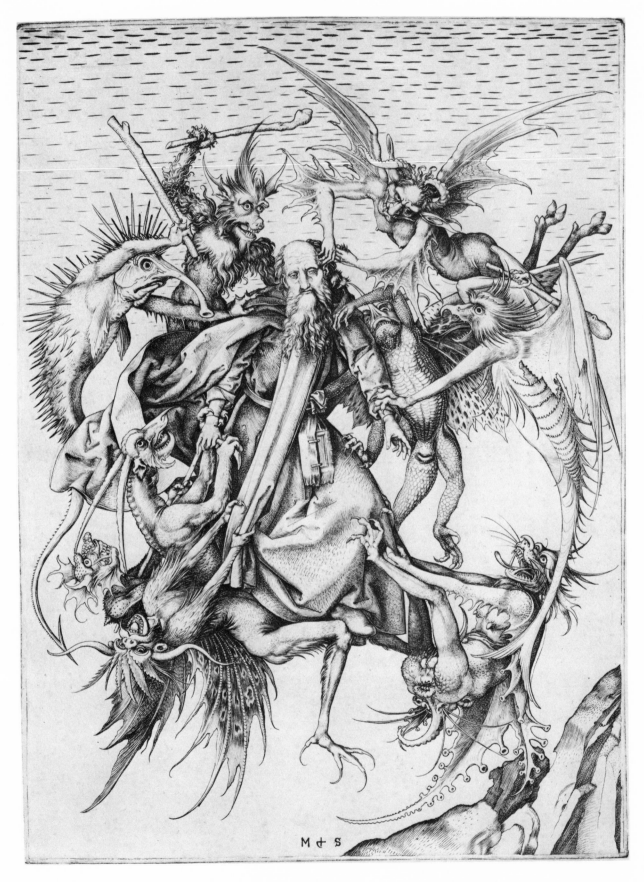

108 St. Anthony Tormented by Demons (Martin Schongauer)

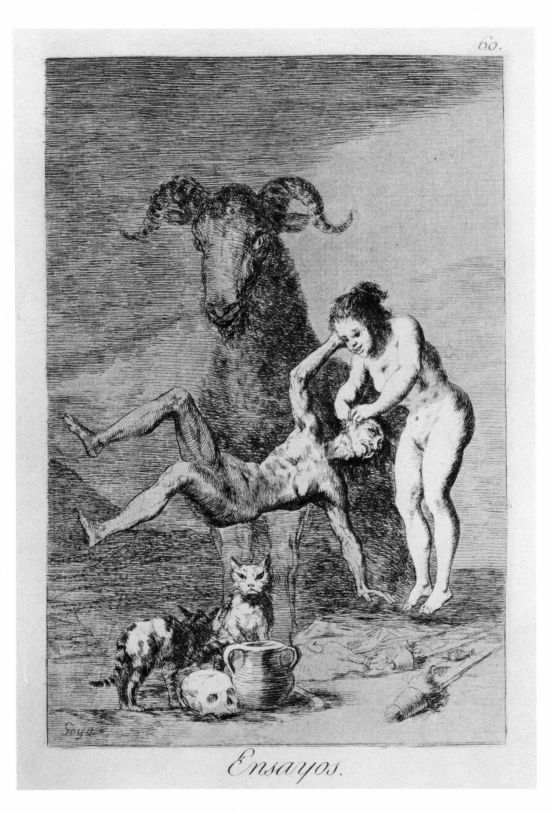

Ensayos.

109 First Attempts (Francisco Goya)

110 The Old Man Wandering among Phantoms (Francisco Goya)

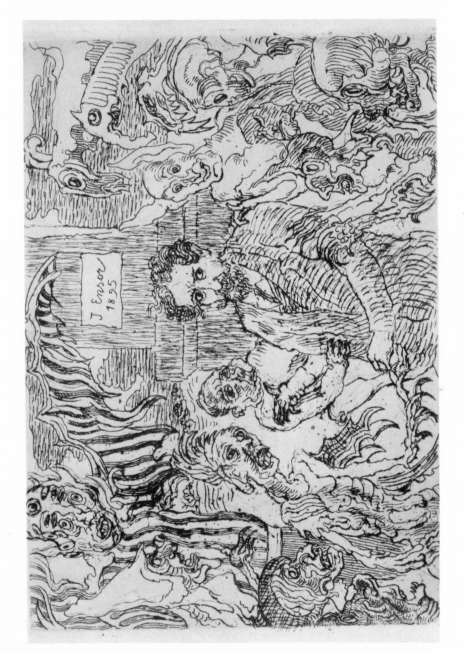

III Demons Ridicule Me (James Ensor)

112 The Vapors (Alexandre Colin)

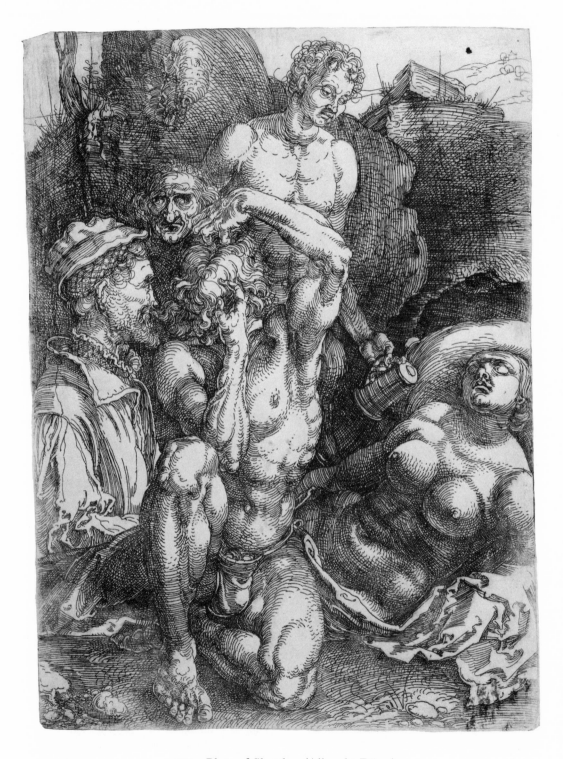

113 Plate of Sketches (Albrecht Dürer)

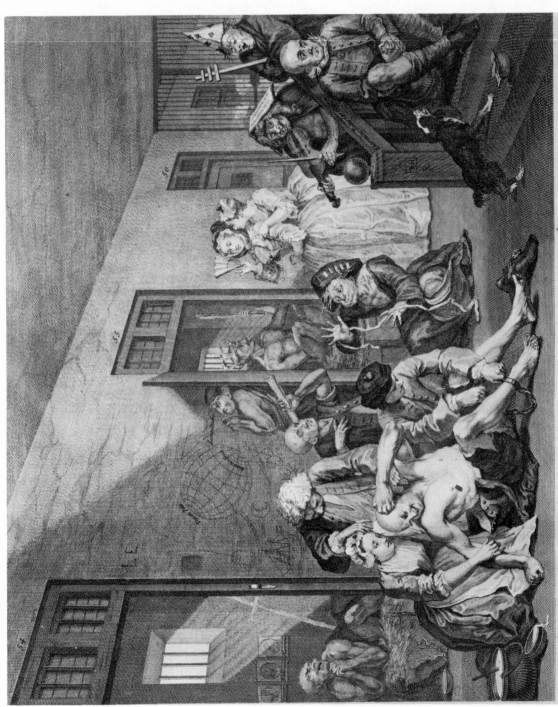

114 Bedlam Hospital, London (William Hogarth)

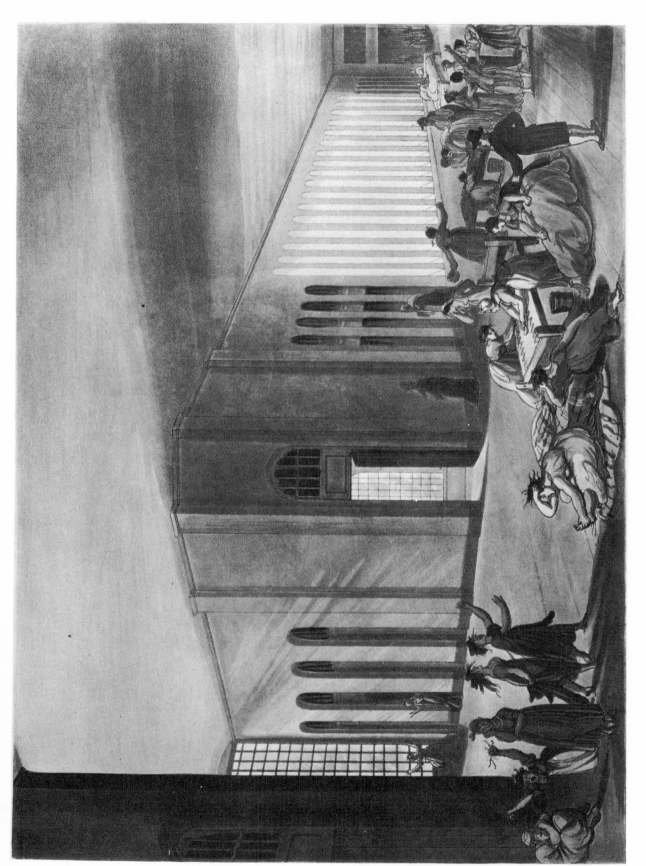

115 St. Luke's Hospital, London (Rowlandson and Pugin)

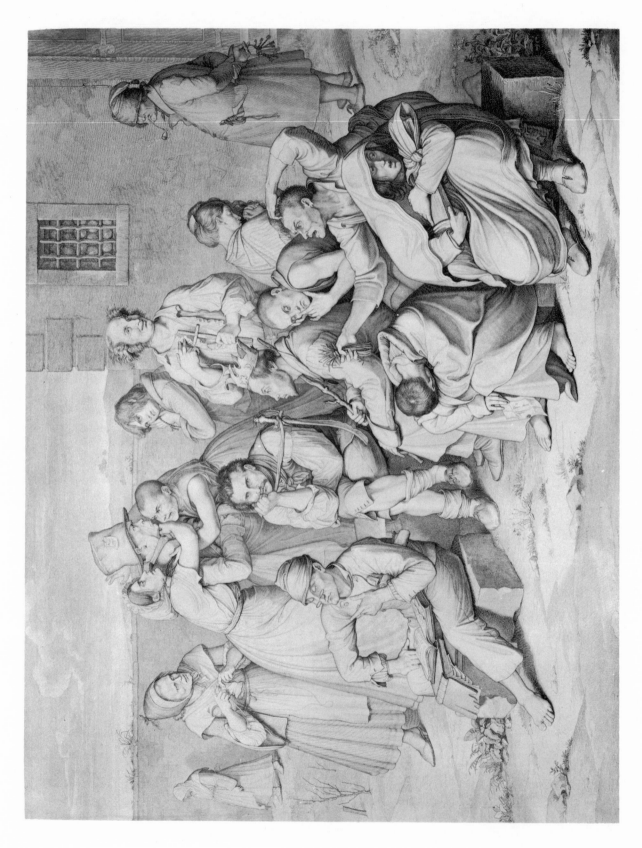

116 The Madhouse (Wilhelm von Kaulbach)

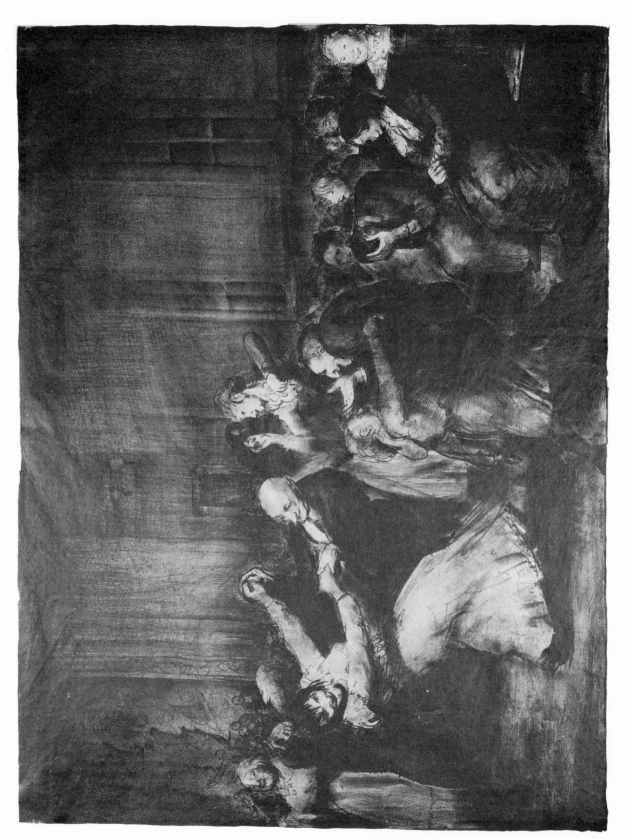

117 Dance in a Madhouse (George Bellows)

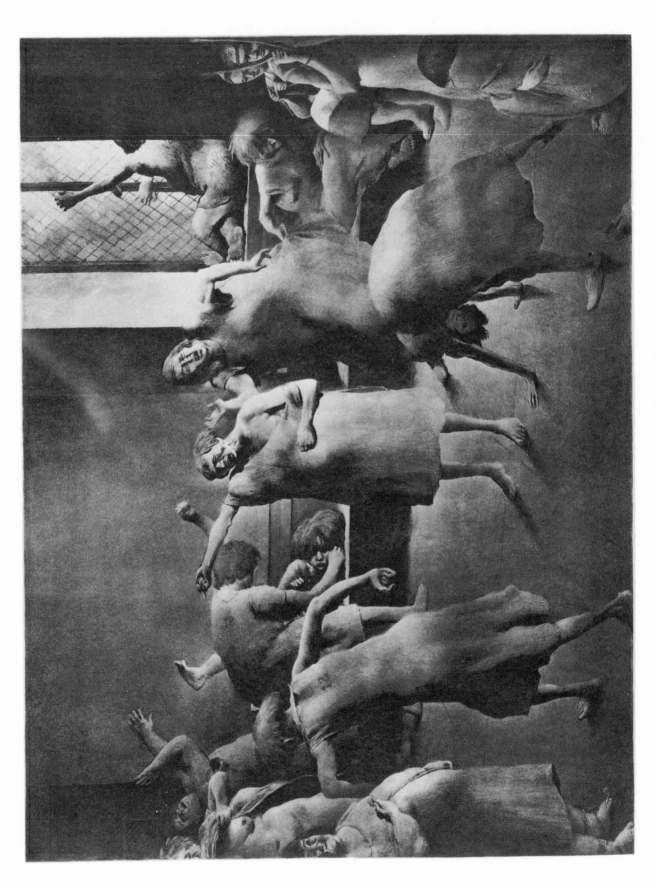

118 Psychopathic Ward (Robert Riggs)

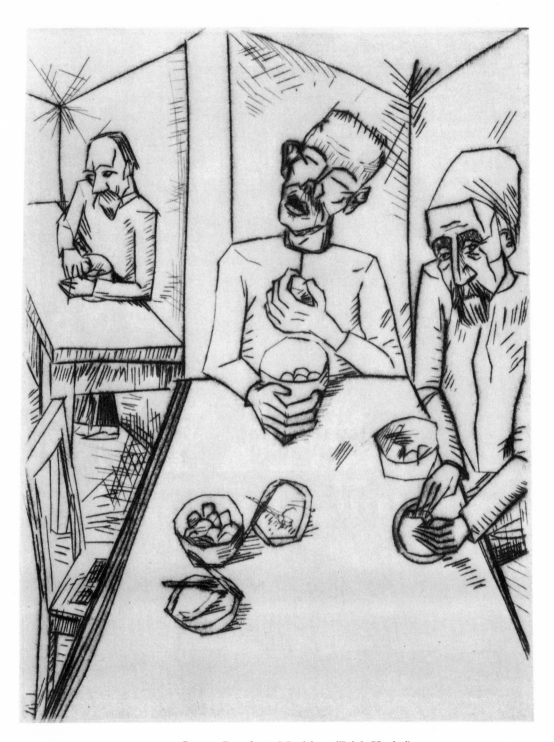

119 Insane People at Mealtime (Erich Heckel)

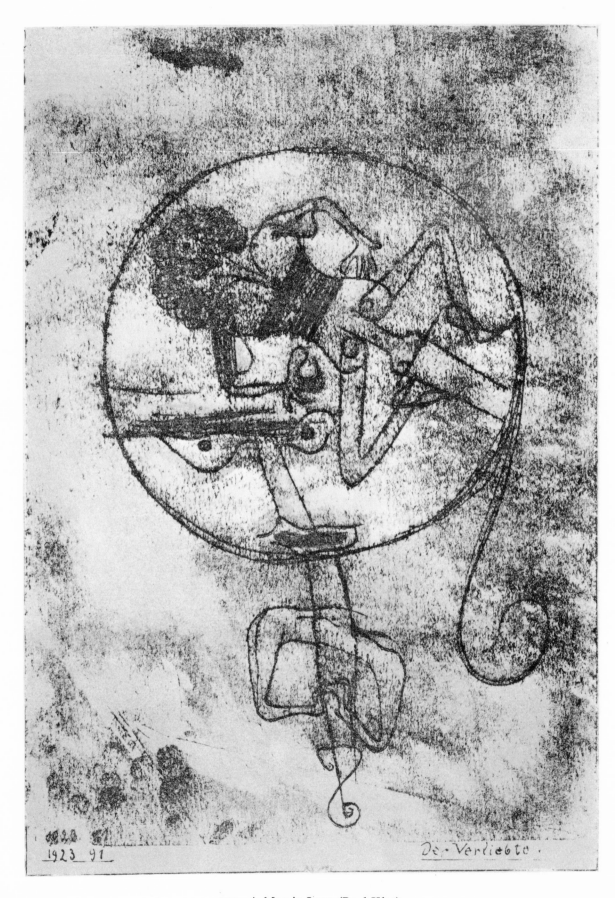

120 A Man in Love (Paul Klee)

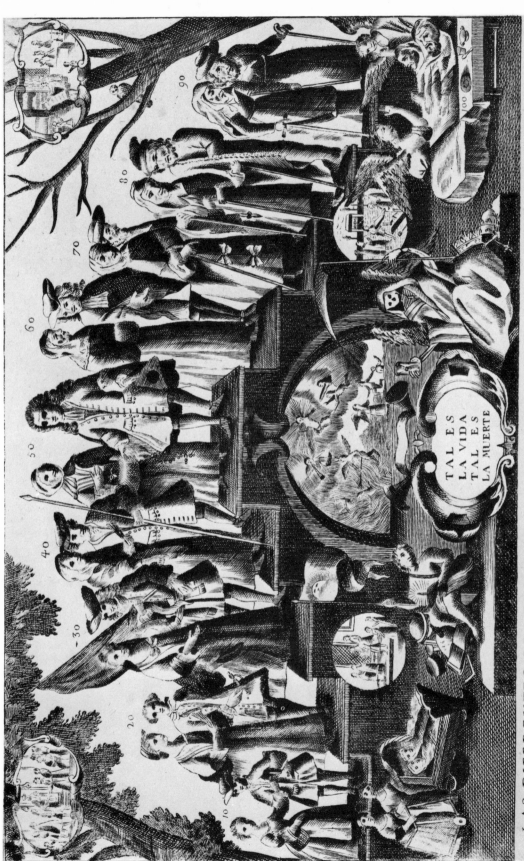

LAS DIFERENTES EDADES DE LA VIDA DEL HOMBRE Y DE LA MUGER DE DESDE SU
NACIMIENTO HASTA SU MUERTE

TAL ES
LA VIDA
TAL ES
LA MUERTE

121 The Course of Life (late XVIII century)

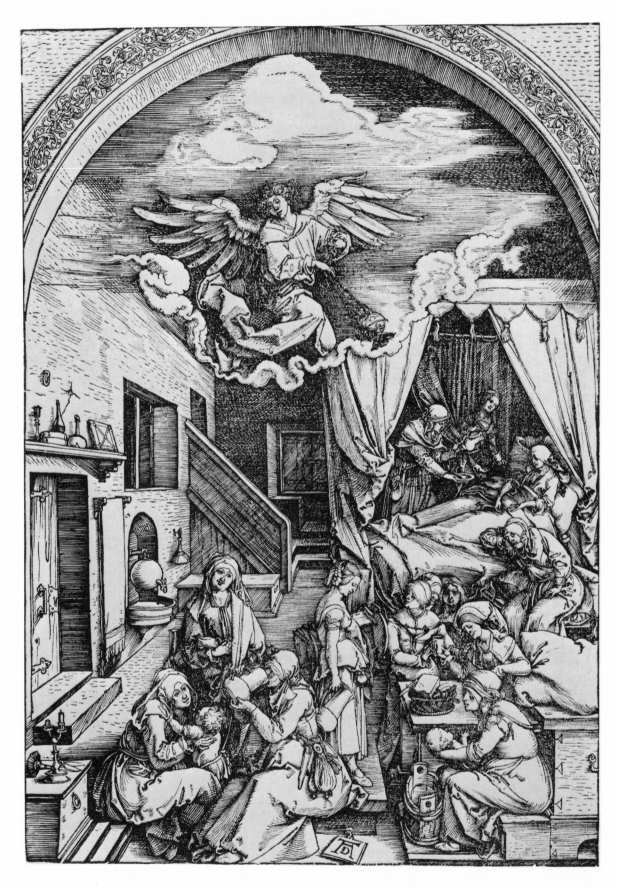

122 The Birth of the Virgin (Albrecht Dürer)

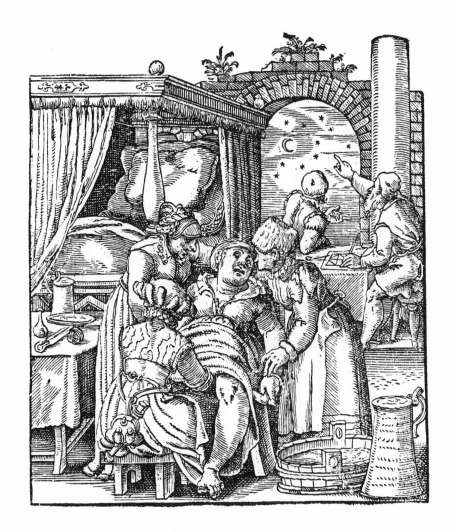

123 Childbirth (Jost Amman)

124 L'Accouchement (Abraham Bosse)

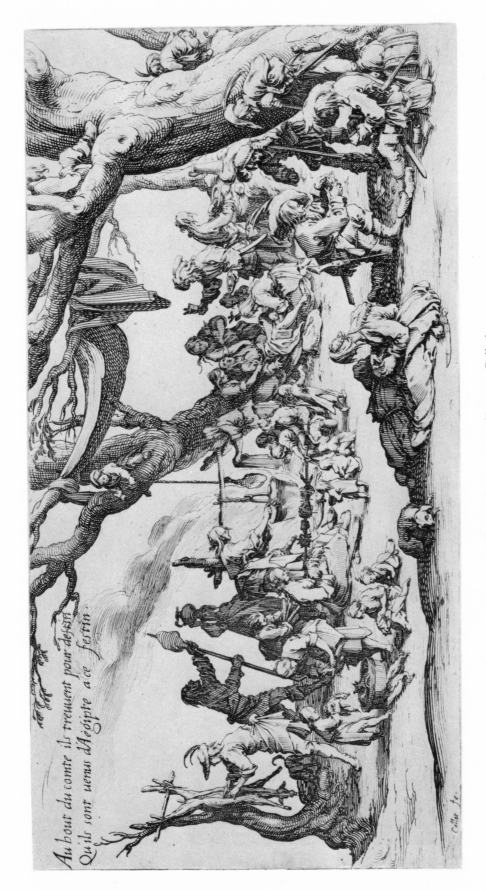

125 Gypsy Encampment (Jacques Callot)

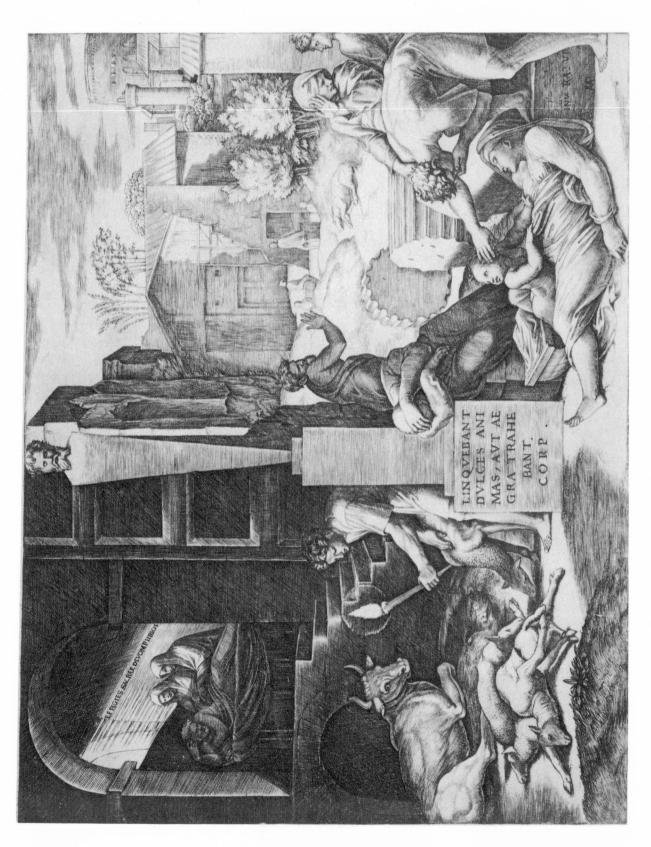

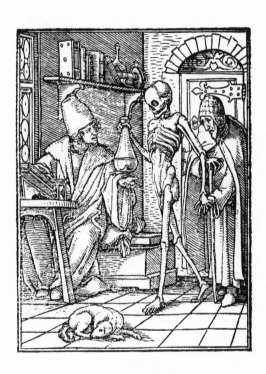

127 Death and the Physician (Hans Holbein the Younger)

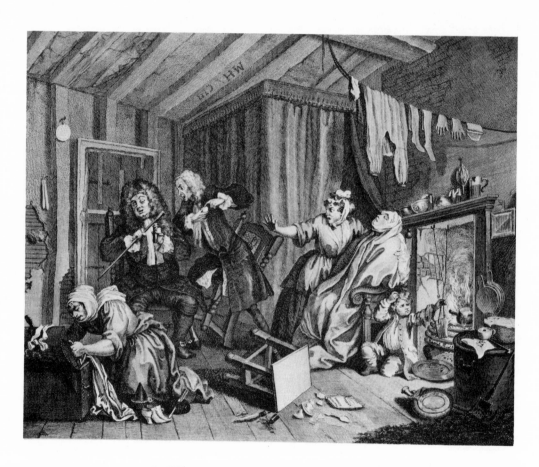

128 The Death Scene (William Hogarth)

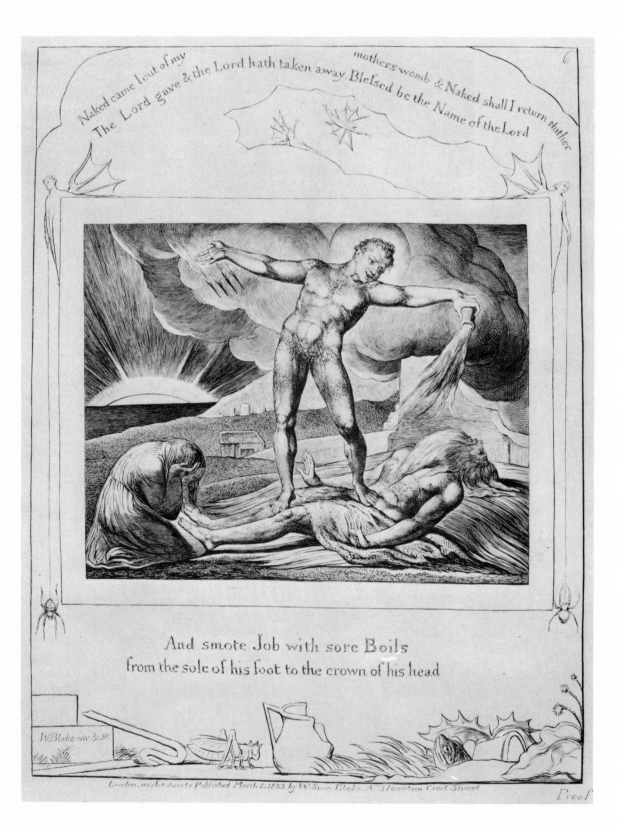

129 Job Afflicted with Boils (William Blake)

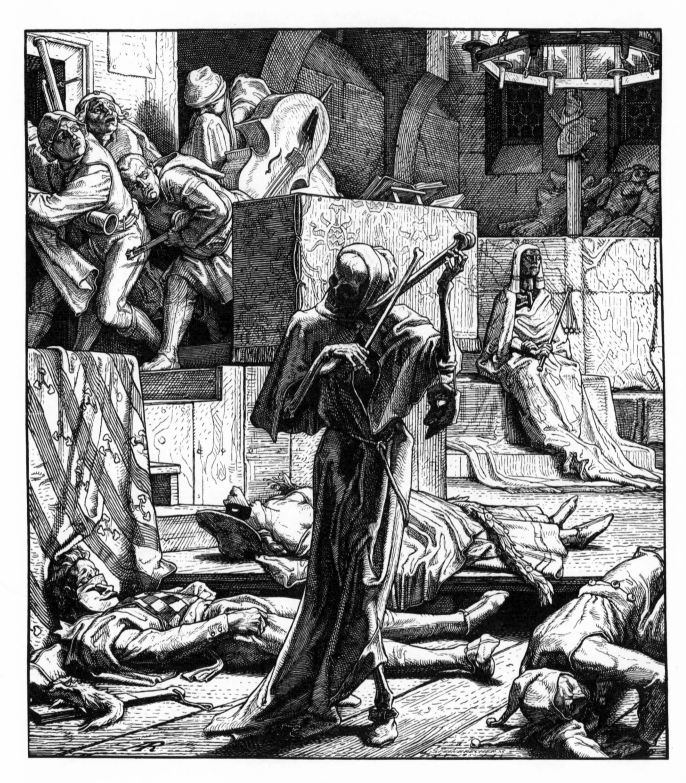

130 Death the Destroyer (Alfred Rethel)

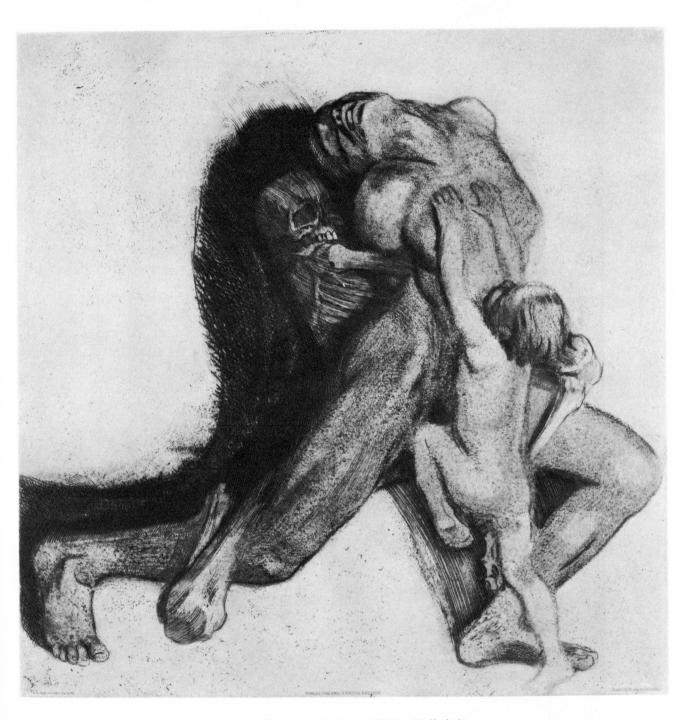

131 Woman and Death (Käthe Kollwitz)

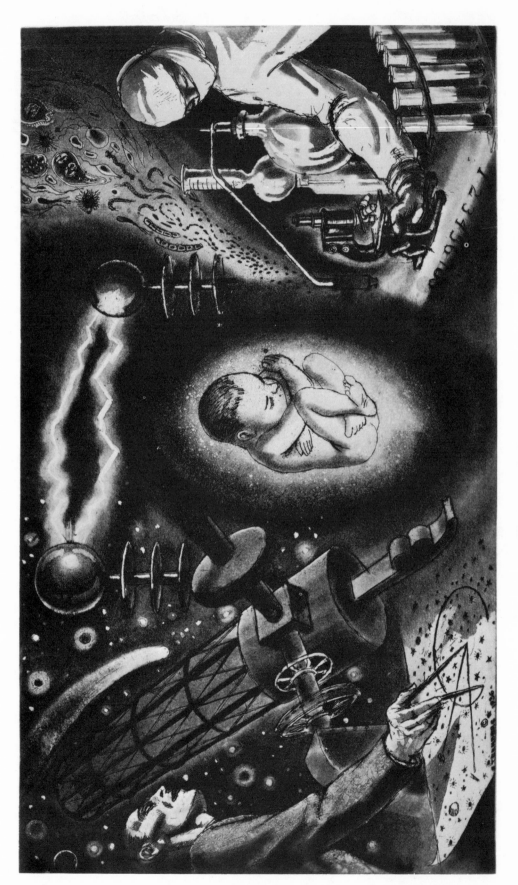

132 The Secret of Life (Harry Sternberg)

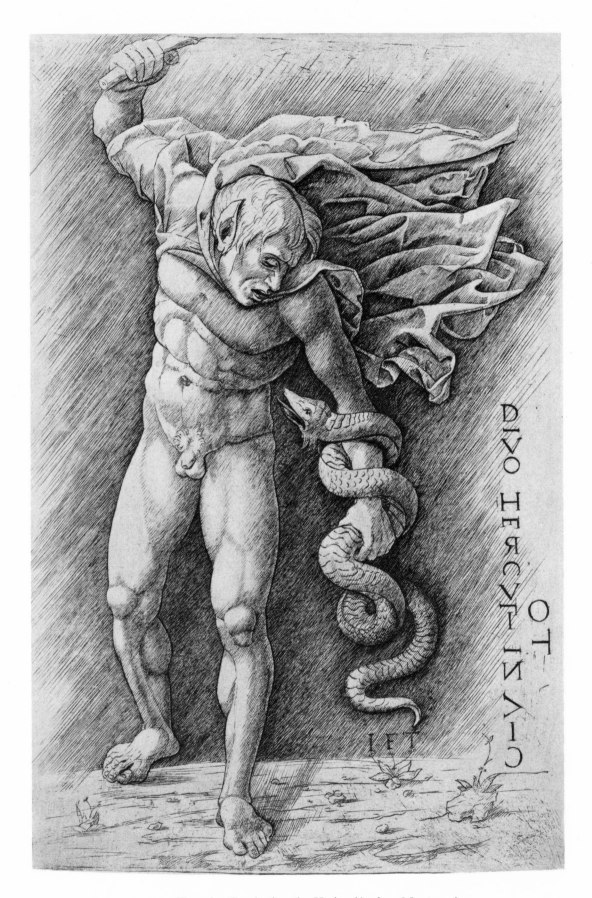

133　Hercules Combating the Hydra (Andrea Mantegna)

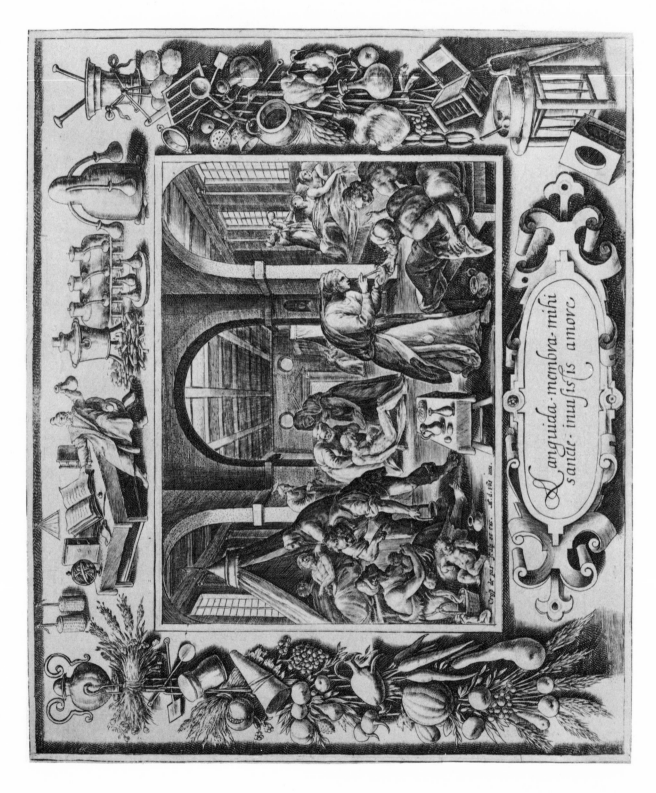

134 To Succor the Sick (Crispin de Passe)

Notes to the Plates

I / From Medicine Man to Doctor of Medicine

In this section may be traced the change in attitude of those whose profession it is to alleviate the maladies of mankind—the change that took place in the transition from superstition to science. There once was a widespread belief among ancient and primitive peoples that disease was caused by supernatural forces or demons, and that illness could be cured through magical rites performed by witch doctors. As mankind, however, began to study Nature intelligently, and acquire experience in coping with its manifestations, the supernatural origin of disease was discarded in favor of a concept more rational and scientific, thereby transforming the medicine man into the doctor of medicine.

1 MEDICINE MAN CURING A PATIENT (BY SETH EASTMAN). This color lithograph by C. Schuessele after the drawing by Captain Seth Eastman (American, 1808–1875) appeared in the book by Schoolcraft on *The Indian Tribes of the United States*, Philadelphia, 1851. It portrays a scene witnessed by the artist while among the Dakota Indians and thus exemplifies the witch doctor's approach to disease.

2 UROSCOPY, OR PHYSICIAN AND PATIENT (BY ERHARD REUWICH). This colored woodcut is from one of the earliest handbooks of medical and botanical knowledge, Johann von Cube's *Gart der Gesundheit*, Mainz, 1485. The artist, Erhard Reuwich, is celebrated as the first book illustrator whose name is known. Breydenbach, who wrote a book on his travels to the Holy Land in 1486, mentions in his text that he took Reuwich along as his illustrator.

Though we know little about him except his name, his work shows him to be an artist of exceptional ability. The woodcut in question is a masterly example of trenchant drawing in the Gothic style. The basic assumption underlying uroscopy is the scientific principle of cause and effect, namely that maladies can be diagnosed through specific symptoms, and thus illustrates another milestone in the development of more rational concepts of disease.

3 THE PHYSICIAN (ITALIAN SCHOOL, 1500). Woodcut from a *Regimen Sanitatis Salernitanum*, with commentary by Arnold de Villanova and others, Venice, 1500. This charming Venetian woodcut was designed in the Florentine style, that is to say with the black areas broken up with white lines and with a characteristic Florentine woodcut border. The book itself, in epigrammatic verse with surrounding commentary, was a popular compendium of hygiene and therapy, deriving from the School of Salerno, the oldest medical institution in Europe. It was one of the chief medieval texts on medicine, and countless editions were published after the invention of printing. The picture symbolizes the role of the physician. Utilizing such "scientific" knowledge—chiefly astrology and uroscopy—as was current and available, he made his diagnosis on the basis of the urine in a flask brought by the boy. Note the astrological equipment, the armillary sphere, compass, and stars.

4 THE CONSULTATION (ITALIAN SCHOOL, XVI CENTURY). A woodcut taken from the title page of Panthaleo's *Pillularium*, Pavia, 1516.

The picture brings to life the Renaissance world in all its beauty and nobility. The dignified gestures of the physicians and the beauty of their robes and of the interior are delineated with the utmost skill and sense of placement and design. The man of the Renaissance endowed even utilitarian objects and aims with the quality of beauty and art. This handsome early sixteenth-century woodcut of North Italian origin was used to decorate a number of medical books and tracts, including a Consilia (book of case histories) and commentaries on Hippocrates and Avicenna.

5 VISIT TO A PLAGUE PATIENT (BY GENTILE BELLINI). The woodcut "Visit to a Plague Patient," attributed to Gentile Bellini (Italian, ca. 1430–1516), is taken from Johannes de Ketham's *Fasciculus Medicinae* (Venice, 1500), one of the earliest illustrated medical books, and generally accounted one of the most beautiful. The first edition was printed in 1491, and two years later, in 1493, the printer de Gregoriis issued a new and better edition, with additional illustrations of which the present woodcut was one. As a compendium of medical knowledge, with chapters on uroscopy, phlebotomy, surgery, gynecology, epidemics, and anatomy, the book was popular and was reprinted many times in the next thirty years.

The illustrations, particularly the four that were added in 1493, are conceived with a grandeur and nobility of form typical of the finest achievements of the Italian Renaissance. Indeed, so outstanding are these four woodcuts —as one authority wrote: "the greatest piece of illustration in the classic style in the fifteenth-century Venetian books"—that they have been attributed to several great Italian artists, to Andrea Mantegna or to his brother-in-law, Gentile Bellini. Both Lippmann and Hind favor Bellini, and this attribution now seems to be generally accepted. As Hind said: "It can hardly be doubted that these woodcuts are the invention of a painter of genius." Lippmann raised the question why illustrations of such high esthetic merit were inserted in a purely practical handbook; and then answered it by suggesting that it was done for purposes of prestige, to make the book more attractive and beautiful. The *Fasciculus Medicinae* and Vesalius' *De Humani Corporis Fabrica* are two supreme examples of works embodying both scientific and esthetic interest.

The Black Death, or bubonic plague, was an ever-present threat during the Middle Ages and Renaissance. Venice, with its enormous sea-trade to the Orient, was especially vulnerable. It was the Venetian Republic which established the first official quarantine as a preventive measure during the great epidemic of 1348 against suspected persons on ships.

Our woodcut dramatizes the traditional obligation of the physician to minister to the sick at the risk of personal jeopardy. The doctor is holding a sponge soaked with vinegar and spices to his nose, while two attendants are fumigating with torches. Concepts of prophylaxis were haphazard and empirical in those days, and various medicaments were tried out to ward off infection. *Eau de Cologne* is a survival of one of these plague waters or essences.

6 THE DOCTORS (HANS BURGKMAIR). This woodcut, designed by Hans Burgkmair (German, 1473–1531), appeared in Cicero's *De Officiis*, Augsburg, 1531. The same wood block was sometimes used to illustrate several books; and this block first was printed in 1519 on the title page of a book by Albucasis (1013–1106), a famous Moorish surgeon of Cordova, whose work had great vogue in the late Middle Ages as a compendium of Greek and Roman medical knowledge. The subject of the Doctors serves as a reminder of how much science today is indebted to the cumulative knowledge and research of the past, transmitted through the printed word. Burgkmair's treatment is not without a satiric overtone in its emphasis on the disputatiousness of the learned doctors; but again a sound moral could be drawn from it with respect to the necessity for skepticism and criticism of past authority.

7 THE PHYSICIAN (BY JOST AMMAN). A woodcut by Jost Amman (Swiss-German, 1539–1591) in Hans Sachs' *Beschreibung aller Stände*, Frankfurt, 1574. The artist's famous gallery of the crafts and professions in the sixteenth century first appeared in 1568 with notes in Latin. The second edition was published in 1574 with German commentary in the form of poems by Hans Sachs, the famous shoemaker-poet whom Richard Wagner incorporated as a character in his opera *Die Meistersinger*. The somewhat uncouth verse may be translated as follows: "I am a Doctor of Medicine. From the urine I can determine what illness plagues a man, whom I can help, with God's grace, through a syrup or prescription which counteracts the malady. In order that mankind may again be healed, Arabo invented medicine."

8 PORTRAIT OF DR. EPHRAIM BONUS (REMBRANDT). An original etching by Rembrandt van Rijn (Dutch, 1606–1669) executed at Amsterdam in 1647.

Among the elements which differentiate the trained doctor of medicine from the witch doctor, may be cited increasingly scientific methods of diagnosis and therapeutics, based on inherited knowledge and current research, and a code of ethics for service to mankind, traditional since Hippocrates. From these significant features emerges the portrait of the ideal physician of modern times, as here typified by Rembrandt's etching of his friend, Dr. Ephraim Bonus, a masterpiece of characterization at once noble, profound, and humane.

This etching is in an exceptionally brilliant and early impression—undoubtedly printed in Rembrandt's studio—which fully reveals the subtle chiaroscuro and psychological overtones characteristic of his greatest portraits. The artist has portrayed his subject in a sympathetic and reflective mood. It is as if the physician had paused at the bottom of the stairs, after having left his patient, to think over the case and ponder over the patient's plight with compassionate understanding. It is all so human in the finest sense of the word.

Ephraim Bonus (Bueno) was by birth a Portuguese Jew. He practiced as a physician in Amsterdam, and became a burgher of the city in 1651. He moved, as did Rembrandt, in the select circle of the art-loving Burgomaster, Jan Six. Rembrandt painted a portrait in oils of Bonus for the Burgomaster, and it has remained in the possession of the Six family until recently. Rembrandt consorted much with physicians and theologians, as his numerous portraits of them bear witness.

Rembrandt was perhaps the greatest etcher who ever lived. No one had a greater range and greater mastery within that range than he. Religious subjects, portraits, landscapes, nude studies, still life—in all of these he created masterpieces. In the field of genre alone he did not produce much: we learn little from him about the externals of life as lived in Amsterdam, but we learn much about humanity, the essentials of life which do not change from age to age. He was the visionary, the man apart, who moved above or below contemporary life. To practical Holland of the seventeenth century, he was an enigma; it took the world several centuries to catch up with him. Besides his matchless achievements in painting and drawing, he raised etching to a major art. It was he who gave to etching the significance and direction it was subsequently to take.

II / Allegories of the Healing Arts

An allegory, or a pictorial symbol, serves to formulate into some tangible aspect an idea or point of view that may exist vaguely in the minds of many. We are here concerned with allegories of the Healing Arts—visual images around which are centered the faith and hope of mankind.

9 HEAD OF ASKLEPIOS (GREEK COIN, II CENTURY B.C.). The earliest icon of medical significance included in the exhibition is the portrait of Asklepios as pictured on a silver drachma, a Greek coin minted on the island of Cos and dating from about 150 B.C. There are numerous versions of the origin of this legendary figure,

the Greek god of medicine, called Aesculapius by the Romans. The commonest story is that he was the son of Apollo, although in Homer he is mentioned only as "the blameless physician." The centers of his cult were located at Epidauros, Pergamon, Cnidos, and Cos, in temples administered by a priestly caste supposed to be descended from the god himself. The regime in the temples to which the sick had recourse was more or less similar to that in our modern sanatoriums, with emphasis upon diet, massage, baths, and the like. The god was supposed to reveal to the patient in a dream the cure for his disease. The serpent, symbolic of regenerative power, was sacred to Asklepios and to Apollo. The emblem, in the form of a rod with a coiled serpent, is still used to represent the art of medicine, though more often in the form of the Caduceus, or winged staff with two twined serpents, presented by Apollo to Hermes, the Heavenly Messenger. Apollo, god of the sun, patron of the Muses, father of Asklepios, is thus revealed as the original personification of the Healing Art. The celebrated Hippocratic oath begins thus: "I swear by Apollo the physician and Asklepios and his daughters, Hygeia and Panacea, and all the Gods and Goddesses. . . ." Hippocrates was born on the Island of Cos.

10 ST. COSMAS AND ST. DAMIAN (JOHANNES WECHTLIN). Colored woodcut by Johannes Wechtlin (German, ca. 1490–1530) from Hans von Gersdorff's *Feldtbuch der Wundartzney*, Strassburg, 1540.

St. Cosmas and St. Damian are traditionally acclaimed the patron saints of the physician and apothecary. In the calendar of saints their day is September 27. The two brothers were Syrian Christians, and were reputed to have effected many miraculous cures before they suffered martyrdom in the reign of the Emperor Diocletian (A.D. 303). Many artists have pictured them in paintings, miniatures, or prints. They are represented here in a woodcut by the German artist, Johannes Wechtlin, around the beginning of the sixteenth century,

in the costume of that time and with the attributes of their profession, the urine flask and the cordial-beaker and spoon. The moralizing quatrain above, may be translated thus: "The wise physician should not offer one medicine in place of another (the original meaning of *quid pro quo*), not white for black; but should desire to succeed through expert knowledge."

There have been other saints, besides Cosmas and Damian, whose names have been invoked for intercession or protection. Physicians also revered St. Luke, whom St. Paul called "the beloved physician," and St. Pantaleon, the martyred physician of the Emperor Maximian in the fourth century. The apothecaries likewise honored the Archangel Raphael for his intervention in the blindness of Tobit, and St. Nicholas of Bari, from whose tomb miraculously flowed a fragrant oil. Certain saints were invoked for special diseases, to mention but a few: St. Anthony against St. Anthony's Fire or ergotism, St. Gilles against epilepsy (called in French *mal de St. Gilles*), St. Vitus against St. Vitus' Dance, St. Denis against headache, St. Apollonia against toothache, St. Roch, St. Genevieve, and St. Sebastian against plagues of various kinds. Three saints were especially renowned for their service to the sick: St. Camillus of Sellis, St. Hildegarde, Queen of France, and St. John of God, founder of the order of Hospitallers or Brothers of Charity.

Uroscopy, or water casting, was so widely employed as a means to diagnosis in the Middle Ages and even later, that the urine flask practically became the symbol of the medical profession. The physician and his flask are to be seen in numerous prints in this collection. The doctors professed to discriminate between minute variations of color, texture, sediment, smell, even of taste, and upon them base their diagnosis. Elaborate diagnostic charts exist, correlating these indications with various maladies. Readers of Shakespeare will recall that in the second part of *Henry IV*, Falstaff cries to his tiny page: "Sirrah, you giant, what says the doctor to my water?" To which the page an-

swers: "He said, sir, the water itself was a good healthy water; but for the party that owned it he might have more diseases than he knew for."

In addition to the urine flask there have been other symbols associated with the medical profession, such as the rod with twined serpents dating back to the Greeks, the clyster, and the act of counting the pulse. The gesture of taking the pulse, as illustrated, for example, in Lautrec's lithograph of "Carnot Ill," would probably be the symbol most current in our day, indicating perhaps that the heart is now accounted the primary index of a patient's well-being.

11 ALLEGORY OF THE MEDICAL PROFESSION (SCHOOL OF HENDRIK GOLTZIUS). A set of four engravings executed under the supervision of Hendrik Goltzius (Dutch, 1558–1616) at Haarlem in 1587. The sequence of the series runs as follows: (A) Physician as God; (B) Physician as an Angel; (C) Physician as a Man; (D) Physician as a Devil. The allegory is not without its humorous aspect. Its four sheets trace the change in attitude of the patient in sickness and in health. When in the throes of disease the patient, and his family, look upon the doctor as a God. But when the patient is cured and expected to pay his fee, he looks upon the physician as a devil. The backgrounds show intimate glimpses of current practice, medical on the left and surgical on the right. It is interesting to note that among the appurtenances of the medical profession in the foreground are books by such authorities as Galen, Avicenna, and Paulus Aeginata, showing that traditional Roman-Arabic concepts still held sway in 1587. The only new name is Hippocrates.

12 CHRIST HEALING THE SICK (REMBRANDT). An original etching by Rembrandt van Rijn (Dutch, 1606–1669) executed at Amsterdam around 1649. This is one of the most famous of Rembrandt's works. The plate is larger in size than most of his coppers; and upon it the artist lavished all the resources of a lofty imagination. The inspired design, the mysterious shadows and dramatic lighting, the compassionate delineation of suffering humanity, the masterly personification of human emotions in a gamut from unquestioning faith to skepticism and scorn, all combine to make this etching a veritable masterpiece. It was renowned as long ago as the early eighteenth century, when it was given the name of the Hundred Guilder Print in consequence of a legend that it had fetched at auction that sum, fabulous for the time. To the man of medicine the print has an added interest as a panorama of the maimed, the halt, and the blind, and raises the question how long and to what extent psychosomatic conceptions of pathology have been current.

13 M.D. (BY HARRY STERNBERG). Color serigraph by Harry Sternberg (American, b. 1904), New York, 1935. This picture is an allegory of the function and wide-ranging outlook of the physician today. His therapeutics are based upon the accumulated experience of the past, augmented and modified by the research of the present. By a curious coincidence, the composition and conception of this picture are similar to those of "The Physician" from the *Regimen Sanitatis*, some four hundred years earlier (Plate 3). This similarity—all the more striking for being unconscious—demonstrates how vital is the tradition of the physician as the informed practitioner. Today the microscope and other tools of science have replaced astrology and uroscopy.

The technique of this print, differing from most others in the collection, is a modern development of an old stencil process. In a serigraph the artist creates a free hand stencil on a stretched screen of silk for each color. The pigment is applied through the open mesh of the silk onto the paper to build up the successive color areas of the composition.

III / Great Names

This tiny portrait gallery of great names in medical history is only a small fraction of what could have

been assembled—the heroes of science are many and sometimes nameless. This selection must therefore serve as an arbitrary summary of a subject too vast for adequate treatment here.

14 TITLE PAGE WITH 24 PORTRAITS OF ANCIENT AND MEDIEVAL PHYSICIANS (HANS WEIDITZ). On the woodcut title page of a practical handbook of medicine (*Spiegel der Artzney* by Laurentius Friesen, Strassburg, 1532) the designer, a famous illustrator named Hans Weiditz (German, fl. 1520–1536), has drawn twenty-four portraits of ancient and medieval physicians, and then added below a representation of Venus and Adonis under the Greek title of the Gardens of Adonis. It has been pointed out that this is a reference to certain rites of plant fertility and regeneration, since Adonis, like the Egyptian Osiris and the Babylonian Tammuz, spent half of his time in the Underworld and was then resurrected, thus symbolizing the periodic return of winter and summer. The Gardens of Adonis also have become the name of the pots or baskets filled with quick-growing plants, used in the Adonis festival and destroyed thereafter, again symbolizing the transitoriness of Nature's cycle. All the medical portraits are of course imaginary, but the characters are selected with a view to historical importance, and thus provide a digest of medical antiquity in capsule form. It may be instructive to spell out and annotate the names, since the artist, in his lettering, made use of certain, almost shorthand, contractions conventionally employed in manuscript writing:

Machaon and Podalirius. In the Second Book of the *Iliad* these two are referred to as the sons of Asklepios, "healers both and skillful."

Hippocrates and Diocles. Hippocrates, called the Father of Medicine and the greatest of Greek physicians, flourished on the island of Cos, 460–370 B.C. One of the most appealing figures in all history, Hippocrates somehow personifies all that is noble and wise and beautiful in Greek culture. Diocles of Carystos (fl. ca. 350 B.C.) was

regarded by the Greeks as the greatest physician after Hippocrates.

Herophilus and Erasistratus. Herophilus (fl. ca. 300 B.C.) was a celebrated anatomist of the Alexandrine School and pioneer of dissection. Erasistratus of Cnidos (ca. 310–250 B.C.) was the founder of the study of physiology.

Asclepiades and Themison. Asclepiades (born at Prusa, ca. 124 B.C.), a Greek physician, came to Rome around the beginning of the first century B.C. to attain fame and riches. He was a friend of Cicero, Crassus, and Mark Antony. He taught that treatment should be given *cito, tute et jucunde* (promptly, safely, and pleasantly). His pupil Themison of Laodicea (123–43 B.C.) also made his fortune at Rome as the founder of the "Methodist" School of Medicine.

Pliny and Theophrastus. Caius Plinius the Elder, author of the well-known *Natural History*, was born in 43 A.D., and perished in 79 A.D. while observing the eruption of Vesuvius which overwhelmed Pompeii. Theophrastus (370–285 B.C.) was the favorite pupil of Aristotle and inheritor of his library. He was the founder of botanical science.

Dioscorides and Crateuas. Dioscorides of Tarsus in Cilicia (fl. 1st century A.D.) wrote his classic *Materia Medica* in Greek, summarizing in somewhat haphazard fashion all existing pharmacological knowledge. Crateuas (120–63 B.C.), botanist and physician to Mithridates VI, King of Pontus, originated the idea of polyvalent drugs and serums. Mithridates himself was a student of poisons and antidotes (*Mithridaticum*) and experimented in the immunities established by minute dosages.

Soranus and Antonius Musa. Soranus of Ephesus practiced in Rome during the reigns of Trajan and Hadrian (98–138 A.D.). His text on *The Diseases of Women* became the foundation of gynecology and obstetrics. Musa was the friend of Virgil and Horace, and physician to the Emperor Augustus.

Nicander and Oribasius. Nicander (fl. ca. 185–135 B.C.), Ionic Greek poet, physician, and hereditary priest of Apollo, wrote didactic poetry on medical subjects including a treatise on

poisons, *Theriaca*. Oribasius (325–403 A.D.), a Byzantine Greek, became personal physician to the Emperor Julian the Apostate.

St. Luke and Galen. According to tradition the apostle Luke was both a doctor and an artist, and thus a patron of both professions. St. Paul refers to him in the Epistle to the Colossians as "the beloved physician." Galen was born at Pergamon in 138 A.D. and died at Rome in 201 A.D. He attended the Emperor Marcus Aurelius. He was the great systematizer of medical knowledge, and his writings were considered authoritative and infallible up to the seventeenth century.

Paulus Aeginata and Serapion. Paul of Aegina, a Greek physician, flourished 625–690 A.D. and wrote a celebrated treatise on surgery of unusual completeness, later translated in Arabic. Yuhennâ Ibn Sarâbiun, or Serapion (9th century A.D.), although a Syrian Christian, was regarded as an Arabic writer. His *Aphorisms* served as a textbook in Arabic schools.

St. Cosmas and St. Damian. The two brothers practiced medicine in Cilicia, Asia Minor, and were martyred in the Christian persecutions of Diocletian (303 A.D.). From early times they became the protectors of the physician and the apothecary.

Avicenna and Rhazes. Abu Alî Ibn Sinâ, or Avicenna, the most renowned of Arabic physicians, as well as poet and philosopher in the spirit of Omar Khayyam, was born in Bokhara, Persia, in 980 A.D. and died in 1037. He wrote commentaries on Aristotle and a Canon of Medicine which was used as a textbook in Europe as late as the seventeenth century. Abu Bakr Ibn Zakariâ, or Rhazes, likewise a Persian-Arabic physician, flourished 865–925 A.D. He wrote an original treatise on smallpox and taught the use of animal gut in sutures.

15 PARACELSUS (BALTHAZAR JENICHEN). Etching by Balthazar Jenichen (German, 1520–1600), ca. 1550, in the form of a broadsheet with a portrait of Aureolus Philippus Theophrastus Bombastus von Hohenheim, called Paracelsus (1493–1541), at the age of 47; this is based possibly upon a drawing by Hirschvogel. Paracelsus was one of the strangest and most paradoxical characters in medical history. Choleric and pugnacious by nature, he believed that the physician could heal only through love and unselfish devotion. Though a brilliant graduate of the schools, he was the contemptuous antagonist of scholastic medicine, stressing the value of clinical experience and knowledge of nature. His homely wisdom was often obscured by fantastic alchemical jargon. He introduced the use of metallic compounds derived from sulphur, antimony, mercury, etc., and, among vegetable preparations, tincture of opium, still known under the name he gave it, laudanum. He thus is a pioneer in the history of medicine and of chemistry. This broadsheet was probably issued in the decade after Paracelsus' death, and, like most popular productions, has become very rare. This one is a duplicate from the Albertina Collection in Vienna. The portrait itself is surrounded by eulogies of Paracelsus, biblical verses, and free adaptations (as are also the two little scenes through the arches) from the 15th and 24th sections of his *Prognostication*, Augsburg, 1536. The word *Azoth* on the globular head of the sword is the alchemical name for mercury, regarded as the first principle of metals, and symbolizing the universal remedy of Paracelsus.

16 AMBROISE PARÉ (GERMAN SCHOOL, XVI CENTURY). This woodcut is from the Latin edition of Paré's works, *Opera Chirurgica*, Frankfurt, 1594. Paré (1510–1590), one of the world's greatest surgeons, effected a revolution in surgery comparable to what Vesalius did for anatomy. He rescued surgery both from the stuffy scholasticism of the "Surgeons of the Long Robe" (who seldom operated themselves) and from the empiric ministrations of quacks and barbers, thus raising it to the dignity of a noble calling. He learned the hard way as a humble barber-surgeon; and through his operative skill, vast experience, and humane wisdom, became the trusted surgeon of the kings of France. He invented new surgical

instruments and artificial limbs, re-introduced ligature, which had fallen into almost complete abeyance since Celsus, revolutionized the treatment of gunshot wounds by use of soothing dressings instead of cautery, popularized the use of a truss in hernia, and made podalic version (first described by Soranus) viable and practical. The therapeutics of this distinguished surgeon often consisted in little more than ordinary cleanliness and intelligent nursing. One of Paré's favorite sayings was, "Je le pansay; Dieu le guarit," or as translated from Renaissance French, "I dressed him; God healed him."

17 ANDREAS VESALIUS (JAN STEPHAN VON CALCAR). This woodcut by Jan Stephan von Calcar (Flemish, ca. 1499–1546/50), from Vesalius' *De Humani Corporis Fabrica*, Basle, 1543, shows Vesalius as he appeared in his twenty-eighth year—eager, energetic, brilliant—while engaged in the research which has made his name a byword in anatomy. He crowded into one short life two distinguished careers, one as author of the epoch-making work on anatomy and the other as imperial court physician and renowned consultant. After twenty years' service at court, he retired and made a pilgrimage to Jerusalem for reasons that are obscure (there are unsubstantiated stories that he was denounced by the Spanish Inquisition). On his way back to resume his old post at the University of Padua (which had been made vacant by the death of Fallopius), he was lost, it is supposed, in a shipwreck off the Island of Zante in Greece.

18 WILLIAM HARVEY (RICHARD GAYWOOD). An etching by Richard Gaywood (English, active 1645–1680, died ca. 1712), London, ca. 1649.

Everybody knows that William Harvey (1578–1657) discovered the circulation of the blood, but his researches into the question of generation and his formulation of the theory of epigenesis, which Thomas Huxley claimed should "give him an even greater claim to the veneration of posterity," are known only to

specialists. His great work on the heart, *De Motu Cordis et Sanguinis*, published in 1628, is a classic of scientific research: step by step he builds up his argument, fortifying it with experimental demonstration and mathematical calculation. Like most revolutionary discoveries it encountered violent opposition; but Harvey lived to see his views accepted and applied. He was also physician to James I and his son Charles I. The etched portrait of Harvey in his seventies is unsigned, but the identity of the etcher has been established by Sir Geoffrey Keynes as Richard Gaywood, an artist in the circle of Wenzel Hollar, if not actually his pupil. An oil painting of Harvey, based on the etching, is in the National Portrait Gallery in London. Keynes cites a letter by Dr. J. Needham to John Evelyn, 5 April 1649: "Dr. Harvey's picture is etcht by a friend of mine and should have been added to his work, but that resolution altred; however I'll send you a proof with your books that you may bind it up with his book *De Generatione*. I'm sure 'tis exactly like him, for I saw him sit for it" (see National Portrait Gallery Catalogue, pp. 159–160). The etching has often been attributed to Hollar—a plausible hypothesis since Hollar and Harvey accompanied the Earl of Arundel on an official mission to the Emperor Ferdinand of Austria in 1636. The print is very rare; less than a half dozen impressions are known to exist today: one in the British Museum, one in the Pepys Library, one in the Royal College of Physicians, John Evelyn's and one now in Philadelphia. Evelyn's impression bound up in his copy of *De Generatione Animalium* (1651) is deposited in Christ Church Library, Oxford.

19 SANTORIO SANTORIO (GIACOMO PICCINI). An engraving by Giacomo Piccini (Italian, 1617–after 1669) from Santorio's *Opera Omnia*, Venice, 1660. Santorio Santorio (1561–1636) was a great seventeenth-century innovator whose precisely controlled quantitative experiments in what he called "insensible perspiration" became the foundation of the physiology

and pathology of metabolism. He designed many other instruments besides the weighing machine or balance in which he performed quantitative research upon himself for over thirty years: he invented the first clinical thermometer, a pulsilogium or pulse clock, a hygrometer, and various instruments used in tracheotomy.

20 PASTEUR IN HIS LABORATORY (TIMOTHY COLE). A wood engraving, 1925, by Timothy Cole (American, 1852–1931) after the painting by Edelfelt, Paris, 1885. The picture of Pasteur in his laboratory symbolizes that trend toward specialized scientific research which, from the nineteenth century onwards, has contributed so much to every branch of medicine and life. The earlier medical men were masters of all existing knowledge, which they enriched in many fields. Later, as the body of knowledge grew by leaps and bounds, one person could not possibly master the whole of medical science, and thus was forced more or less to specialize in some one branch. And since, for the doctor, research became as absorbing a career as general practice, the boundaries between medicine and general science became less hard and fast. Louis Pasteur (1822–1895), though not medically trained, made many notable discoveries in the elucidation and treatment of disease—anthrax in cattle and sheep, chicken cholera, silkworm disease, and rabies in dog and man—and in the organic causes of fermentation and putrefaction (pasteurization as a remedy). His demonstration of the existence of pathogenic and other micro-organisms in the atmosphere discredited once and for all the theory of "spontaneous generation," and, what was even more important, stimulated Lister to develop the technique of antisepsis (later modified to asepsis) in open wounds which made possible the enormous expansion of modern surgery.

21 SIGMUND FREUD (HERMANN STRUCK). An etching by Hermann Struck (German, 1876–1944), Berlin, 1914, with autograph signature of Freud. In this sensitive etching from life we see the profile of Freud, another great innovator who revolutionized psychopathology, and whose discoveries in normal as well as in abnormal psychology have modified basic concepts in education, literature, and art.

IV / Physicians and the Arts and Sciences

In this section—with token portraits to bear witness—we explore the avocations of medical men, since many of them, in addition to distinguished service in their profession, have also achieved renown in some other branch of the arts and sciences.

There are many doctors who are also known—and sometimes better known—for their contribution to English literature. Besides Sir Thomas Browne, one could cite the following: Thomas Campion (1567–1620), who wrote lyrics and masques and composed the music for his songs while practicing medicine in London; Henry Vaughan (1622–1695), one of the "metaphysical poets"; John Arbuthnot (1667–1735), physician to Queen Anne and author of the comic *History of John Bull* which coined the national nickname; Sir Samuel Garth (1661–1719), the only medical member of the Kit-Kat Club and author of the satirical poem *The Dispensary*; the poet and playwright Oliver Goldsmith (1728–1774); the novelist Tobias Smollett (1721–1771); Erasmus Darwin, botanist, didactic poet, and grandfather of Charles Darwin; Peter Mark Roget (1779–1869) of *Thesaurus* fame; the poet *par excellence*, John Keats (1795–1821); the Irish novelist Charles Lever (1806–1872); John Brown (1810–1882), author of *Rab and his Friends*; the biographer Samuel Smiles (1812–1904); and in recent times Sir Arthur Conan Doyle, the creator of Sherlock Holmes; the poet-laureate, Sir Robert Bridges; the novelists W. Somerset Maugham and Archibald G. Cronin; the Irish poet Oliver St. John Gogarty; and Geoffrey Keynes, the bibliographer and editor of Blake, Paré, Donne, and others.

In the American field one may cite Oliver Wendell Holmes (1809–1894), the genial *Autocrat of the Breakfast Table*; the novelist S. Weir Mitchell (1829–1914); and the poet William Carlos Williams (1883–1963).

[145]

Girolamo Fracastoro (1489–1533), physician, poet, geologist, astronomer, epidemiologist, wrote perhaps the most famous of all medical poems, *Syphilidis sive de Morbo Gallico Libri Tres* (Venice, 1530), celebrating the vicissitudes of the Arcadian shepherd, Syphilis, and thereby coining the definitive name of a venereal disease. The Swiss physician Albrecht von Haller (1708–1777) was noted as an anatomist and botanist, who also composed poems, historical novels, and compendious bibliographies of the literature of botany, anatomy, surgery, and medicine, still used as reference works today. The fabulous Roger Bacon (1214–1294) was an alchemist, astronomer, philologist, philosopher, and physician who explored theoretically the possibility of the submarine, the flying machine, and the automobile, and is credited with the invention of eyeglasses and telescope. Albertus Magnus (1206–1280), who made all knowledge his province, studied medicine at Padua. Other versatile physicians were the Swiss, Conrad Gesner (1516–1565), bibliographer, botanist, zoologist, mountain climber, who was one of the first to write in appreciation of mountain scenery; the Neapolitan, Giovanni Battista della Porta (1536–1615), who established one of the first botanical gardens, and wrote of alchemy and natural magic, physiognomy, geometry, architecture, hydraulics, and ophthalmology, perfected the camera obscura and other optical instruments, and wrote two tragedies and numerous comedies; Athanasius Kircher (1602–1680), occultist, orientalist, mathematician, physicist, musician, and one of the first to use the microscope in investigating the cause of disease. Thomas Young (1773–1829) might be accounted the prime exemplar of the versatile physician. He gave up his lectureship in physics at the Royal Institution because it interfered with his medical practice, but found time to make brilliant contributions to the wave theory of light and to physiological optics (discovery of astigmatism) and, in a totally different field, to the decipherment of Egyptian hieroglyphics.

In addition to François Rabelais, the following physicians contributed to European literature: Francesco Redi of Arezzo (1626–1698), poet, naturalist, helminthologist; and Giovanni Meli (1740–1815), the Sicilian "Anacreon." Claude Bernard (1813–1878) was a dramatic poet before embarking on a brilliant career in physiology and experimental medicine. The Viennese, Arthur Schnitzler (1862–1931), practiced medicine all his life, even after he became famous as a novelist and playwright (*Anatol, Reigen, Professor Bernhardi*). In recent times, Elie Faure (1873–1937) was an art critic, historian, and physician; Charles Vildrac (b. 1882), a novelist and surgeon; and Georges Duhamel (1884–1966), being both a writer and physician, was elected to the French Academy and the Academy of Medicine.

Among the famous humanists of the Renaissance were Hieronymus Mercurialis and Thomas Linacre (1460–1524), physician to Henry VIII, teacher of Erasmus, and founder of the Royal College of Physicians. Hartmann Schedel (1440–1514), town physician of Nuremberg, wrote the famous world history known as the *Nuremberg Chronicle*, 1493. The German physician, Engelbrecht Kämpfer (1651–1716), wrote an important *History of Japan*.

Moses Maimonides of Cordova (1135–1204), Jewish philosopher and court physician to Saladin, liberalized Jewish culture, hitherto restricted to a study of the Talmud, by introducing science and philosophy also. His book, *A Guide for the Perplexed*, is read with interest even today. Michael Servetus (1511–1553), theologian and anti-Arabic physician, was burned at the stake in Geneva for heretical opinions concerning the Trinity. In his writings he anticipated to a certain extent Harvey's discovery of the circulation of the blood. John Locke (1632–1704), in addition to being the personal physician of the Earl of Shaftesbury, was a philosopher of renown. In his *Essay Concerning Human Understanding* (1690) and in other writings he laid the foundation of a philosophy and psychology of "sensation."

Physicians have made numerous contributions to physics and electricity. William Gilbert (1540–1603), who was physician to Queen Elizabeth, wrote a treatise on magnetism in which he coined the word "electricity." Another doctor, Luigi Galvani (1738–1798), while professor of anatomy at Bologna, made a contribution to electrical science: his experiments with contractions produced in the muscles of a frog in contact with metals were the first steps in the discovery of galvanic or voltaic

electricity. Pieter van Musschenbroek of Leyden (1692–1761) and Louis le Monnier (1717–1799), physician to Louis XVI, are identified with the development of the Leyden jar for the storage of static electricity. Peter Mark Roget gave the correct theoretical explanation of contact electricity. William Hyde Wollaston (1766–1828) made numerous contributions to electrolysis and optics; and William Watson (1715–1787), physician, apothecary, and curator at the British Museum, published over fifty papers on electricity, botany, and medicine in the *Philosophical Transactions*. Denis Papin (1647–1714), Joseph Black (1728–1799), discoverer of latent heat, and Sir Goldsworthy Gurney (1793–1875), made contributions to the technology of the steam engine. In the field of pure mathematics one might cite Daniel Bernoulli (1700–1782) of Basle, and Leonard Euler (1707–1783), called "mathematical analysis incarnate," who was on the medical faculty in St. Petersburg. Renowned in natural history are the botanist Carolus Linnaeus and H. Salviati, ichthyologist and physician to three popes. Johann von Cube, town physician of Frankfurt, wrote the *Gart der Gesundheit*, the first illustrated printed herbal, Mainz, 1485 (see Plate 72).

The first man to fly a balloon and also the first aeronautical martyr was a French physician, Jean Pilâtre de Rozier (1756–1785). The Boston physician, John Jeffries (1744–1819), was the first to fly the English Channel.

Art has always been a sympathetic avocation for the physician and surgeon. In addition to Sir Francis Seymour Haden, one could cite the dentist Adalbert Volk of Baltimore (1828–1912) for his Civil War caricatures, and William Rimmer (American, 1816–1879) for his sculpture and anatomical studies. Alexander Anderson (American, 1775–1870) began as a doctor but gave up medicine for wood-engraving. Among the medical men who had facility with a pencil or who illustrated their own work may be mentioned Albinus, Bell, Bright, Camper, Cheselden, Cushing, Estienne, His, Haller, Hodgkins, Leidy, Lister, Scarpa, Vesalius, and Willis.

The interest in music and performing skill of the following doctors have been on a sufficiently professional basis to warrant mention in their biographies: the Swiss anatomist and earliest supporter of Vesalius, Felix Platter (1536–1614); the great Dutch teacher, Hermann Boerhaave (1668–1735); Leopold Auenbrugger (1722–1809), pioneer of percussion in diagnosis; William Withering (1741–1799); William Jenner (1749–1823), of vaccination fame; and Theodor Bilroth (1829–1894), pioneer of visceral surgery, composer and lifelong friend of Brahms. Hermann von Helmholtz (1821–1894), in addition to having been a military surgeon at Potsdam, was noted for his discoveries in thermodynamics, optics (color perception, ophthalmoscope), acoustics and musical harmony. Alexander Borodin (1834–1887) was both professor at the Medico-surgical Institute of St. Petersburg and composer of the opera *Prince Igor*, three symphonies and other works. Recently there was the example of Albert Schweitzer (1875–1965), who was not only a medical missionary in Africa, but also a celebrated organist and authority on Johann Sebastian Bach. Mention of medical missionaries recalls the role played by David Livingston (1813–1872) in Africa, and Sir Wilfred Grenfell (1865–1940) in Labrador. One may also cite several doctors who played a part in public affairs. The Scotch Quaker, Dr. John Fothergill (1712–1780), negotiated with Benjamin Franklin for the welfare of the American Colonies. Jean Paul Marat (1744–1793) was a successful physician and author of works on optics and electricity before he became a leader in the French Revolution. Our American president, William Henry Harrison (1773–1841), studied medicine under the advice of Dr. Benjamin Rush, who himself was much in the public eye as a patriot and signer of the Declaration of Independence, abolitionist and temperance reformer. Marcelin Berthelot (1827–1907) was a distinguished chemist, statesman, and member of the Academy of Medicine. Sun Yat Sen (1866–1925), founder of the Chinese Republic, was a Western-trained physician and surgeon. Elizabeth, Queen of the Belgians, as the enlightened daughter of a Bavarian duke, had regular medical training and organized the Belgian nursing service during World War I, thus following in the noble tradition of Florence Nightingale. In quite a different tradition, a French physician, J. I. Guillotin (1738–1814), invented a machine, named after him.

To conclude the roster of arts and sciences, one

might enumerate several very famous men who received early medical training, but who made their mark in other fields. Aristotle very probably studied medicine, since he belonged to the Asklepiad clan, with whom the study and practice of medicine were hereditary. Dante was influenced by Pietro d'Abano and may well have attended his lectures. The Polish astronomer Copernicus (1473–1543) was a fellow pupil of Fracastoro at Padua. Others who gave up medicine for science or art were the physicist and astronomer Galileo (1564–1642), the German poet Schiller (1759–1805), the French critic Sainte-Beuve (1804–1869), the naturalist Charles Darwin (1809–1882), the Norwegian playwright Ibsen (1828–1906), and the Russian writer Chekhov (1860–1904). Among the legendary medical figures are Im Hotep, the Egyptian physician, who eventually became the god of healing, and the Centaur, Chiron, who instructed many Greek heroes in music and medicine, and, according to some accounts, even taught Asklepios himself.

22 FRANÇOIS RABELAIS (BALTAZAR MONCORNET). Engraving by Baltazar Moncornet (French, 1600–1668), Paris, early seventeenth century. Rabelais (1490–1553) is known the whole world over as the lusty chronicler of the exploits of Gargantua and Pantagruel. That he was a physician is not so widely known; yet he practiced medicine for most of his life. For many years he was on the faculty of the great medical school of Montpellier.

23 SIR THOMAS BROWNE (ROBERT WHITE). Engraving by Robert White (English, 1645–1703), frontispiece to the *Collected Works of Sir Thomas Browne*, London, 1686. Sir Thomas Browne (1605–1682) is remembered today more as a learned and philosophic writer than as a physician. Such writings as *Religio Medici* (the Religion of a Physician), *Pseudodoxia Epidemica* (Inquiries into Vulgar Errors), and *Hydriotaphia* (Urn-burial) are distinguished not only by grave and lofty sentiment but also by a sonorous and stately prose style, strongly colored by Latin diction.

24 CAROLUS LINNAEUS (ROBERT DUNKARTON). Mezzotint by Robert Dunkarton (English, 1744–ca. 1817) after Hoffman, from Thornton's *Temple of Flora*, London, 1805. The Swedish botanist and systematizer of natural science, Karl von Linné, better known in the Latinized form of Carolus Linnaeus (1707–1778), was a practicing physician and also professor of medicine at the University of Upsala. He is shown in the costume of Lapland, the scene of some of his most celebrated researches.

25 SIR FRANCIS SEYMOUR HADEN (SELF-PORTRAIT). Original etching, self-portrait by Sir Francis Seymour Haden (English, 1818–1910), made at London in 1862. Haden, a distinguished surgeon of the Victorian era, achieved international renown as an etcher and landscape artist. He was founder and president of the Royal Society of Painter-Etchers and Engravers. In a lecture he summed up eloquently the benefits of art training for the medical profession: "How much sooner would the eye—accustomed to observe and estimate closely the differences of color, aspect, weight, and symmetry—learn to gauge their aberrations as the signs which make up the *facies* of the disease; how much better the hand, trained to portray them accurately, be able to direct with precision and safety the course of the knife!"

26 ALBERT SCHWEITZER (ARTHUR WILLIAM HEINTZELMAN). Etching by Arthur William Heintzelman (American, 1890–1965). This etching was done from life and sold for the benefit of Dr. Schweitzer's medical mission in Africa. Albert Schweitzer, born in Alsace in 1875, was a man of many talents and prodigious industry. As a student he majored in philosophy and theology, at the same time perfecting himself as a professional musician and organist. During an active life as a teacher and minister of the gospel, he wrote numerous books on theology and philosophy and definitive works on Bach and on his organ music, as well as giving many concerts as an organ virtuoso. At the age of thirty he resigned his post as principal of the Theological College of St. Thomas in Strassburg

to become a student of medicine. In 1913, after the completion of his medical studies, he went to Lambaréné in French Equatorial Africa as a medical missionary to take charge of a hospital. He was in Lambaréné off and on until his death there in 1965.

V / Pharmacy

Readers of Shakespeare's *Romeo and Juliet* will remember Friar Lawrence's monologue in the second act:

O, mickle is the powerful grace that lies
In herbs, plants, stones, and their true qualities:
For naught so vile that on the earth doth live,
But to the earth some special good doth give;
Nor aught so good, but, strain'd from that fair use,
Revolts from true birth, stumbling on abuse:
Virtue itself turns vice, being misapplied,
And vice sometime's by action dignified.
Within the infant rind of this small flower
Poison hath residence, and medicine power.

From the earliest times mankind has been aware of the properties—whether palliative or baneful—of plants and minerals, and gradually this therapeutic lore was codified in manuscript herbals and materia medica. At first the medicine man concocted his own simples, but in due course a division of function ensued whereby the physician prescribed and the pharmacist prepared the healing drugs. This is the partnership of Cosmas and Damian.

27 PHARMACY, WITH DOCTOR SELECTING DRUGS (GERMAN SCHOOL, XVI CENTURY). From this woodcut out of H. Brunschwig's *Buch der Chirurgia*, Strassburg, 1500, we get some idea of the interior of drug stores around 1500; and we also gather that the doctor often did not write out a prescription but went in person to select the ingredients.

28 PREPARATION OF THERIAC (GERMAN SCHOOL, XVI CENTURY). A woodcut from H. Brunschwig's *Das Neuwe Distillier Buch*, Strassburg,

1531. In the late Middle Ages, when polypharmacy had reached absurd heights, there was a medicament much in vogue called Theriac. The prescription for this by the Emperor Nero's physician, Andromachus, as recorded by Galen, consisted of fifty-seven ingredients, including the flesh of vipers. The composition, however, varied according to the time and place, the Theriac of Venice being especially famous. The preparation, which was very complicated and required about two months of skilled manipulation, was done under the public supervision of accredited doctors and pharmacists. In the woodcut, the standards with the Lion of St. Mark's indicate the Venetian place of origin.

29 THE APOTHECARY (BY JOST AMMAN). This woodcut by Jost Amman (Swiss-German, 1539–1591), from Hans Sachs' *Beschreibung aller Stände*, Frankfurt, 1574, shows a typical interior and likewise illustrates the economic status of pharmacy toward the end of the sixteenth century. From the twelfth century up to the Renaissance, Arabic medicine, as well as its very complex pharmacopoeia, had been in the ascendent. As the original Greek texts were rediscovered and studied, Hippocratic concepts of simple diet and the regime of nature began to play a greater part in therapeutics. The decline of polypharmacy caused the druggist's business to shrink, and he tended to supplement it by dealing also in sugar, confections, and spices, which were often called "colonial wares." And so we see on the shelf, beside the jars and drugs, the characteristic conical shapes of sugar "hats," the form in which sugar was sold in Europe almost to the end of the nineteenth century. The verse by Hans Sachs, of Meistersinger fame, may be translated as follows: "I have in my drug store many pleasant-tasting drugs and also confections made of sugar and spice; also I prepare purges and enemas, and can compound various cordials to strengthen the infirmities of the sick—all this by the doctor's advice on the basis of water casting."

30 PREPARATION OF MEDICINAL OILS (ENGLISH SCHOOL, XVI CENTURY). A woodcut from the *Newe Iewell of Health*, translated by George Baker from the Latin of Conrad Gesner, London, 1576. The Swiss physician, Gesner, like Brunschwig, emphasized the superiority of distillation over simple decoction for materia medica. Distilling and decanting apparatus are shown in the picture. The translator, George Baker, thus summarizes in Elizabethan English the contents of the text: "In which are the best approved remedies for the diseases, as well inwarde as outwarde, of all the partes of man's bodie: treating very amplye of all Dystillations of Waters, of Oyles, Balmes, Quintessences, with the extraction of artificiall Saltes, the use and preparation of Antimonie and potable Gold."

31 A SEVENTEENTH-CENTURY APOTHECARY SHOP (GERMAN SCHOOL). Etching from a book of regulations for pharmacies, Frankfurt, 1668, showing the elegance of the seventeenth-century drug store.

32 RIDE TO RUMFORD (THOMAS ROWLANDSON). The colored etching after Thomas Rowlandson (English, 1756–1827), London, 1802, furnishes a touch of broad humor, characteristic of the artist's lusty and rollicking style. We see the shop interior of a country apothecary with veterinary practice, around the beginning of the nineteenth century. The stout agonized lady, whose horse looks through the door, raises her riding habit to expose a blistered posterior, on which the kneeling apothecary is about to place a plaster. Note the jar with the label "Diaculam," a corruption of Diachylon, "lead plaster," a mixture of litharge with olive oil and lard.

33 APOTHECARY AND PHARMACIST (HONORÉ DAUMIER). In this lithograph the great French artist, Honoré Daumier (1808–1879), depicts a typical Parisian pharmacy of 1837. Yet the interior, for all its realistic details, is merely the setting for the drama of roguery centered in the two personages. The print, which appeared in 1837 in the satiric periodical, *Charivari*, is one of a series called *Caricaturana*, castigating the quacks and humbugs and charlatans, the get-rich-quick schemes of the day. A single character, Robert Macaire, who personifies all this *blague* and chicanery, gives a common pattern to situations taken from all branches of enterprise, medicine, law, architecture, banking, finance, and the like. In this picture, Robert Macaire, as he talks with his humbler colleague, Boniface, exploits the possibilities of nostrums or patent medicines: "My dear Boniface, it once used to take an apothecary forty years to gain an income of two thousand francs. You were plodding; we fly!"—"But how do you do it?"—"We take some tallow, brick dust, or starch; we call this paste Onicophane, Racahout, Nafé, Osmaniglou, or some other name more or less gibberish; we make advertisements, we issue circulars and prospectuses; and in ten years we realize a million. One must attack fortune headlong; you were taking her from the adverse side."

VI / The Practice of Medicine

This panel presents a brief synopsis of the practice of medicine over the centuries. Among the activities may be mentioned diagnosis and prescription, the dispensing of medicaments, phlebotomy, and consultation with colleagues.

34 PHYSICIAN MINISTERING TO A PATIENT (BY HANS WEIDITZ). This woodcut designed by Hans Weiditz (German, active 1520–1536) appeared in Cicero's *De Officiis*, Augsburg, 1531. It is a good illustration of sixteenth-century medical practice. Besides phlebotomy, the physician prescribed medicaments, which he administered himself from a cordial-beaker. In the section on Pharmacy one can see the doctor personally selecting the ingredients, since prescriptions were seldom written out owing to the scarcity and expense of paper. The cordial-beaker of pewter or silver, which can also be seen in the

portrait of Cosmas and Damian, was usually furnished by the apothecary, and afterwards returned to him. The picture also symbolizes the withdrawal from life of the sick patient, in contrast with the many forms of activity visible outside the window—building, hunting, husbandry, mining, and the like.

35 PHYSICIAN PRESCRIBING VENESECTION (HANS WEIDITZ). Woodcut designed by Hans Weiditz (German, active 1520–1536) in Avila, *Ein nutzlich Regiment der Gesundtheyt*, Augsburg, 1521. Originally physicians did not bleed patients personally, but had an assistant do so, as in this picture. In the seventeenth century, as we see in Bosse's engraving (Plate 36), the physician himself performed venesection. The illustration accompanies the chapter on the treatment of abscesses (apostema).

36 PHLEBOTOMY (ABRAHAM BOSSE). An etching by Abraham Bosse (French, 1602–1676), Paris, 1635, which illustrates one of the commonest therapeutic measures in the repertory of the doctor of old: *Phlebotomy*. Bloodletting was also often practiced by barbers and village surgeons; in fact the conventional red and white barber's pole refers directly to this aspect of their profession. "Particular kinds of bloodletting in use are three," in Robert Burton's quaint enumeration: by venesection, by cupping, and by leeches. In this picture we see venesection performed in the grand manner.

In the hortatory poem below, the lady speaks as follows: "Courage, Sir, you have begun, and I'll be brave; tighten the bandage, puncture with confidence, make a good opening. Ah, that gush of blood surprises you! How phlebotomy purifies the spirits and cleanses the blood of great putrefaction! Oh gods, the gentle hand, the agreeable puncture! The recollection makes me smile once more. Only a little blood drawn makes me feel much better. Above all remedies I value bloodletting. I sense my vigor return anew. But if you should consider it necessary, then operate again. I

have enough spirit. I shall endure as much as you may wish to do."

Abraham Bosse gives a marvelously detailed picture of comfortable French life during the Regency and early part of the reign of Louis XIV. He was typically the artist of the upper middle class, and he has depicted their manners and customs with peculiar fidelity, sobriety, and vividness.

37 PHYSICIAN ATTENDING A YOUNG WOMAN (JAN STEEN). An engraving by J. J. Avril after the painting by Jan Steen (Dutch, ca. 1626–1679). The two pictures by Bosse and Steen portray the elegant and fashionable physician in action. One could hardly find anywhere a better illustration of an impressive bedside manner than in Jan Steen's painting in the Royal Painting Gallery at The Hague.

38 CONSULTATION (LOUIS BOILLY). Colored lithograph by Louis Boilly (French, 1761–1845), Paris, 1823. The artist was well known for his groups of heads, or genre portrayals of people in all ranks and conditions. It is interesting to contrast this with the older woodcut of the same subject. This one is not actually a consultation scene, but a study of expressive gestures or a group of types under a convenient title.

39 (*Frontispiece.*) "OH, DOCTOR, I'M SURE I'M CONSUMPTIVE" (HONORÉ DAUMIER). A lithograph by Honoré Daumier (French, 1808–1879) from the series, *All One Could Wish For* (Tout ce qu'on voudra), Paris, 1847. Daumier was the great chronicler of the middle class, and he introduces us here not to the elegance of fashionable society but to the more or less humdrum life of the bourgeois practitioner. In the lithograph, we see him on one of the red-letter days of his life, when he visits a corpulent hypochondriac, who tells him, "Oh, doctor, I'm sure I'm consumptive." There is a touch of satire in the picture, but of a humane and understanding kind, as always with Daumier.

40 THE COUNTRY DOCTOR (HONORÉ DAUMIER). A wood-engraving after Honoré Daumier

(French, 1808–1879) from Fabre's *Némésis Médicale*, Paris, 1840. The artist here pays tribute to the quiet devotion, the unrewarded and often even unchronicled self-sacrifice of the country doctor.

VII / The Practice of Surgery

There are cogent reasons why surgery, of all the major branches of the Healing Arts, should be one of the last to attain complete development. The chief reason, of course, is that anesthesia and asepsis were not perfected until the nineteenth century. Without these two aids, surgery was more or less limited to amputation, bone setting, wounds, and the external field in general; but with them there seems to be no organ, however hidden or vital, that is beyond the reach of the surgeon's scalpel. The final expansion of surgery occurred at a time when the graphic artist was more concerned with art for art's sake than with factual reportage. And thus it happens that there are relatively few artistic records of modern operations outside of photography. Our illustrations, therefore, are taken from what may be called the primitive phase of surgery.

41 AMPUTATION (JOHANNES WECHTLIN). Colored woodcut by Johannes Wechtlin (German, ca. 1490–1530) from Hans von Gersdorff's *Feldtbuch der Wundartzney*, Strassburg, 1540. According to Garrison's analysis of the surgical practice in this picture, the operator "esmarched" the limb by means of a constricting band and, discarding cautery, checked hemorrhage by a styptic of his own devising (containing lime, vitriol, alum, aloes, and nutgalls), and finally enclosed the stump in the bladder of an ox or hog—which may in some cases have been a good Listerian protective. Note that the figure in the background exhibits such a stump. The patient appears to be unconscious. Some primitive forms of anesthesia were known and administered: intoxicant wines; tinctures of mandragora in wine (described by Dioscorides); sponges soaked with narcotics such as opium, jusquiamus, or mandragora;

and derivatives of hemp (bhang and hashish, used in the Orient).

42 CAUTERY (JOHANNES WECHTLIN). Colored woodcut by Johannes Wechtlin (German, ca. 1490–1530) from Hans von Gersdorff's *Feldtbuch der Wundartzney*, Strassburg, 1540. Following Arabic precedent, cautery, rather than surgery, was practiced extensively during the late Middle Ages in extirpation; and later was used as a hemostatic and haphazard antiseptic, particularly in the form of boiling oil on gunshot wounds, which were believed to be poisonous. It so happened that in many cases the cure was worse than the disease; and it is Ambroise Paré's great achievement to have been the first to recommend simple dressings instead of cauterizing oil. He recounts (in the quaint English translation of 1617) his experience in treating the wounded as a French military surgeon in the Italian campaign of 1536: "It chanced on a time, that by reason of the multitude that were hurt, I wanted (i.e. lacked) this Oyle. Now because there were some few left to be dressed, I was forced, that I might seem to want nothing, and that I might not leave them undrest, to apply a digestive made of a yolke of an egg, oyle of Roses, and Turpentine. I could not sleep all that night, for I was troubled in the minde, and the dressing of the precedent day (which I judged unfit) troubled my thoughts; and I feared that the next day I should find them dead, or at the point of death by the poyson of the wound, whom I had not dressed with the scalding oyle. Therefore I rose early in the morning, I visited my patients, and beyond expectation, I found such as I had dressed with digestive onely, free from vehemencie of paine, to have had a good rest, and that their wounds were not inflamed, nor tumified; but on the contrary, those that were burnt with the scalding oyle were feverish, tormented with much paine, and the parts about their wounds were swolne. When I had many times tryed this in divers others, I thought this much, that neither I or any other should ever cauterize anyone wounded with Gun-shot."

43 EXTENSION APPARATUS FOR FRACTURED ARM (JOHANNES WECHTLIN). Colored woodcut by Johannes Wechtlin (German, ca. 1490–1530) from Hans von Gersdorff's *Feldtbuch der Wundartzney*, Strassburg, 1540. It represents a mechanical aid to surgery surprisingly modern in principle. The accompanying doggerel evidently refers to a nickname attached to the contraption: "I am usually called the Fool, though always politely, since he who needs me does not laugh at me."

44 THE DEATH OF HENRI II (JACQUES PERRISSIN). Woodcut by Jacques Perrissin (French, fl. 1559–1570), ca. 1560. It is a woodcut copy of an illustration (the fourth plate) in Perrissin's and Tortorel's *Histoires des Guerres*, possibly used as a separate broadside. The scene is in the chamber of the dying King Henri II of France, who in July 1559 was accidentally but mortally wounded by a lance thrust through the eye in a joust with the Duke of Montgomery. Ambroise Paré, the chief surgeon to the King, was in attendance. The King lingered for ten days before succumbing to his injuries. Meanwhile, Philip II of Spain sent his own physician, Andreas Vesalius, posthaste for consultation. The picture thus dramatizes the meeting of the two greatest medical men of the sixteenth century. The *dramatis personae* are enumerated below the margin: (A) The Queen crying; (B) the Cardinal of Lorraine; (C) the Commander-in-Chief of the Army; (D) (through the window) couriers and physicians and surgeons, very expert, sent from Flanders by the King of Spain; (E) palace guard of the King; (F) physicians and surgeons. Tradition has it that Ambroise Paré is standing at the table (F), and that the man to his right is Andreas Vesalius. The man standing at the foot of the bed is probably the Protomedicus, or Chief Physician, Jean Chapelain.

45 VILLAGE SURGEON (BY CORNELIS DUSART). An original etching by Cornelis Dusart (Dutch, 1660–1704), Haarlem, 1695. Far away from the luxury of the court and the big cities, life went on in rustic and homely ways, where the village surgeon generally served as barber, dentist, surgeon, physician, and pharmacist. In Dusart's etching of 1695, we see him performing a minor operation on a squirming peasant. We also see, suspended in the background, a stuffed animal, probably an armadillo; such exotic animals often were among the stock in trade and the emblems of the apothecary.

46 "LET'S SEE, OPEN YOUR MOUTH" (HONORÉ DAUMIER). The lithograph by Honoré Daumier (French, 1808–1879) is from the series, *The Difficult Moments of Life*, Paris, 1864. The extraction of teeth used to be performed by the barber-surgeons and wandering practitioners or charlatans (see L. van Leyden's engraving, Plate 96), but, later, dentistry became a specialized branch of surgery. The subject of this picture, somehow timeless and universal, speaks for itself.

VIII / Hospitals in Peace and War

The original meaning of hospital (derived from medieval Latin) was a place of rest and entertainment in our modern sense of hospice, hostel, hotel; and then was extended to cover charitable institutions for the care of the aged and infirm. These connotations are now obsolete; and the word today is used only to denote the place where the sick are given treatment. The temples of Asklepios and the "Valetudinaria" of the Romans were not, strictly speaking, hospitals, but more in the nature of nursing homes. The first real hospitals were probably established in the Arab world in the ninth century, and in the Western world several hundred years later. At first they were under ecclesiastical administration, but during the fourteenth century lay institutions began to be established. Today public and private hospitals far outnumber those directed by the Church as such.

War, with its abundant casualties, has always been a pragmatic training field for the physician and especially the surgeon. Likewise, the drama of martial conflict, the emotional tensions of suffering

and sudden death have provided engrossing themes for the artist.

47 HOSPITAL INTERIOR (FRENCH SCHOOL, CA. 1500). Woodcut from Saint-Gelais, *Le Vergier d'Honneur*, Paris, Jehan Petit, ca. 1500. One of the rarest and loveliest of medical prints. It was designed by an artist who furnished many of the illustrations to the *Livres d'Heures* or devotional Books of Hours which appeared in Paris around 1500. The iconography of the Paris presses of the period is exceedingly complicated, as readers of Claudin's monumental work well know: the printers copied and borrowed much from one another, and it is therefore not possible to establish the identity of the pictorial designers. As a group, these *Livres d'Heures* are rated among the most beautiful illustrated books of the world, and represent the quintessence of the Gothic spirit in France. In this picture the artist (and most unusually) has portrayed a secular subject with the same directness, simplicity, and tenderness that were manifest in the dramatizations of sacred legend. The scene, in all likelihood, is not a literal delineation of a hospital interior, but rather—as an accompaniment to the poem *La Complainte et Epitaphe de feu Roy Charles*— a recapitulation of the vicissitudes of man. We see various types, the sick man attended by a physician, the man receiving spiritual consolation, the corpse being prepared for burial, and the well man, about to leave, receiving a word of advice from a physician in the background. Numerous incidental and revealing details are portrayed; and we are grateful for a documentation which, even if not intentional, does give us an insight into the daily life of the time. Early pictures of hospitals are rare.

48 INFIRMARY OF THE CHARITY HOSPITAL, PARIS (ABRAHAM BOSSE). This etching by Abraham Bosse (French, 1602–1676), Paris, ca. 1635, depicts an ecclesiastical foundation which still carries over some of the earlier meaning of the word "hospital." The interior of about 1635 seems curiously different from that of a modern hospital. The appended verses and dedication to Françoise Robin celebrate the virtues of good works and the benefactions of a generous donor.

49 PENNSYLVANIA HOSPITAL IN PINE STREET, PHILADELPHIA (WILLIAM BIRCH). This colored etching by William Birch (American, 1755–1834) is from the artist's famous series of Philadelphia views around 1800. The Pennsylvania Hospital, founded in 1751 by Benjamin Franklin, Thomas Bond, and others, is generally considered to be the oldest independent hospital in the American Colonies, although the Philadelphia General Hospital has had a continuous existence, beginning as the Infirmary of the Almshouse, since 1731. The picture shows the exterior of the building very much as it is today. Note the sick man being carried in a chair.

50 MIDDLESEX HOSPITAL, LONDON (ROWLANDSON AND PUGIN). Colored etching by Thomas Rowlandson (English, 1756–1827) and Augustus Pugin (English, 1762–1832), with aquatint by Stadler, from *The Microcosm of London*, London, 1808. This work is one of the most comprehensive pictorial surveys of a big city ever made, and a most interesting example of the collaboration of two well-known artists. Pugin drew the architecture and setting, and Rowlandson supplied the figures and animation. Middlesex Hospital was founded for the care of the sick and lame, and, as it was said, for the relief of pregnant wives of the industrious poor, being the first lying-in hospital in London. Later the obstetrical services were organized on an out-patient basis in people's homes, and the vacated wards on the second floor devoted to patients suffering from cancer.

51 EXTRACTION OF AN ARROWHEAD (JOHANNES WECHTLIN). The colored woodcut by Johannes Wechtlin (German, ca. 1490–1530) is taken from Hans von Gersdorff's *Feldtbuch der Wundartzney*, Strassburg, 1540, a popular field manual of surgery which ran through several editions, the first having been issued in

1517. It is a schematic representation (certainly not realistic, in view of the absence of blood flow) of the instrument and technique of extraction for arrowheads. Joined to the picture is a quatrain so personal and subjective in mood that it would seem strangely out of place in a modern surgical handbook. The wounded soldier speaks: "Is this our thanks and our reward? Then let the Devil take war! Let another go through with it; I've had enough! They have put the check and checkmate on me!"

52 A Military Hospital (Francisco Goya). This etching by Francisco Goya (Spanish, 1746–1828) is one of a series of eighty plates entitled *Disasters of War* made by the artist during the years 1810–1820. They represent scenes from the Napoleonic invasions and subsequent famine and disaster in Spain. Never has there been a more harrowing panorama of war and its appalling savagery and bestiality. Sometimes delicate and subtle, sometimes smashingly brutal in draughtsmanship, these coppers, in spite of their moderate size and apparent casualness, carry a monumental emotional impact. They have the immediacy of an eyewitness reaction set down at white heat. Under each, Goya set down some laconic comment, in this case "Those Also" (Tambien estos). The picture shows some nondescript cave or warehouse temporarily turned into a hospital. The wounded are sprawled here and there; one in front is examining his own wound. In the center a surgeon is probing for a bullet in a wounded soldier's left thigh, close to the tourniquet. In the absence of anesthesia, the patient is being held by several comrades. The whole series was considered so shocking and horrible that Goya never published it during his lifetime. The first edition, from which this print was taken, appeared in 1863. Subsequent editions, inferior in quality, have been issued by the Calcografía Nacional at Madrid.

53 Surgeon at Work during an Engagement (Winslow Homer). A wood-engraving after Winslow Homer (American, 1836–1910), published in *Harper's Weekly*, New York, 1862. During the Civil War it was customary for staff artists and war correspondents to send their drawings up north, where they were engraved on wood for publication. One of the artists attached to *Harper's Weekly* was Winslow Homer, who was later to achieve renown as one of America's leading painters. His picture shows the organization and practice of the Army Medical Corps to have been substantially the same as it is in modern warfare.

IX / Hygiene and Preventive Medicine

In Greek mythology Hygeia was the daughter of Asklepios and was venerated as the goddess of health. She thus has given her name to that daily obligation, personal hygiene, and likewise inspired all measures for the maintenance of public health, such as preventive medicine or public hygiene. Cleanliness in general, bathing, exercise, and massage are common forms of personal hygiene. In the field of sanitation and preventive medicine one might cite such topics as purity in food and water supply, disposal of sewage and garbage, destruction of vermin and other disease carriers, quarantines in contagious diseases, and immunizations through vaccines and antitoxins. Some of these measures are pictured or suggested in this section.

54 Men's Bath (Albrecht Dürer). Woodcut designed by Albrecht Dürer (German, 1471–1528), Nuremberg, 1496. This is one of the first large woodcuts which Dürer designed after his return from Italy in 1495. It is curious that it shows so little influence of the classic style. It is very Gothic in feeling, full of delightful personal details, and therefore a perfect foil to the generalized classical tone of the Italian rendering of a similar subject. The figures have definite personality and are supposed to be actual portraits of Dürer's friends. Edgar Wind has seen in this print one more example of Dürer's preoccupation with the Four

Temperaments. The man at the pump is supposed to typify the melancholic humor and has long been regarded as a portrait of Dürer himself. The two people in the foreground are conjectured to be portraits of the Paumgärtner brothers, representing the sanguine temperament (man with flower) and the choleric (man with scraper). The exemplification of phlegmatic humor, the man with the stein of beer, is regarded as a caricature of Wilibald Pirckheimer, the celebrated humanist of Nuremberg.

During the Middle Ages, when there were little if any bathing facilities in houses, public baths were popular. They were often the scene of social gatherings, gay parties with accompaniment of music, food, and drink. Public baths were a measure of personal and public hygiene inherited from classical antiquity, even though at times they did become a source of infection for disease or a provocation toward moral laxity. The impression of the woodcut is of exceptional beauty and brilliance.

55 MEN'S BATH (ITALIAN SCHOOL, XVI CENTURY). Woodcut from the book *De Arte Gymnastica* by Hieronymus Mercurialis, Venice, 1573. The woodcuts have been attributed to Cristoforo Coriolano but without adequate foundation. The illustration follows the classical tradition of the Roman bath or fountain, vestiges of which were of course to be seen all over Italy. The book itself is famous as the first illustrated edition of the fundamental work on gymnastics based upon classical authors; it treats of the therapeutic value of baths, exercise and sports (boxing, wrestling, ball playing, etc.). Mercurialis (1530–1606) was a celebrated humanist and Greek scholar, translator of Hippocrates, as well as a distinguished physician attached to the Papal court in Rome.

56 BUSINESS MEN'S CLASS (GEORGE BELLOWS). Lithograph by George Bellows (American, 1882–1925), New York, 1916. An amusing caricature of gymnastics in modern life.

57 THE RAT CATCHER (CORNELIS VISSCHER). Engraving by Cornelis Visscher (Dutch, 1629–1658), 1655. The Latin quotation may be translated as follows: "You chase away mice (and rats) with a cat! If you do away with petty thieves by means of big thieves, you are crazy. Call upon me and, provided that there is a little money in the transaction, I will chase away both mice and cats." In olden days rats and mice were treated as thieving nuisances and not as potential carriers of disease. The artist, in his short life, attained a reputation as the most brilliant technician of the Dutch graphic school, and his engraving of the "Rat Catcher," after his own design, is still considered one of the great masterpieces of engraving.

58 THE CIRCUMCISION (CRISPIN DE PASSE). Engraving by Crispin de Passe the Elder (Dutch, ca. 1565–1637), 1599. Circumcision is ordained as a prescribed rite in the Jewish and Mohammedan religions, and likewise figures in the initiation ceremonies at puberty among numerous primitive tribes all over the world. Many physicians also recommend the practice as a hygienic measure, particularly in hot countries.

59 VACCINATION (LEOPOLDO MÉNDEZ). Wood-engraving by Leopoldo Méndez (Mexican, b. 1893), Mexico, 1935. Ever since its successful demonstration by Jenner, the theory of vaccination has remained incontrovertible as a tool in immunization. The latest triumph in preventive medicine has been Dr. Salk's vaccine against polio.

60 THAMES WATER (WILLIAM HEATH). Colored etching by William Heath (English, 1795–1840), ca. 1828. A satire on the contamination of water supply, which no doubt would be applicable to many other places at various times. A London commission, appointed in 1827, reported in 1828, but suggested no remedy for the deplorable contamination. The complaint, among other things, stated that the water taken from the Thames at Chelsea was "charged with

the contents of the great common-sewers, the drainings of the dunghills and laystalls, the refuse of hospitals, slaughterhouses, and manufactures."

X / Medical Teaching

The first organized medical school in Europe was located at Salerno in southern Italy. It began obscurely in the ninth century, reached the zenith of its influence in the tenth and eleventh centuries. In the thirteenth century it was superseded by the prestige of the medical faculties at the universities of Montpellier, Paris, Bologna, and Padua. An example from the *Fasciculus Medicinae* gives a picture of university instruction at Padua during the late fifteenth century. Medical instruction at that time was predominantly scholastic and theoretical, stressing the authority of the past. In time, however, the importance of clinical experience was recognized, and, beginning in the eighteenth century, instruction was organized around hospitals, either existing or founded for the purpose.

61 PETRUS DE MONTAGNANA IN THE LECTURE CHAIR (GENTILE BELLINI). Woodcut attributed to Gentile Bellini (Italian, ca. 1430–1516), from Ketham's *Fasciculus Medicinae*, Venice, 1522. The three figures seen below are patients awaiting urine examination. Above are a number of textbooks in use, which can be identified as follows: Pliny's *Natural History*; the *Thesir* of Avensoar (Spanish Arabian, 1072–1162); the *Consiliator* by Peter of Abano (1250–1315, a former professor at Padua); and the *Collected Works* of Isaac Judaeus (ca. 845–940, Egyptian Jew and physician to the Moslem rulers of Tunisia). Little is known of Petrus de Montagnana except that he was an exponent of Arabic medicine at Padua. Bartolomeo Montagnana, who compiled a *Consilia* or collection of case histories around 1470, may have been his father.

62 THE COLLEGE OF PHYSICIANS (ROWLANDSON AND PUGIN). Colored etching by Thomas Rowlandson (English, 1756–1827) and Augustus Pugin (English, 1762–1832), with aquatint by Bluck, London, 1808. From *The Microcosm of London*. The scene exemplifies the corporate and social aspect of the doctor's life. The College provided the setting for social gatherings and friendly intercourse as in a club, and the facilities for study and research as in a library. But especially, as an institution, it represented the physicians' responsibility to maintain control over admissions to the profession through the granting of licenses to practice. Thus we see in the foreground a candidate being given an oral examination. In this connection, the accompanying text to the picture cites an amusing anecdote. After a variety of other questions, the candidate was thus interrogated: "Now, sir, in a case of desperate fever, the patient wanting relief by perspiration, how would you act?" "Why, sir," answered the student, "I should give etc. etc." "Well, sir, if that did not operate, what would you do then?" "Why, sir, I should have recourse to etc. etc." "But if that did not produce the desired effect, what remedy have you left?" "Gentlemen," said the worried student with a profound bow, "if all these should fail, I would direct the patient be brought here for examination; and I should despair of success by any other means, if this failed to produce *relief by perspiration*."

63 THE GROSS CLINIC (THOMAS EAKINS). A photogravure of the painting by Thomas Eakins (American, 1844–1916) in Jefferson Medical College, Philadelphia, 1875. Of the later aspects of medical and surgical teaching based upon practical demonstration and clinical experience, the famous painting by Thomas Eakins, "The Gross Clinic," stands as an eloquent exemplification. Eakins had many associations with Jefferson Medical College and Hospital; he made dissections there and was on terms of close friendship with many of the doctors. In 1875 he painted the great canvas which is still in the possession of the College. In the following year he had a

photogravure made to give away to his friends. This photogravure has become rare, since only a small quantity was ever printed. Our print was inscribed in pencil by the artist to a friend of his, who later gave it to her own physician, Dr. Loeb of Philadelphia. The finished picture, showing the practitioners in everyday clothes, is a reminder that the whole idea of asepsis, so commonplace today, has had but a brief history in point of time.

64 WARD ROUNDS (ROBERT RIGGS). Lithograph, executed in 1945, by Robert Riggs (American, b. 1896). It illustrates the practical aspect of modern medical teaching—the resident physician making his rounds in company with the interns through the hospital wards. The setting is in the University Hospital in Philadelphia. The condition of the patient in question could be diagnosed theoretically as one of three possibilities: (1) pregnancy; (2) ovarian cyst; (3) ascites or dropsy of the peritoneum.

65 A LESSON IN ANATOMY (GAVARNI). The lithograph by Paul Gavarni (French, 1804–1866), from the series *The Students of Paris*, Paris, 1840, celebrates the gay *vie de bohème* of students in all the arts and professions during the golden age of Romanticism. It depicts a bit of medical teaching from the viewpoint of a student. The young student, as we learn from the accompanying legend, is showing off his learning, and jokingly tells his friend that the skeleton is that of Eugénie, whom they once knew. "You remember the beautiful blonde who was so fond of meringue tarts. Badinguet was so crazy about her that he paid 36 francs to have her skeleton mounted." When the student sees that the girl is still skeptical, he breaks down and says, "Stupid, can't you see it's a man? He was a drummer in the National Guard."

XI / Anatomy Demonstrations

The name indissolubly linked with anatomy demonstrations is Andreas Vesalius. But the magic of another great name has also shed its luster upon anatomical drawing—Leonardo da Vinci. Leonardo's anatomical studies are of surpassing beauty and astonishing accuracy of observation, more correct, indeed, though done some fifty years earlier, than many by Vesalius, as Osler and others have pointed out. Unfortunately they are buried in manuscripts housed at the Royal Library in Windsor, and thus are relatively inaccessible to the public at large. The theme of this section, therefore, is the contrast between Vesalian and pre-Vesalian concepts of anatomy.

66 LESSON IN DISSECTION (ITALIAN SCHOOL, XV CENTURY). The woodcut from Ketham's *Fasciculus Medicinae*, Venice, 1522, illustrating the chapter on anatomy by the medieval authority, Mundinus, portrays the traditional method of teaching anatomy. The professor lectures from a book while a barber-surgeon or demonstrator performs a superficial dissection, more in the nature of an autopsy than of a complete anatomy.

67 SKELETON (GERMAN SCHOOL, XVI CENTURY). The colored woodcut from Hans von Gersdorff's *Feldtbuch der Wundartzney*, Strassburg, 1540, first appeared in 1517 as a separate medical broadside and was later incorporated in the field manual of surgery by the publisher, Schott. It is a typical example of pre-Vesalian osteology.

68 SKELETON LEANING ON A SPADE (WORKSHOP OF TITIAN). Woodcut from Vesalius' *De Humani Corporis Fabrica*, Basle, 1543. A comparison between this skeleton from Vesalius with the comparable frontal view of the skeleton from Gersdorff will demonstrate how much truer to nature the new rendering is. Vesalius was the first to articulate skeletons, and an example of one thus strung together by him still exists in Basle. But, as Vesalius himself has said, a mounted skeleton "contributes more to display than to instruction." It is probable that the book illustrations of the skeletons and muscle men were intended as

much for painters as for doctors. Vesalius may thus be accounted the father of artistic anatomy as well as of medical anatomy. It is interesting to note that this woodcut inspired one of Baudelaire's poems, *Le Squelette Laboureur*.

69 THE NINTH PLATE OF MUSCLES (WORKSHOP OF TITIAN). Woodcut attributed to the workshop of Titian (Italian, 1477–1576) from Vesalius' *De Humani Corporis Fabrica*, Basle, 1543. This plate may perhaps be of greater interest to the artist than to the physician. In Vesalius' own words: "These plates display a total view of the scheme of muscles such as only painters and sculptors are wont to consider." Vesalius had an unusually high and sensitive regard for the fine arts. He spared no effort to make his magnum opus, the *Fabrica*, a thing of beauty in typography and illustration. The woodcuts by their noble style and inspired draughtsmanship are a monument in the history of fine art: no matter how scientific in purpose, they were always conceived as works of art. The landscape in our illustration could not possibly have had other than esthetic motivation. Jackschath in 1903 had pointed out that the landscape backgrounds formed a continuous panorama in the two series of muscle figures, the eight front views and the six back views, each showing successive strippings of musculature down to the bare skeleton (the ninth plate of the book being the first of the "six" series). Thirty years later, after considerable research, Dr. Harvey Cushing and Willy Wiegand, the Munich printer, succeeded in identifying the spot, of which the woodcuts are a faithful delineation—Abano Terme in the Euganean Hills not far to the southwest of Padua, a region made famous by Petrarch and Shelley.

The whole problem of the authorship of the Vesalius illustrations poses many fascinating questions. There were literary references to an *Anatomy of Titian* around the time that the *Fabrica* was published in 1543, and the tradition linking the designs with Titian persisted through the eighteenth century. On the other hand, Vasari (who was not always accurate) in the second edition of his *Lives of the Painters and Sculptors* in 1568 attributes the drawings to his friend, Jan Stephan von Calcar, of whom Vesalius makes mention elsewhere, but not in the *Fabrica*. The consensus of critical opinion today is that Titian probably had no direct hand in the *Fabrica* illustrations but perhaps an indirect influence by criticism and inspiration, and that more than one artist worked on the drawings, including Vesalius himself and several draughtsmen from Titian's workshop, such as perhaps Calcar and Domenico Campagnola (for landscape) and possibly others. It is known that the woodblocks actually were cut in Venice, where a flourishing school of skilled craftsmen existed, and then were sent over the Alps to be printed in Basle.

70 VESALIUS TEACHING ANATOMY (JAN STEPHAN VON CALCAR). Woodcut by Jan Stephan von Calcar (Flemish, ca. 1499–1546/50), title page of Vesalius' *De Humani Corporis Fabrica*, Basle, 1543. This title page to the first edition of Vesalius' book *On the Mechanism of the Human Body* is one of the most famous medical prints in all history. The scene showing Vesalius teaching anatomy is undoubtedly fanciful, since he did not operate out of doors amid such imposing classical architecture, but in the well-known anatomical theater of the University of Padua. The woodcut does, however, exhibit his method of instruction. It shows the bearded figure of the great anatomist—surrounded by an animated crowd of students, fellow physicians, nobles, churchmen, and the Rectors of the university and the city—performing the dissection himself on the abdominal cavity of a female cadaver, whereas the menial ostensors, who were traditionally employed for the task, are relegated—symbolically—to the floor beneath the table. Saunders and O'Malley have pointed out other symbolic touches in the details of the picture. Galen's mistaken belief in the similarity between human and animal anatomy is indicated by the dogs and chained monkey. It

was particularly this challenge to the dogmas of Galen—unquestioned for a thousand years—by Vesalius that brought the storm of criticism upon the innovator's head. The nude figure clinging to the column at the left may symbolize the importance of surface anatomy. The articulated skeleton in the middle distance recalls Vesalius' habitual use of skeletons as teaching aids, for in his lectures he constantly referred to the bones, which in his opinion formed the basis of anatomical study, but which naturally were the last to appear in the course of a dissection. Several personages in the picture, other than Vesalius, have been identified: the bearded man in the right foreground is presumed to be his assistant, Realdus Columbus, and the old man peering over the balcony to be Johannes Oporinus, professor of Greek at Basle and the publisher of the *Fabrica* in 1543. Sir William Osler has called this work on anatomy "the greatest book ever written, from which modern medicine dates." The work was based upon original research rather than on past authority—a revolutionary idea for the time—and was published in his twenty-ninth year while he was a professor at the University of Padua. The storm of controversy that broke out over this challenge to Galenist dogmas so disturbed the author that he gave up research and entered the service of the imperial court. As personal physician to the Emperor Charles V until his abdication in 1553, and thereafter to King Philip II of Spain, Vesalius was easily the foremost medical personage in Europe.

71 ANATOMY LESSON OF PIETER PAAW (JACOB DE GHEYN). Engraving by A. Stock after Jacob de Gheyn (Flemish, 1565–1629), from Paaw's *Succenturiatus Anatomicus*, Leyden, 1616. After the classic demonstration of Vesalius, almost any other anatomical print might be considered in the nature of an anticlimax. This is, however, a handsome engraving, and shows how the Vesalian tradition was carried on and spread to other countries. Holland became one of the great centers of medical teaching during the

seventeenth and eighteenth centuries. In this connection it is interesting to note that one of the most celebrated of Rembrandt's paintings is the "Anatomy Lesson of Dr. Tulp" (ca. 1632) at The Hague Museum.

XII / Charts and Diagrams

Graphic art has always been of great service to medical science in the publication and diffusion of charts and diagrams. And somehow in the days of hand production even utilitarian designs displayed some quality of beauty and individuality lacking in those made by photo-mechanical processes. Two examples from herbals are shown. This type of book—a cross, one might say, between botany and materia medica—was quite popular during the fifteenth to seventeenth centuries, often serving as a popular medical guide for those who could not afford the services of a physician. The properties of many plants and herbs were listed, and their use as medicaments (simples, tinctures, or direct applications) tabulated. Three charts relating to phlebotomy are also shown in this section, since bloodletting was a technique much employed by the physician of four hundred years ago.

72 BETONY (GERMAN SCHOOL, XV CENTURY). Colored woodcut from Johann von Cube's *Gart der Gesundheit*, Mainz, 1485. This illustration of betony or wood mint comes from one of the earliest, if not the earliest, of printed herbals. The printer was Peter Schoeffer of Mainz, who originally was an assistant of Gutenberg in the first great printing enterprise some thirty-five years previously, and thus is a link with the origins of printing by movable type in the Western World. The botanical drawings in this pioneer work are rather crude in comparison with those in Brunfels' *Kräuterbuch*, published about forty-five years later.

73 CORN POPPY (HANS WEIDITZ). Woodcut by Hans Weiditz (German, fl. 1520–1536) from Brunfels' *Kräuterbuch*, Strassburg, 1532. The designs by Weiditz are considered among the

finest of all botanical illustrations for beauty and accuracy. Incidentally it was through mention in the preface of this book that the identity of the artist as Hans Weiditz came to light. His charming and delightful woodcuts had long been admired under the name of The Master of the Petrarch Illustrations. The text by Brunfels is a curious mixture of sound pharmaceutical knowledge, of quotations from Pliny and Dioscorides, and of fantastic empirical and legendary lore. Among the therapeutic properties listed for Corn Poppy (Klapperose) may be mentioned: decoctions good for ulcers, menstrual disturbances, weak heart, sore eyes, and bad breath; when applied directly over the liver and covered with a rag, it will stop a nose bleed.

74 THE ZODIAC MAN (ITALIAN SCHOOL, XV CENTURY). This woodcut from Ketham's *Fasciculus Medicinae*, Venice, 1493, is the oldest printed bloodletting chart. As the "Zodiac Man," it shows the astrological signs for bloodletting, or the correspondences between the parts of the body and the Zodiacal regions, which were supposed to have a direct bearing on the method and time of treatment. The Zodiacal signs also could be related to the humoral pathology of Galen, namely the four dominant humors which affected the well-being of the body, according to the following tabulation: Aries, Leo, Sagittarius: warm-dry: yellow bile: choleric temperament. Gemini, Libra, Aquarius: warm-wet: blood: sanguine temperament. Taurus, Virgo, Capricorn: cold-dry: black bile: melancholy temperament. Cancer, Scorpio, Pisces: cold-wet: phlegm: phlegmatic temperament.

75 BLOODLETTING CHART (JOHANNES WECHTLIN). This colored woodcut by Johannes Wechtlin (German, ca. 1490–1530) illustrates Guy de Chauliac's treatise on surgery inserted in Hans von Gersdorff's *Feldtbuch der Wundartzney*, Strassburg, 1540. The proper spots for venesection are indicated on the figure, and the viscera are represented *in situ*. The artist based his drawing on the dissection of an executed criminal (as quaintly told in the text). It first appeared in 1517, but is here taken from a later edition of 1540.

76 A CHART OF VEINS (WORKSHOP OF TITIAN). Woodcut attributed to the workshop of Titian (Italian, 1477–1576) from Vesalius' *De Humani Corporis Fabrica*, Basle, 1543. One need but compare the "Zodiac Man" with the "Chart of Veins" from the *Fabrica* to realize the gulf that separates medieval from modern medicine. Vesalius' diagram, or as he entitled it, "A Delineation of the entire Vena Cava freed from all Parts," is a straightforward scientific rendering, unencumbered by astrological or magic connotations. Though not strictly accurate according to modern standards—having been made before Harvey's great discovery—it nonetheless represents a definite and irrevocable break with Galenist anatomical conceptions.

77 SURGICAL INSTRUMENTS (GERMAN SCHOOL, XVI CENTURY). Colored woodcut from Hans von Gersdorff's *Feldtbuch der Wundartzney*, Strassburg, 1540. Still another category of chart is represented by the illustration of surgical instruments. These were copied from miniatures in an Arabic manuscript of Albucasis' treatise on surgery. The Arabs, though not as a rule great surgeons owing to religious scruples, were adept in techniques relating to the eye, ear, and nose. The Strassburg publisher, Johannes Schott, had brought out a translation of Albucasis in 1532, and for good measure incorporated some of the woodcut illustrations in his edition of von Gersdorff's handbook.

78 THE MUSCLES OF THE HEAD (JACQUES GAUTIER DAGOTY). Mezzotint printed in color by Jacques Gautier Dagoty (French, 1717–1786) based upon a demonstration by the famous anatomist M. Duverney, being Plate I of *L'Anatomie de la Tête*, Paris, 1748. The older medical prints appeared in black and white; if they were colored, the pigments were laboriously applied by hand. Since color was an

asset in medical and other scientific diagrams, there always was the incentive to devise a process for producing uniform color illustrations in quantity. Around the beginning of the eighteenth century a German, Jakob Christoph Le Blon, invented the three-color process for printing from three separate plates, founded on Newton's color theory that all colors can be created by a mixture of three primary colors, yellow, red, and blue. The technique used to apply the color was mezzotint. This was a pioneer example of the principle upon which, with many improvements and modifications, modern methods of photo-mechanical color reproduction are based. Jacques Gautier Dagoty applied the process, which he learned directly from Le Blon, in making several sumptuous anatomical atlases in color. This print, therefore, is a landmark in the history of graphic art as well as in medical iconography.

XIII / The Artist Observes the Sick

In their capacity as observers of life in all its phases, artists have had occasion to study and represent humanity in sickness as well as in health. Their approach to these pictorial records in minor key is sometimes humorous, sometimes rather flippant, but most often sympathetic and compassionate. Examples of all these varying moods are assembled herewith; all are prints by world-famous artists of the nineteenth and twentieth centuries.

79 An Omnibus during an Epidemic of Grippe (Honoré Daumier). Lithograph by Honoré Daumier (French, 1808–1879), Paris, 1858. In the hands of a great master, caricature can be most expressive, and actually penetrate to the essential truth—in this case to the feel and outward symptoms of the common cold, or perhaps influenza.

80 Colic on His Wedding Night (Gavarni). Colored lithograph by Paul Gavarni (French, 1804–1866) from the series *The Vexations of Happiness* (*Les Petits Malheurs du Bonheur*),

Paris, 1838. The picture shows a bridegroom suffering an attack of colic on his wedding night. The characters and their emotions are delineated with great subtlety and skill; and the situation, somehow, does become irresistibly funny and absurd. Gavarni and Daumier were the two great chroniclers of modes and manners in Paris from 1830 to 1860. In a sense, they complement each other in their work, since Gavarni's almost feminine sensibility and grace are a perfect foil to Daumier's more ruggedly masculine style.

81 Carnot Ill (Henri de Toulouse-Lautrec). Lithograph by Henri de Toulouse-Lautrec (French, 1864–1901), Paris, 1893. This lithograph transports us to the Paris of the Gay Nineties. The artist, of an aristocratic family descended from the Counts of Toulouse, died of drink and dissipation at the age of thirty-seven. That he was crippled and conspicuously ugly, possibly gave him a certain detachment from life and therefore the impulse to record it. His subject matter—drawn from the theater and music hall, the demimonde and the sporting world—is transformed and made memorable by his superb draughtsmanship and incomparable sense of style.

The present lithograph is an illustration to a monologue delivered by a cabaret performer at the Chat Noir: a facetious and irreverent take-off on the President of France, Sadi Carnot, in 1893. The summary treatment and witty stylizations admirably suggest the tone and atmosphere of a music hall ditty. The monologue intimates either that he is perhaps a victim of the *pari-mutuel* at the race track or that he is at odds with the government and could be cured by putting a sticking plaster on parliament. It ends up with the constant refrain: "If Carnot is ill, it is probably in order to be like the government."

The large black mass to the right of the picture may possibly need some explanation: it portrays the dark habit of a nursing nun, who is approaching the bed with a bowl of food. There was something ominously pro-

phetic about this representation of Carnot as ill, for early in the following year, 1894, he was assassinated by an anarchist at Lyons.

82 THE SICK CHILD (BY EDVARD MUNCH). Drypoint by Edvard Munch (Norwegian, 1863–1944), executed at Berlin, 1894. This work seems poles apart in mood and style from Lautrec's lithograph of "Carnot Ill," though they were made at practically the same time. Where the Frenchman was objective and almost frivolous in attacking his subject, the Norwegian artist was concerned with psychological values of tragic import. The theme of a young girl dying of phthisis is based on vivid memories in Munch's life: both his mother and his younger sister died of the same disease. He has portrayed, with a masterly hand, the pallor, the febrile sensibility, the physical lassitude so characteristic of pulmonary tuberculosis. The emotional overtones evoked by the picture are extraordinary and of a peculiar intensity: the tragedy of youth cut off before its prime, the longing for a fulfillment never to come. It is instructive to analyze how the artist has handled certain details to reinforce the emotive effect: the dark accent and bowed grief of the mother's head; the black mass along the left margin, shaping up as vague creeping shadows—sinister and relentless and suggestive of death—that looms up like an impenetrable curtain before the young girl's view; and in the blank margins below, a tenuous vision of earth, tree, and sky, the phantasmagoric image, as it were, of a world forever lost. The mood is almost exactly paralleled by that of a song by Edvard Grieg, "The Last Spring," in which there is expressed the yearning of the invalid during the long dark winter of the North for spring and the rebirth of health.

Munch is without doubt the most celebrated Scandinavian painter in modern times. He lived for a number of years in Paris and especially in Germany, where his influence as a pioneer of the Expressionist School was of great consequence. His print production of about seven hundred works developed along much the same lines as his painting: the dramatization of inner emotional experiences bearing on the theme of life and death and the relation of the sexes. He summed up his credo as follows: "I paint not what I see, but what I saw."

83 VISIT TO THE CHILDREN'S HOSPITAL (KÄTHE KOLLWITZ). A lithograph by Käthe Kollwitz (German, 1867–1945), Berlin, 1926. Käthe Kollwitz, one of the greatest of all women artists, has achieved special distinction in printmaking and sculpture. Born in Königsberg in 1867, she was reared in an atmosphere of religious idealism, a feeling which in her took the form of social consciousness. As the wife of a doctor who dedicated himself to practice in the slums of Berlin, she had ample opportunity to observe the sick and unfortunate. On such experience, no doubt, was based her lithograph, "Visit to the Children's Hospital." The setting is a ward on visiting day, but attention is focused solely on three characters. There sits the child, appealing in its unfledged helplessness, whom the mother with maternal practicality is inducing to drink from a cup. The father, equally solicitous but more awkward of ministration, gazes with loving concern upon his little child. The work is executed with the simplest of means—inspired draughtsmanship—and with a tender and expressive power that lifts it far above the sentimental and mawkish.

XIV / The Artist Looks at Disease

In this section are presented what might be called clinical reports by artists. They may not be scientific or professional in the medical sense, but they do manage to convey the "feel" of a malady from the victim's point of view. Added to these are several compositions somewhat farther afield, more in the nature of fanciful personifications or pasquinades of medical import.

84 ST. ANTHONY'S FIRE OR ERGOTISM (JOHANNES WECHTLIN). Colored woodcut by Johannes

Wechtlin (German, ca. 1490–1530) from Hans von Gersdorff's *Feldtbuch der Wundartzney*, Strassburg, 1540. There were epidemics of ergotism from the Middle Ages until as late as 1816. It was caused by a fungus on rye grain, one of the bread staples of the poorer classes. The fungus is also the source of the drug ergot. One of the two forms of the disease was characterized by intense burning pains in the affected parts, the limbs becoming gangrenous and eventually dropping off. In the present woodcut, the victim is appealing to St. Anthony for aid. The bones of the great Egyptian hermit were eventually transported to Southern France, where they miraculously cured the disease which was then named after him, "St. Anthony's Fire." The quatrain which appears somewhat skeptical in tone, may be translated thus: "Anthony, how come you are here! Who made a legend out of you? You holy man, beloved of God, are you now taking up medicine also?"

85 AGUE AND FEVER (THOMAS ROWLANDSON). A colored etching by Thomas Rowlandson (English, 1756–1827), London, 1792, after a design by James Dunthorne. This is one of the classics of medical iconography.

86 THE GOUT (JAMES GILLRAY). Colored etching by James Gillray (English, 1757–1815), London, 1799. This is perhaps the most famous imaginative portrayal of a disease: it does manage to suggest the "feel" of a malady in an expressive way. It could also serve as the perfect illustration of the four cardinal signs of inflammation as enumerated by the great Roman physician, Celsus: *Calor, Dolor, Rubor, Tumor* (fever, pain, redness, swelling). The Romans were acquainted with gout, and the poet Ovid speaks of it as *podagra nodosa*, the adjective *nodosa* being used in the sense of tying up in knots. The disease has long been associated with rich living, and it is one of the maladies, along with apoplexy, epilepsy, stone, and quartan agues, which doctors of old frankly said they could not cure.

The English rank James Gillray as the greatest of their political caricaturists. He was originally apprenticed to a letter engraver, but finding the work dull, he ran away to join a band of strolling players. Later his strong bent for art led him to give up a roving life and settle down in London to study engraving at the Royal Academy. He became a very accomplished technician of the graphic arts, and in time achieved considerable celebrity as a political caricaturist. His draughtsmanship has a kind of brutal power (witness his lampoon on Jenner) most effective in the rough and tumble game of satirical caricature. His pictorial diatribes against Napoleon and the English King and his ministers, have to a certain extent overshadowed his contribution to social caricature, which was substantial. His death in 1815 was caused, it is said, by intemperance. It is quite possible, therefore, that Gillray's vivid rendering of the pains of gout was based upon actual experience.

87 THE HEADACHE (GEORGE CRUIKSHANK). The colored etching by George Cruikshank (English, 1792–1878) after the design by Maryatt (as symbolized by the anchor), London, 1819, dramatizes the impact of a headache of such intensity that one might almost venture to diagnose it as migraine. It is interesting to note that Daumier made a drawing of Headache along much the same lines some fifteen years later. It is not known whether he had ever seen Cruikshank's version.

88 DROPSY COURTING CONSUMPTION (THOMAS ROWLANDSON). Colored etching by Thomas Rowlandson (English, 1756–1827), London, 1810. Rowlandson is more whimsical than scientific in his delineation of Dropsy Courting Consumption. Indeed it seems almost certain that the artist's chief interest was in depicting types or variations of physique—"the long and the short of it." The antithesis between the main pair of figures and the pair in the background (fat woman, lean man) is almost too obvious; furthermore all four figures are contrasted with a classical type, the Muscular

Hercules. It is nonetheless an amusing fancy, and executed with Rowlandson's customary verve.

XV / Satire and Caricature

It seems to be a truism that, for the observer, foibles are often more picturesque than virtues. Dante, as we know, wrote more vividly of Purgatory than of Paradise. And so it happens that artists have contributed their fair share of telling satire to the medical scene. One of the chief tools in the delineation of satire is caricature, which is nothing else than deliberate exaggeration or distortion of details for a definite end.

89 THE IMAGINARY INVALID (BY FRANÇOIS BOUCHER). Engraving by Laurent Cars after François Boucher (French, 1703–1770), an illustration to Molière's play, *Le Malade Imaginaire*, Paris, 1734. This brilliant early impression, taken from the first edition of that classic among illustrated books, *Molière's Works*, is the frontispiece to the play of the same name, *Le Malade Imaginaire*. Boucher was one of the most famous artists of the rococo period in France, director of the schools of the Academy and of the tapestry manufactory of Beauvais and the Gobelins, and painter of murals for the king and for Madame de Pompadour.

The engraving, in addition to possessing intrinsic interest for its delineation of the hypochondriac and the instruments of the doctor's trade, clysters, flasks and the like, recalls Molière's celebrated play, perhaps the most caustic satire ever leveled against the medical profession. The plot is concerned with a hypochondriac in the clutches of exploiting practitioners. After various vicissitudes he loses his faith in the doctors and thereby cures himself of his malady. He then determines to become a doctor himself, and the play ends in the farcical scene of his examination and admittance to the doctorate. The faculty in full regalia question him on how he would treat various diseases, one after another; and to each he gives one and the same answer in an absurd jargon of Latin and French:

Clysterium donare,	To give a clyster,
Postea seignare,	Then to bleed,
Ensuita purgare.	Finally to purge.

To which the chorus of medicos invariably responds: "Bene, bene respondere, good, good is the answer; worthy is he to enter our learned body." The scene closes with a burlesque ballet by the assembled surgeons and apothecaries to the sound of a chant: "May he eat and drink, and bleed and kill for a thousand years."

90 HOW MERRILY WE LIVE THAT DOCTORS BE (ROBERT DIGHTON). Mezzotint engraving after Robert Dighton (English, ca. 1752–1814), London, 1793. Dighton's caricature has as its setting an apothecary shop of the late eighteenth century. The portrait of the three doctors in merry mood originally had the title "A Comical Case." But the publishers substituted for it the two lines to be seen in the margin, thus transforming the accent of the picture from humor to satire.

91 THE DOCTOR AND HIS FRIENDS (GEORGE M. WOODWARD). Watercolor drawing by George M. Woodward (English, 1760–1809). The scene shows a physician and an undertaker making merry with death and the devil. The words of a drinking song have been written in ink above. This drawing was copied in etching by Isaac Cruikshank about 1798.

92 A VISIT TO THE DOCTOR (THOMAS ROWLANDSON). A colored etching by Thomas Rowlandson (English, 1756–1827) after Woodward, London, ca. 1810. An interesting collaboration is indicated by the signatures on this print: Woodward del. (drew it); Rowlandson sculp. (etched it). Rowlandson was a much greater artist than his friend and carousing companion, Woodward; but he was constantly in need of money owing to his extravagant habits, and he often had to execute potboilers, making etchings after other people's designs.

[165]

93 ADDRESS OF THANKS TO INFLUENZA (T. WEST). Colored etching by T. West (English, active around 1800), London, 1803. The point of this amusing lampoon is fairly obvious.

94 COW POCK (JAMES GILLRAY). Colored etching by James Gillray (English, 1757–1815), London, 1802. "Cow Pock" is outright caricature that pulls no punches. Vaccination was a very controversial issue at the beginning of the nineteenth century, and was violently attacked by word and picture. The scene is probably the Smallpox and Inoculation Hospital at St. Pancras. The administering physician is unmistakably Jenner himself. It seems strange to us today that a rational technique such as vaccination should have generated such virulent opposition when it was first proposed.

95 VACCINE IN CONFLICT WITH THE MEDICAL FACULTY (FRENCH SCHOOL, XIX CENTURY). Colored etching, French School, ca. 1800. It is instructive to compare this witty and objective satire on vaccination with Gillray's vituperative caricature of Jenner. It is also interesting to note that the enraged cow has more than once appeared as a pictorial symbol in French graphic art. About a hundred years later, Toulouse-Lautrec made one of his most delightful posters to advertise a humorous periodical called La Vache Enragée.

XVI / Charlatans

In this section are gathered an engaging group of quack doctors and charlatans—a veritable rogues' gallery from Holland, England, Italy, Spain, and France. Rogues and cheats are found in every profession, and have existed from the beginning of time. But there generally is a silent partner in their transgressions, namely the gullible public. As the legend on the Buytewech engraving states: Populus vult decipi, "the public wants to be deceived."

96 A SURGICAL OPERATION (LUCAS VAN LEYDEN). This engraving by Lucas van Leyden (Dutch, 1494–1533), made at Leyden in 1523, has been variously titled as a "Surgical Operation" or as "The Dentist." The outdoor setting indicates that the operator has set up a booth at a fair; he may either be a wandering barber-surgeon or a charlatan, probably the latter, because his confederate is in the act of picking the patient's purse.

97 OPERATION FOR STONES IN THE HEAD (H. WEYDMANS). Engraving by H. Weydmans (Dutch, early seventeenth century). There was a byword of old—and current even now—to describe a mentally unbalanced person: "He has stones (or rocks) in his head." Quacks in the sixteenth and seventeenth centuries took advantage of this superstition of a physical cause for dementia to pretend to cure insanity by making a superficial incision in the scalp, and feigning to extract small stones supplied by a confederate from behind. The translation of the Dutch inscription has been obligingly supplied by Dr. Erwin Panofsky: "Come, come with great rejoicing; here the stones can be cut out of your wife." The subject of stone drawing was popular in caricature; and similar scenes have been portrayed by Bosch, Bruegel, Vinckeboons, and Allard. The superstition that malign spirits causing aberration could be liberated by boring a hole in the head is very ancient. Trepanned skulls have been found dating from prehistoric times.

98 THE QUACK (BY WILLEM BUYTEWECH). Engraving by Jan van de Velde after Willem Buytewech (Dutch, ca. 1585–ca. 1627). There is an inscription in Latin and Dutch: "The public wants to be deceived."

99 THE QUACK (BY ANNIBALE CARRACCI). Etching by G. M. Mitelli after the design by Annibale Carracci (Italian, 1560–1609) from the set of Street Characters of Bologna, 1660. The verses underneath may be translated as follows: "This man, who would lecture glibly on the anatomy of the snake and stinging viper, shows only, as his actual authority, the licence

to swindle the world." It has been suggested by Peters that the quack is peddling theriac (see note to Plate 28).

100 DR. MISAUBIN (ANTOINE WATTEAU). Engraving in the crayon manner by Arthur Pond after the drawing by Antoine Watteau (French, 1684–1721), London, 1739. Watteau, who died at an early age of tuberculosis, had no great love for doctors. He made a number of satiric drawings of physicians, of which the present print is one. Dr. Misaubin was a notorious quack who peddled a brand of pills—hence the legend "Prenez, prenez des Pilules," "Take pills, take pills." Misaubin established himself in London; and it was in London that this print was published as a caricature. Misaubin also appears as the lean physician in Hogarth's engraving of the "Death Scene" from *Harlot's Progress*, 1734 (Plate 128).

101 THE COMPANY OF UNDERTAKERS (WILLIAM HOGARTH). Original etching by William Hogarth (English, 1697–1764), London, 1736. This is a rather heavy-handed piece of humor, with punning allusions in heraldic vocabulary. Of the group of physicians sniffing their vinaigrette-headed canes, the three in the top row from left to right are actually portraits of notorious quacks: Chevalier Thomas (Ophthalmiator Pontifical, Imperial, and Royal), Crazy Sally Mapps (bonesetter of Epsom), and "Spot" Ward, who prescribed "drops" and "pills" to a gullible public, including the king.

102 OF WHAT ILLNESS WILL HE DIE? (FRANCISCO GOYA). Etching and aquatint by Francisco Goya (Spanish, 1746–1828) from the series *Los Caprichos*, Madrid, 1799. Among the many satires etched by Goya in his magnificent series of "Caprices," there are two others referring to medicine, namely "What a Golden Beak" and "The Count Palatine." The present picture has been interpreted both as a caricature of Goya's own physician and as a veiled satire on the state of Spain under the premier, Godoy.

XVII / The Sleep of Reason

Long before psychiatry became a science, artists and writers had been dimly aware of the existence of unconscious irrational elements in man's constitution. Infantile and abnormal impulses in all of us—generally repressed by social conditioning or the rational censor—manifest themselves indirectly in sleep as dreams, and in the waking state often as vagaries or even delusions. It is only when the aberrations become violent, tending toward the psycho-pathologic, that society confines the victims in a hospital for their own and the public's protection. In this panel are gathered some representations by artists of dreams and delusions. These irrational fantasies may be personal and constitutional, or may be induced by religious fanaticism or by popular superstition, as in witchcraft. People in the past did not always make a clear distinction between madness and folly. But there is a difference which can best be illustrated by their antonyms: the opposite of madness is sanity and the opposite of folly is wisdom.

103 THE SLEEP OF REASON PRODUCES MONSTERS (FRANCISCO GOYA). This etching and aquatint by Francisco Goya y Lucientes (Spanish, 1746–1828) is from the first issue of the *Caprices*, Madrid, 1799. The eighty plates of the "Caprices," one of the world's masterpieces, is a detached and ironic commentary on mankind. Goya has brought into the light of day and made concrete in the shape of recognizable types, certain basic drives that lie buried in most of us, impulses of vanity, pride, greed, gluttony, lust, cruelty and the like. He thus seems to anticipate many of the findings of modern psychology. The Spanish inscription on the print reads: "The sleep of reason produces monsters." The picture obviously is a self-portrait, haunted by the creatures of nightmare; and indeed we see one of the owls handing the sleeping artist a crayon and bidding him to draw. The whole conception points to the connection between the irrational unconscious and artistic creation. The idea is, of course, as old as Aristotle, who said: "There

[167]

never was great genius without a touch of madness." The artist, however, uses his latent forces for his own creative ends, whereas the psychotic and severe neurotic are overwhelmed by them. A commentary on this print attributed to Goya reads: "Imagination deserted by reason begets impossible monsters. United with reason, she is the mother of all art, and the source of its wonders."

104 DREAM (ALBRECHT DÜRER). Original engraving by Albrecht Dürer (German, 1471–1528) at Nuremberg, ca. 1497. The precise meaning of this allegory is obscure; several interpretations have been suggested. Perhaps the most obvious is that it represents a dream, possibly of sexual import. The bellows is often used to signify a dream, for it was conventionally supposed that dreams were injected into the ear by good or evil agencies. The nude is one of the most alluring that the Germanic Dürer portrayed; the lame Cupid may imply that the love offered was not healthy or normal. On the other hand, Dr. Panofsky has suggested that the picture is a satire on *acedia* or sloth, which, among other things, incites to lust. In any case the print is one of Dürer's most charming engravings, and is here shown in an impression of exceptional brilliance.

105 JOB TROUBLED BY DREAMS (WILLIAM BLAKE). Engraving by William Blake (English, 1757–1827) from the set of *Illustrations of the Book of Job*, London, 1825, early impression in the proof state. Blake's title "With Dreams upon my bed thou scarest me & affrightest me with Visions" seems to be a variation of Job XXXIII:15–16: "In a dream, in a vision of the night, when deep sleep falleth upon men, in slumberings upon the bed; Then he openeth the ears of men, and sealeth their instruction." The set as a whole is a masterpiece, and one of the choicest treasures in the world of graphic art. It is an epic of the imagination, outstanding in pictorial design and endowed with a profundity of hidden meaning which only years of study can reveal. Blake has made the problem

of Good and Evil the central theme of his drama, and he has resolved this everlasting problem by departing somewhat from the original Bible story, and conceiving the conflict in terms of man himself; by making it, in the words of Joseph Wicksteed, "a primarily subjective experience; the conflict between his indwelling Good and Evil powers." Only two of the twenty-one plates have medical interest, this and the Affliction of Boils.

106 NIGHTMARE (ROCKWELL KENT). Lithograph by Rockwell Kent (American, b. 1882), 1941. A psychologically impressive dramatization of the sensation of nightmare or devastating emotional conflict by the celebrated American artist and writer.

107 THE PHYSICIAN CURING FANTASY (FRENCH SCHOOL, XVII CENTURY). This anonymous engraved broadsheet is an amusing travesty on the idea that wisdom or folly are tangible entities, and therefore that wisdom can be imbibed, and crotchets or vagaries can be eliminated by physical means. We see "Wisdom" being poured from a bottle. Other substances in bottles or jars on the shelf are labelled Virtue, Reason, Piety, Humility, Patience, and the like. The picture may be a satire on medical theories fashionable in the seventeenth century, or it may merely be a humorous exaggeration of the absurd. Similar versions are to be found among Dutch and German engravings of the period. The caption in older French, "Le Médecin guarissant Phantasie, purgeant aussi Par drogues la Folie," may be translated as, "The physician curing fantasy, also purging madness by drugs." As Shakespeare said: "Jesters do oft prove prophets," for in recent times drugs are being used effectively in the treatment of mental aberration.

108 ST. ANTHONY TORMENTED BY DEMONS (MARTIN SCHONGAUER). Engraving by Martin Schongauer (German, ca. 1445–1491), formerly in the collections of Archinto, Arozarena, Vanderbilt, and Brayton Ives. This rare and famous

engraving by a distinguished early German artist is in an impression of exceptional quality and state of preservation. Although Schongauer was a painter, he worked largely in the goldsmith tradition, and is better known for his engravings than his paintings. His work was the last flowering of the Gothic tradition in Germany; his fame penetrated even to Italy. Vasari wrote of him in his *Lives of the Italian Painters*, and specifically mentioned this engraving: "In another he did *St. Anthony* beaten by devils and carried into the air by a swarm of them, of the most curious forms imaginable, a sheet which so pleased Michelangelo when young that he began to color it."

The episode of the "Temptation of St. Anthony," one of the famous examples of hallucination, has been treated by numerous artists and writers, who have been fascinated by its dramatic possibilities. St. Anthony the Great—not to be confused with St. Anthony of Padua, the Portuguese disciple of St. Francis who became the patron saint of both Portugal and Padua—was born in Egypt around the middle of the third century A.D. He lived most of his long life in the desert as a hermit practicing incredible austerities. He was the founder and organizer of ascetic monasticism, the first Christian monk. He was often, according to his own belief, sorely tempted during his fasting and solitude by the devil, who appeared in many forms, such as a seductive woman, a deceptive friend, a banquet of delectable food, and as wild beasts, dragons, and demons to torment him. In many representations St. Anthony was accompanied by his familiar, the pig (see Plate 84). The pig may have been one form of diabolic visitation, or it may have symbolized the saint's animal nature.

109 FIRST ATTEMPTS (FRANCISCO GOYA). Etching and aquatint by Francisco Goya y Lucientes (Spanish, 1746–1828) from the first issue of the *Caprices*, Madrid, 1799. In this plate Goya has reported on the folklore of witchcraft. Goya's manuscript commentary reads: "Gradually she makes progress. She can

already jump a little, and in time she will know as much as her teacher." Witches and wizards very often were either completely innocent or mildly psychotic, suffering from several forms of hysteria, such as anesthesia of the skin (witches' patches) or fugues, or else mild psychoses, and the like. For defending them as foolish but not heretical, and for undertaking to cure them by regular medical means, Johann Weyer or Wier (1515–1588) has been hailed as the founder of psychiatry.

110 THE OLD MAN WANDERING AMONG PHANTOMS (FRANCISCO GOYA). Etching and aquatint by Francisco Goya y Lucientes (Spanish, 1746–1828) from the set of eighteen *Disparates* or *Extravagances*, Madrid, 1810–1819. Where the *Caprices* were a mixture of realism and fantasy, the *Extravagances* were the work of unbridled imagination, the direct outpouring, as it were, of the unconscious. Malraux has suggested that some of the *Disparates*, as well as the paintings in Goya's villa La Quinta del Sordo, were mediumistic transcriptions. Goya was driven back into himself owing to his almost total deafness and the state of affairs in Spain. The etching is remarkable for its evocation of nocturnal phantasmagoria through the painter-like handling of light and shade. This impression is from the first edition of the set, which was not published until after the artist's death.

111 DEMONS RIDICULE ME (JAMES ENSOR). Etching by James Ensor (Belgian, 1860–1945), Ostend, 1895. Ensor was a famous Belgian artist, who became one of the pioneers of the modern Expressionist School. In this etching he seems to reveal temptations and guilt complexes stemming from his youth.

112 THE VAPORS (ALEXANDRE COLIN). Colored lithograph by Alexandre Colin (French, 1798–1875) from an *Album Comique*, ca. 1823, depicting various afflictions, such as nightmares, migraine, colic, and St. Vitus' Dance. It was once supposed that certain nervous disorders and depression, hysteria, and the like could be

caused by noxious vapors arising in the intestines. In nineteenth-century France or Victorian England, vapors or "nerves" were sometimes a lady's escape from boredom.

XVIII / The Madhouse (XVI–XIX centuries)

The attitude toward mental illness has fluctuated during the ages. In primitive times the madman was considered to be possessed by an outside force, whether god or demon. Hippocrates, however, is reputed to have treated mental derangement as a disorder of the brain. His more humane concept was lost sight of, and during the Dark or Middle Ages the belief in demonology was carried to an extreme. Madmen were assumed to be not sick but willfully perverse; like witches, they were treated accordingly by exorcism and were often tortured. It was not until the end of the eighteenth century, in the reform of St. Luke's Hospital in London and in Pinel's gesture of unchaining patients at Salpêtrière and Bicêtre in Paris, that a more humane mode of treatment was inaugurated. It is only in recent times that psychiatry has attained professional status as the third major branch of the healing arts.

113 PLATE OF SKETCHES (ALBRECHT DÜRER). Etching by Albrecht Dürer (German, 1471–1528), Nuremberg, 1514. This was the artist's first etching, and one of the earliest examples of the recently perfected medium of etching on iron. Dürer made some more or less casual sketches on the plate to try out the technique. But Dr. Panofsky in his study of Dürer has offered a plausible interpretation that gives a somewhat deeper meaning to four of the characters. The interpretation is based on theories derived from the writings of Avicenna, Melanchthon, Boccaccio, and William of Conches, and presumably accessible to the artist, regarding the effects of a severe depression (melancholia) upon the four temperaments (or dominant humors according to Galen), the choleric, sanguine, melancholic, and phlegmatic. Having first idly sketched a portrait of his brother (the man in profile at the left), Dürer filled in the rest of the plate with illustrations of the four types. The desperate man tearing his hair in the foreground is the "choleric deranged"; his derangement causes him to inflict injuries on himself and potentially on others. The haggard mask-like face in the background is the melancholic both by nature and by disease. The youth with the drink in his hand, naturally gay and amorous, is the sanguine type now degenerated into the madman staring dully at the nude woman. The sleeping woman exhibits the phlegmatic type who sleeps almost without interruption. It is possible that the artist, in portraying the last type as a woman, wished to emphasize the amorous connotations of the sanguine type, as well as to illustrate the theory—unchallenged from the twelfth to the eighteenth century—that all women are by nature cold, that is to say phlegmatic, "because the warmest woman is still colder than the coldest man."

114 BEDLAM HOSPITAL, LONDON (WILLIAM HOGARTH). Engraving by William Hogarth (English, 1697–1764) from the series A Rake's Progress, London, 1735, in the rare first state before the retouch of 1763. It is the eighth and final plate of the series, where the hero, now out of his mind, has experienced the last degradation, and is seen writhing in chains in the foreground. The scene is a faithful picture of the famous insane asylum, Bethlem, a word generally corrupted to Bedlam and thus become a byword in the English language, Originally a hospice of St. Mary of Bethlehem, it was handed over to the city of London in 1547 by Henry VIII for use as an insane asylum, thus making it one of the earliest of such foundations. But, as everywhere, the treatment accorded to lunatics was brutal in the extreme. In the eighteenth century Bedlam was one of the sights of London. Visitors came to be amused at the antics of the inmates, and sight-seers incidentally were a source of revenue to the hospital. We see two such well-dressed women in this picture, one shielding her eyes with her fan from the nude and deluded "king" holding court in the alcove. Hogarth's engraving is a

classic in the delineation of the mentally ill, and no doubt a psychiatrist could easily diagnose many of the types of mental illness portrayed there.

115 ST. LUKE'S HOSPITAL, LONDON (ROWLANDSON AND PUGIN). Colored etching by Thomas Rowlandson (English, 1756–1827) and Augustus Pugin (English, 1762–1832), with aquatint by Stadler, London, 1809. From the set *The Microcosm of London*. Pugin sketched the architecture and Rowlandson drew in the figures. The hospital was founded in 1751 to supplement Bethlem hospital, where conditions were notoriously bad. A new building was erected in 1782 embodying certain reforms in treatment of the mentally ill, including greater freedom for the inmates.

116 THE MADHOUSE (WILHELM VON KAULBACH). Engraving by Casper Heinrich Merz after the drawing by Wilhelm von Kaulbach (German, 1805–1874), 1835. Kaulbach was a German painter very much esteemed in his own country and century. As court painter to the King of Bavaria he painted numerous ambitious but mediocre frescoes. He is remembered now for his early, rather satiric, drawings and his delightful illustrations to Goethe's *Reinecke Fuchs*. The present picture, also early, caused quite a sensation when the engraving was published, and was the subject of a hundred-page pamphlet in explanation by Guido Görres. The author purported to give the life histories of each of the characters, but the accounts seem fictional and merely pegs on which the author has hung his own opinions regarding the moral and political conditions of the time. The artist himself intimated that the work served as a catharsis, and helped him recover from a mental illness (*ein Rettungsmittel aus einer geistigen Erkrankung*). It is said that he was inspired to make the picture by seeing Hogarth's "Bedlam." Görres suggested that the seated figure in the immediate foreground, with his face buried in his arms in deep melancholy, is none other than the artist himself. There

must have been a touch of whimsey about the conception, for the depressed artist apparently is holding in his hand a letter to the engraver of the picture, Merz. Kaulbach's treatment of the subject, in general, is romantic, possibly with a slightly satiric overtone. He certainly shows careful observation of various types of aberration. That the motivation of the work was not primarily compulsive or documentary, is confirmed by the title *Narrenhaus*, which can mean, in older German, insane asylum (*Irrenhaus*), but has as its chief connotation "House of Folly" (*Narr:* fool).

XIX / The Madhouse (xx century)

In this section four artists of the twentieth century have portrayed subjects having some bearing on mental illness. Their motive in choosing such subject matter was not primarily medical, but in achieving their esthetic objective they have also made a contribution to medical iconography. The approach of the artists varies from the romantic to the realistic to the expressionist.

117 DANCE IN A MADHOUSE (GEORGE BELLOWS). Lithograph by George Bellows (American, 1882–1925), New York, 1917. The career of this genial American painter and lithographer was cut off at an early age, but he gained recognition for his bold and vigorous interpretations of the American scene, boxing matches, and the like. In the "Dance in a Madhouse" his approach is essentially romantic, possibly stemming from Goya and a nineteenth-century tradition. The emphasis is on the melodrama, the picturesqueness of the scene, and not necessarily on the character of mental derangement.

118 PSYCHOPATHIC WARD (ROBERT RIGGS). Lithograph by Robert Riggs (American, b. 1896), Philadelphia, 1945. In preparation for this picture the artist made detailed studies at the Philadelphia State Hospital for the Mentally Ill, commonly known as Byberry. The treatment, though realistic, is not literal or photographic,

but rather a composite derived from many observations in a ward for disturbed patients. Today, owing to new methods of treatment, such violent scenes no longer exist.

119 INSANE PEOPLE AT MEALTIME (ERICH HECKEL). Drypoint by Erich Heckel (German, b. 1883), 1914. Heckel is one of the leading German Expressionist painters. The present print is based upon his experience as a hospital orderly in the First World War.

120 A MAN IN LOVE (BY PAUL KLEE). Color lithograph by Paul Klee (Swiss-German, 1879–1940), 1923. A distinguished modern artist here presents a sexual obsession in symbolic form. The man's head is literally filled with sexual symbols. There are many double images: for example, eyes become breasts or breasts serve as eyes. The representation of the obsession is all the more vivid because it is cast in a mode that is akin to the visual expression of the mentally ill. But it does not follow that the artist himself was emotionally deranged; he merely selected the form of treatment which was most expressive of the subject he chose to render. Klee was a conscious artist of great subtlety and originality.

XX / The Beginning and End of Life

The keynote of this section is provided by the folk print, "The Course of Life from birth to death: Such is Life, such is Death" (Tal es la Vida, tal es la Muerte). At the beginning and end of life, the physician's presence somehow seems appropriate. But it is interesting to note that in early times attendance at childbirth was usually the exclusive province of midwives. It is only recently that obstetrics, prenatal care and the like, became concerns worthy of the medical profession.

121 THE COURSE OF LIFE (LATE XVIII CENTURY). An anonymous engraving published by Remondini of Bassano, Italy, for export to Spain in the late eighteenth century. The theme of the various ages of man was popular in folk art during the

centuries. Even Shakespeare wrote about it in *As You Like It*.

122 THE BIRTH OF THE VIRGIN (ALBRECHT DÜRER). Woodcut designed by Albrecht Dürer (German, 1471–1528), Nuremberg, 1505. From the set *The Life of the Virgin*, published by the artist in 1511. One of the most famous and charming delineations of birth in the history of the graphic arts. It was more or less traditional to conceive of the nativity of Christ in terms of fantasy and imagination, but to treat of the birth of the Virgin as a genre piece with a wealth of realistic detail. In this picture the actual *accouchement* has just taken place, and we see the exhausted mother receiving nourishment, the tired midwife sitting nearby, and a jolly company of housewives busied with various occupations, such as bathing the child, preparing the cradle, and generally having a good time.

123 CHILDBIRTH (JOST AMMAN). This woodcut by Jost Amman (Swiss-German, 1539–1591) appeared in Rueff's *De Generatione Hominis*, Frankfurt, 1580, a famous and widely used handbook for midwives. An astrologer is seen in the background, casting a horoscope of the newly born.

124 L'ACCOUCHEMENT (ABRAHAM BOSSE). An etching by Abraham Bosse (French, 1602–1676) made in 1633 at Paris. The *dramatis personae* of the tableau include the mother, the midwife, the friend of the family (Devout Woman) and the husband. Each recites, as it were, a quatrain, engraved below the picture and translated as follows. The Mother: "Alas, I can no more; the pain possesses me, enfeebling all my senses; my body is dying, and there is no remedy for the pangs I feel." The Midwife: "Madame, have patience, do not cry out so; its all over; by my faith, you are delivered of a fine son." The Husband: "That news comforts me; all my grief has vanished; keep on, dear heart, take courage, your pain will soon be over." The Devout Woman: "From this painful effort, so unlike any other torment,

deliver her, oh Lord, and be of help in her childbirth."

125 GYPSY ENCAMPMENT (JACQUES CALLOT). An original etching by Jacques Callot (French, 1592–1635), from the set of four prints entitled *Gypsy Life*, made at Nancy in 1621. This print by Callot and the preceding one by Bosse afford an instructive contrast in the circumstances in which a child is brought into the world. Off on one side of the "Gypsy Encampment," a woman may be observed in the act of giving birth; the incident causes little stir among the activities of the camp. In "L'Accouchement" the birth takes place with much more ceremony amid elegant surroundings.

126 MORBETTO (RAPHAEL). Engraving by Marcantonio Raimondi after the design of Raffaello Sanzio (Italian, 1483–1520). This is one of Raphael's most beautiful and monumentally designed compositions. The *Term* (boundary post surmounted by a head) is the central pivot of a composition in depth. Around it the figures are ingeniously arranged in the form of two balancing curves: on the left, a semicircle is made by the cow, the dead sheep, and the man with a torch; on the right, a complementary semicircle is made by the plague victims. The dark interior on the left is balanced against the desolated open-air vista on the right. For some reason this print is one of the rarest of the Raphael engravings. It was a favorite of Goethe, and his correspondence reveals that he searched for almost twenty years before he was able to purchase an impression of it, already scarce in his day.

Through the courtesy of Dr. Moses Hadas it has been possible to identify the inscription on the *Term*, and thus to establish the correct title of the picture. The Latin inscription comes from the third book of Virgil's *Aeneid*, and may be translated thus: "Men gave up their sweet lives or dragged enfeebled frames." Of the two titles under which this print is known, "Morbetto" (Little Plague) and "The Plague of Phrygia," the latter is incorrect, for

the setting of Virgil's plague was in Crete. It is recounted that Aeneas in his wanderings to establish a new Troy in the land of his forefathers mistakenly started to settle down in Crete, when there appeared "a pestilence and season of death, to the wasting of our bodies and the piteous ruin of our crops."

"The sacred images of the Gods, the Phrygian Penates," the guardian spirits of the family, appeared to Aeneas in his sleep (seen in the upper left) to warn him that he must continue his wanderings for, as fate decreed, Rome and not Crete was to be the site of the New Troy.

The beginning of life is always individual, but the end of life can be either individual or collective, as in times of great disaster. The triumph of death in great numbers is here portrayed symbolically.

127 DEATH AND THE PHYSICIAN (BY HANS HOLBEIN THE YOUNGER). Woodcut by Lützelburger after Hans Holbein (German, 1497–1543) from the series *The Dance of Death*, Lyons, 1545—perhaps the most famous death scene in all medical iconography. In this print, the grim drama of mortality is focused upon the healing mediator himself, under the pertinent caption, quoted from the Gospel of St. Luke: "Physician, heal thyself" (Medice, cura te ipsum). The complete sequence of Holbein's *Dance of Death*, small in size, exquisite in the beauty and perfection of its execution, and profoundly moving in its significance, is beyond question the most celebrated of all representations of man's mortality. Its success was immediate; it was published in many editions and copied in many more. This print comes from the second Latin edition of 1545, printed from the original wood blocks engraved by Hans Lützelburger under Holbein's supervision.

128 THE DEATH SCENE (WILLIAM HOGARTH). This original engraving by William Hogarth (English, 1697–1764) is Plate V of the series *A Harlot's Progress*, London, 1734; it shows her dying while two doctors are arguing about the

respective merits of their remedies. It is said that Hogarth thereby satirized two notorious quacks of the day. The lean man is supposed to represent a Dr. Misaubin (portrayed by Watteau in Plate 100), who concocted various "pills," and the fat one is presumed to be either a Dr. Rock or Dr. "Spot" Ward, who also appears in "The Company of Undertakers" (Plate 101). The Latin abbreviations in the lower right margin stand for: "Invented, painted, and engraved by Wm. Hogarth." He often composed pictures in a series of related scenes, dramatizing the course of a single character. Other famous sets in similar vein were *A Rake's Progress* and *Marriage à la Mode*.

XXI / Emblems of Mortality

To be born is to assume the burdens of mortality, the pains of sickness, the pangs of death. Artists throughout the ages have been eloquent in their dramatization and description of the human predicament, just as they have of man's many activities in happier vein. The reality of disease, however, and the finality of death are inescapable. Against this never-ending flood of affliction, past and present, the practitioners of the healing arts have waged a constant if losing battle. In the past the contest was fought with limited knowledge and individual resources, as typified by Mantegna's drawing of the strong man, Hercules, strangling the Hydra of disease. Today—with the colossal advance of science and man's apparent conquest of the atom and the universe, as symbolized in Sternberg's "Secret of Life"—is there any hope of an ultimate victory over death and disease?

129 JOB AFFLICTED WITH BOILS (WILLIAM BLAKE). Engraving by William Blake (English, 1757–1827). From the set of *Illustrations of the Book of Job*, London, 1825. The quotation from Job II:7 reads: "So went Satan forth from the presence of the Lord, and smote Job with sore boils from the sole of his foot unto his crown." *The Book of Job*, one of the masterpieces of world literature, deals with one of the most universal of topics, the Mystery of Suffering. The question of why there are pain and affliction and death has been asked by all of mankind. A philosophic discussion of the question in literary form is therefore apposite to the theme of this section, especially when there exists so superb an illustration to it as Blake's engraving. Satan is here symbolized as the source of evil and disease.

130 DEATH THE DESTROYER (ALFRED RETHEL). Wood-engraving by Steinbrecher after Alfred Rethel (German, 1816–1859), 1851. This impressive rendering of a Dance of Death was inspired by an account by Heinrich Heine of the first appearance of cholera at a masked ball at *Mi-carême* in Paris, 1832. The picture has the macabre tone of a tale by Edgar Allan Poe.

131 WOMAN AND DEATH (BY KÄTHE KOLLWITZ). Etching and sandpaper aquatint by Käthe Kollwitz (German, 1867–1945), Berlin, 1910. This print is one of the artist's most emotionally moving designs, superb in draughtsmanship and in technical execution. There is epic grandeur in her dramatization of the struggle in a woman between life and death. Seldom has the agony of death been more compellingly delineated; the gesture of the child trying to call the mother back to life is an inspired conception. The work has the same expressive power as Richard Strauss's tone poem *Death and Transfiguration*, where the same theme is treated musically. As a distinguished woman and a great artist, Käthe Kollwitz was concerned with the basic facts of life and death. She has expressed feminine sensibility with masculine directness, or perhaps one should say, with the outspokenness of the elemental woman and mother. This maternal viewpoint is one of her greatest contributions, and she takes her place among the growing body of modern artists (for it is a modern phenomenon) whose utterance is valid, not as an imitation of what man has already done very well, but as an authentic voice of womankind.

132 THE SECRET OF LIFE (HARRY STERNBERG). Etching and aquatint by Harry Sternberg (American, b. 1904), New York, 1936. This print is a symbolic representation of the quest by science for the elusive enigma. On the one side is the biologist with his test tubes and microscope, and a stream of highly magnified micro-organisms in the background; on the other side, the astronomer with his telescope and sky map against a background of comet and stars. In the center, the focus of these two worlds of microcosm and macrocosm, is the presence, not of an hypothesis but of the fact of life, a little child. Above are two huge sparks of electricity bridging the gap between the two poles. It is a dynamic, monumental composition, ingeniously balanced: the two great acute angles drive the eye irresistibly to the center mystery.

133 HERCULES COMBATING THE HYDRA (ANDREA MANTEGNA). Heliogravure of the engraving by Master IFT after the design by Andrea Mantegna (Italian, 1431–1506), late fifteenth century. One of the rarest and most beautiful of the early engravings of the Mantegna School. It depicts the second of the *Labors of*

Hercules, which was to conquer the Hydra, a poisonous water snake living in the marshes near Argos. In the present version the Hydra has only one head, whereas in another interpretation the snake had numerous heads, and when one was cut off, others grew in its place. The present engraving, besides being an illustration of the Hercules legend, might well serve as an almost perfect symbol of the art of medicine—the good and strong physician combating the Hydra of disease.

134 TO SUCCOR THE SICK (CRISPIN DE PASSE). Engraving by Crispin de Passe (Dutch, ca. 1565–1637) after Marten de Vos. It is the fifth of the *Seven Acts of Mercy*, based upon the parable of the Last Judgment in the twenty-fifth chapter of the Gospel of St. Matthew. This section of the parable serves as a reminder that the physician by profession belongs to the company of the merciful and compassionate, and thus is dedicated to moral values as well as scientific practice. In the print, the physician and other charitable souls are tending various sick people. The charming engraved border annotates and embellishes the central picture in the manner of old illuminated manuscripts.

Index of Artists

THE NUMBERS ARE THOSE OF THE PLATES

Amman, Jost, 7, 29, 123
Avril, J. J., 37
Bellini, Gentile, 5, 61
Bellows, George, 56, 117
Birch, William, 49
Blake, William, 105, 129
Bluck, 62
Boilly, Louis, 38
Bosse, Abraham, 36, 48, 124
Boucher, François, 89
Burgkmair, Hans, 6
Buytewech, Willem, 98
Calcar, Jan Stephan von, 17, 70
Callot, Jacques, 125
Carracci, Annibale, 99
Cars, Laurent, 89
Cole, Timothy, 20
Colin, Alexandre, 112
Cruikshank, George, 87
Dagoty, Jacques Gautier, 78
Daumier, Honoré, 33, 39, 40, 46, 79
Dighton, Robert, 90
Dürer, Albrecht, 54, 104, 113, 122
Dunkarton, Robert, 24
Dunthorne, James, 85
Dusart, Cornelis, 45
Eakins, Thomas, 63
Eastman, Seth, 1
Edelfelt, Albert, 20
English School, xvi century, 30
Ensor, James, 111
French School, 1500, 47
French School, xvii century, 107
French School, ca. 1800, 95

Gavarni, Paul, 65, 80
Gaywood, Richard, 18
German School, xv century, 72
German School, xvi century, 16, 27, 28, 67, 77
German School, xvii century, 31
Gheyn, Jacob de, 71
Gillray, James, 86, 94
Goltzius, School of, 11
Goya, Francisco, 52, 102, 103, 109, 110
Greek School, b.c. 150, 9
Haden, Sir Francis Seymour, 25
Heath, William, 60
Heckel, Erich, 119
Heintzelman, Arthur William, 26
Hogarth, William, 101, 114, 128
Holbein, Hans, 127
Homer, Winslow, 53
IFT, Master, 133
Italian School, xv century, 66, 74
Italian School, xvi century, 3, 4, 55
Jenichen, Balthazar, 15
Kaulbach, Wilhelm von, 116
Kent, Rockwell, 106
Klee, Paul, 120
Kollwitz, Käthe, 83, 131
Lautrec, Henri de Toulouse-, 81
Leyden, Lucas van, 96
Lützelburger, Hans, 127
Mantegna, Andrea, 133
Maryatt, 87
Méndez, Leopoldo, 59
Merz, Casper Heinrich, 116
Mitelli, G. M., 99

Moncornet, Baltazar, 22
Munch, Edvard, 82
Passe, Crispin de, 58, 134
Perrissin, Jacques, 44
Piccini, Giacomo, 19
Pond, Arthur, 100
Pugin, Augustus, 50, 62, 115
Raimondi, Marcantonio, 126
Raphael (Raffaello Sanzio), 126
Rembrandt van Rijn, 8, 12
Remondini, 121
Rethel, Alfred, 130
Reuwich, Erhard, 2
Riggs, Robert, 64, 118
Rowlandson, Thomas, 32, 85, 88, 92
Schongauer, Martin, 108
Schuessele, C., 1
Steen, Jan, 37
Steinbrecher, 130
Sternberg, Harry, 13, 132
Stock, A., 71
Struck, Hermann, 21
Titian, workshop of, 68, 69, 76
van de Velde, Jan, 98
Visscher, Cornelis, 57
Vos, Marten de, 134
Watteau, Antoine, 100
Wechtlin, Johannes, 10, 41, 42, 43, 51, 75, 84
Weiditz, Hans, 14, 34, 35, 73
West, T., 93
Weydmans, H., 97
White, Robert, 23
Woodward, George M., 91, 92